Objects and Meaning

New Perspectives on Art and Craft

Edited by
M. Anna Fariello
Paula Owen

The Scarecrow Press, Inc.
Lanham, Maryland • Toronto • Plymouth, UK
2005

SCARECROW PRESS, INC.

Published in the United States of America
by Scarecrow Press, Inc.
A wholly owned subsidiary of
The Rowman & Littlefield Publishing Group, Inc.
4501 Forbes Boulevard, Suite 200, Lanham, Maryland 20706
www.scarecrowpress.com

Estover Road
Plymouth PL6 7PY
United Kingdom

British Library Cataloguing in Publication Information Available

Library of Congress Cataloging-in-Publication Data

Fariello, M. Anna, 1947–
 Objects and meaning : new perspectives on art and craft / M. Anna Fariello,
Paula Owen.
 p. cm.
 Includes bibliographical references.
 1. Art objects. 2. Handicraft. 3. Art and society. I. Owen, Paula, 1948–.
II. Title.
NK25 .F37 2004
701'.1—dc21 2003013062

ISBN-13: 978-0-8108-5701-8 (pbk. : alk. paper)
ISBN-10: 0-8108-5701-4 (pbk. : alk. paper)

♾™ The paper used in this publication meets the minimum requirements of
American National Standard for Information Sciences—Permanence of
Paper for Printed Library Materials, ANSI/NISO Z39.48-1992.
Manufactured in the United States of America.

Contents

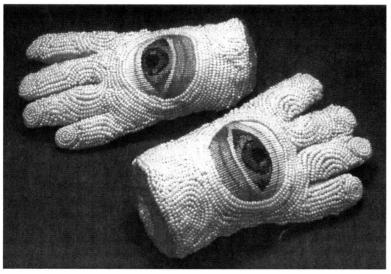

Jon Eric Riis, Hands of the Oracle. *Handwoven tapestry, stitched and couched freshwater pearls and coral, each 9 × 5 × 4 inches, 1999.*

Preface

This book has grown out of many conversations about the different ways various academic disciplines and cultural institutions approach and assign meaning to the artist-made object in postmodern North America. Though most of the discourse since mid-century has revolved around the split between art and craft, our personal interest extended to other facets of the topic, especially when, during the 1980s, we began to assemble articles written by people with similar concerns.

Although the style of writing in this collection of essays ranges from passionate conviction to cool observation, and points of view emerge from different professional backgrounds, each essay reflects original ideas introduced into the cultural dialogue during this period. In producing *Objects and Meaning: New Perspectives on Art and Craft*, our intent is to document the contributions of individuals who challenged the norm. In addition, because we had personally experienced frustration over the lack of published material on the topic, we want to fill a void by compiling a collection of related essays that might involve and inspire readers in a way that an isolated article cannot.

The essays all stem from previously published or presented material and have been loosely organized into three parts—"Historical Contexts," "Cultural Systems," and "Theoretical Frames"—although the ideas in the three groups contradict and overlap each other.

The first part, "Historical Contexts," consists of essays that provide a historical context from which to view the contemporary artist-made object. In chapter 1, "Regarding the History of Objects," Anna Fariello presents a brief overview of the place held by craft objects within an art historical continuum. In chapter 2, "Labels, Lingo, and Legacy: Crafts

at a Crossroads," Paula Owen elaborates on the institutionalized systems of separation in light of the trend toward interdisciplinary and crossover art. Patricia Malarcher, in chapter 3, "Critical Approaches: Fragments from an Evolution," looks at the critical reception given to the exhibition of craft objects since mid-20th century. Finally, in chapter 4, "Paradise Lost? American Crafts' Pursuit of the Avant-Garde," Rob Barnard chronicles the subdivisions within the craft field since 1950, arguing for function as an essential element in craft.

In part 2, "Cultural Systems," the second group of writers expresses theories about the cultural position of artist-made objects. In an annotated version of a previously published essay, "Crafts Is Art: Tampering with Power" (chapter 5), John Perreault declares that craft objects are some of the most important of the period, although they are resisted by hierarchical constructions. In chapter 6, "Moving Beyond the Binary," Jim Sanders proposes that the cultural rationale for the art-craft hierarchy is based on racial, social, gender, and sexual prejudice. In chapter 7, "A Labor of Love," Marcia Tucker examines labor-intensive works in a time-is-money culture and suggests reasons why the process is often discredited. And in chapter 8, "Affectivity and Entropy: Production Aesthetics in Contemporary Sculpture," Johanna Drucker remarks on young sculptors who have returned to making objects using and embracing the materials of consumer culture.

The third group of essays included in the third part, "Theoretical Frames," suggests new ways to consider craft and the artist-made object through a variety of theoretical frames. In chapter 9, "'Reading' the Language of Objects," Anna Fariello suggests that objects operate outside dominant modes of communication, but nevertheless communicate as document, metaphor, or ritual. In chapter 10, "Feminism, Crafts, and Knowledge," Michele Hardy challenges the authority of knowledge based on objectivity and science and proposes "whole body sensitivity" as a way of approaching craft. Suzanne Ramljak, in chapter 11, "Intimate Matters: Objects and Subjectivity," proposes that art jewelry is powerful and meaningful on a personal level and that the intimate art experience has increasing resonance in our rapidly changing world. In chapter 12, "Workmanship: The Hand and Body As Perceptual Tools," Polly Ullrich argues for "embodied art" and notes that the aesthetic values of the craft arts have been dispersed into the larger contemporary art realm. Finally, in chapter 13, "Evolutionary Biology and Its Implications for Craft," Bruce Metcalf analyzes elements of craft to find un-

derlying moral principles, including the "sympathetic gesture," a fundamental element of our humanity.

We are sincerely grateful to the individual writers for their contributions to this project and applaud them for their forward and innovative thinking. We would also like to recognize the many artists and scholars who, while not among this group of writers, have contributed to this dialogue. Many of them are listed in the endnotes or references. Likewise, we are grateful to Scarecrow Press for bringing these ideas before a broader audience in order to expand the conversation. While the bulk of the essays in this collection were written in the last two decades of the 20th century, the ideas in them will most certainly continue to inform our view of artist-made objects in the 21st.

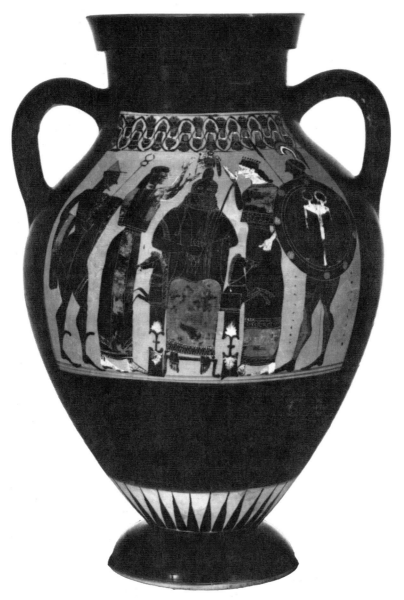

Greek (Attic), Amphora. Terra cotta, circa 540 B.C. From the Arthur and Margaret Glasgow Fund, Virginia Museum of Fine Arts in Richmond. Copyright the Virginia Museum of Fine Arts. Photo by Katherine Wetzel.

1

Regarding the History of Objects

M. Anna Fariello

EXAMINING THE PARADIGM

In order to gain a perspective focused more sharply on objects and their meanings at the turn of the 21st century, it is helpful to look at the broader sweep of human expression and consider the ways in which aesthetic objects[1] have been valued over time. To be thorough in this exploratory endeavor, one must examine the systems of belief that support current assumptions regarding objects and meaning. Cultural relationships—of creative acts to other activities, of aesthetics to other intellectual disciplines, of objects to each other—are not fixed. Meaning fluctuates—from place to place, over time, and according to purpose—in an ebb and flow of changing value. On the shifting sands of the 21st century, the devaluation and revaluation of the object are not apparent. Some will notice the changing tide, but others won't recognize it until their feet are wet. One purpose of this book is to give recognition to the voices of change, those writers, thinkers, and makers who have been willing to wade into the churning surf, leaving their fellows behind in dry shoes.

The purpose of this introductory essay is to brief the reader on the rich history of object-making and to explore assumptions and methods which affect the presentation and reception of this history. Traditional art historical practice generally uses a formal analysis as a starting point

This essay is a revised version of a paper first presented at the Southeastern College Art Conference in Birmingham, Alabama, in 1992 under the title "Ebb and Flow: The Devaluation and Revaluation of the Object." An abstract of that paper, "Ebb and Flow," was published in *Southeastern College Art Conference Review*, vol. 12, no. 3, 1993: 232–233.

in extracting meaning from an object. This method, in and of itself, is not problematic, but its widespread application has disallowed other methods of inquiry until more recent contextual analysis has arisen. Growing out of the field's primary focus on painting, formalism—as a means of critical analysis—was taught to every art history student up through the middle of the 20th century. For those whose primary interest is the history of three-dimensional objects, the discipline lacks a specific language or system of evaluation appropriate to their needs. With frustration, those interested in three-dimensional objects attempted to apply a language structured upon the painted image to volumetric form. Paul Greenhalgh, writing as curator of ceramics at the Victoria and Albert Museum, put it succinctly: "Ceramics is occasionally the subject of art history, but more often it is its victim."[2] Although postmodern thought has expanded the critical dialog to include women, African Americans, Native Americans, "outsiders," and non-Western artists, a similar expansion with regard to particular classes of objects has not been forthcoming. Are we to conclude that certain art forms are subordinate to others, certain materials inherently humble, or certain makers incapable of expressive voice?[3]

To view objects anew, one must step outside the paradigm, step off the sand so to speak, and into the murky waters of postmodernism. Author Ellen Dissanayake suggests aesthetic analysis begin from a physiological point of view. In *What Is Art For?* and *Homo Aestheticus*, she uses examples from non-Western culture to craft a paradigm in which aesthetics is imbedded in the cultural core. Thomas Schlereth, working from within the broad field of material culture studies, proposes an objective analysis for object study. Skirting the issue of aesthetics, his definition allows for aesthetic meaning, nevertheless.

> [O]bjects made or modified by humans, consciously or unconsciously, directly or indirectly, reflect the belief patterns of individuals who made, commissioned, purchased, or used them, and, by extension, the belief patterns of the larger society of which they are a part.[4]

Others have suggested a psychological, anthropological, or sociopolitical starting point. Some—especially those from other disciplines that use object study as a methodology—have been critical of art historical methods because of the importance placed upon economic value, innovation, exclusivity, originality, and individual biography. Yet these

fields—primarily cultural anthropology, folklore, and social history—
have tended to use the object as illustration, reducing substantive eval-
uation to an aid in understanding behavioral systems, modes of com-
munication, or social structure, rather than considering the object
worthy of study in its own right.

In this chapter I propose a methodology that may yield new insights
into understanding the meaning of objects. Such an analysis involves a
front-end consideration of the object, object study from the point of
view of its making. Such a method can augment the summative evalua-
tion commonly used to reveal the object's purpose, status, and recep-
tion. If intent, materials, and process were considered as primary com-
ponents of object analysis, would conclusions be any different from
those drawn from a postproduction point of view?

THE CULTURALLY INTEGRATED OBJECT

Major art historical texts tend to overlook the influence that material
properties and technical process have on the finished object. An exam-
ple from H. W. Janson's *History of Art* illuminates the shortcomings of
the established methodology, what I am calling a postproduction analy-
sis. In the *Palette of Narmer*, a slate object carved in low relief, the pres-
ence of two long-necked beasts that frame a depression in the center of
the palette appears to be a mystery. The Janson text provides a detailed
explanation of scenes depicted on the palette, disclaiming that

> the center section fails to convey an explicit meaning; the two long-
> necked beasts have no identifying attributes and may well be a carry-over
> from earlier, purely ornamental palettes.[5]

Here the artisan may inform the historian, based on the former's un-
derstanding of conditions that arise in carving slate. The depression in
the center of the palette *requires* material reinforcement to avoid in-
herent structural weakness. Obviously, its maker met this challenge;
appropriate reinforcement was supplied by surrounding the thinner, in-
terior portion of the palette with a built-up circular rim (the long necks)
that strengthens an otherwise weak point in the construction. Examin-
ing the palette from the perspective of its material (slate) and its
process (carving) reveals that its maker did not apply a symbol arbi-

trarily as the author would suggest; rather, the method of making determined the form that the symbol would take. Thus, decoration, often considered to be a superfluous afterthought, may actually be a matter of construction. Such integration of construction and decoration in a symbiotic state is a hallmark of fine craftsmanship, or what I like to call the "Craftsman Ideal."[6]

Throughout much of early human history, what people did—or what they were capable of doing—was inextricably linked to identity, evident in surviving surnames. Smith, Miller, Cooper, Baker, Tanner, Sawyer, Potter, and Turner each refer to a particular trade and, by implication, a particular skill. Throughout much of the early history of the Western world, craft production was, indeed, at the core of a civilized society. The Middle Ages particularly appealed to craftsmen because of the powerful influence that guilds exerted over society. The organizing principle of the medieval guild system was based upon accumulated technical knowledge and guaranteed the orderly dissemination (and protection) of that knowledge. Manual labor was the mainstay of society and technological[7] skill its future. The centuries bracketed by two points of high culture in Western Europe are referred to as "medieval." The classical world forms the first bracket and the Renaissance is the terminus; the Middle Ages are just that, in the middle.

For the medieval worker, guilds were a vehicle for exercising professional advancement, political power, and social organization. For the industrial worker living on the threshold of the modern age, the guild appeared to be a workable model to counteract industrial ills. In his seminal essay "On the Nature of Gothic," theoretician John Ruskin proposed that the medieval period represented the "life and liberty of every workman who struck the stone," in contrast to the restrictive "absolute precision" and visual fidelity demanded by the Renaissance and classical styles.[8]

The English Pre-Raphaelite Brotherhood responded to Ruskin's selection of Raphael as a symbol of aesthetic demarcation. To them, art after Raphael represented a shift toward a predictable and restrictive approach to *making* that began in the Renaissance and culminated with the current industrialized state of Europe. Ruskin proposed that the way out of the current situation of poor design, shoddy craftsmanship, and abhorrent labor conditions was to study art before Raphael, that is, the Gothic.[9] Making frequent use of medieval typography, America's *The Craftsman* magazine picked up on this philosophical thread from the start. An article in

its first volume stated, "The [medieval guild] succeeded, through the principles of liberty, equality and fraternity . . . and in achieving the highest degree of freedom."[10]

Contemporary scholarship reveals a measure of equality that operated during the period. In *Artistic Theory in Italy*, Anthony Blunt commented on the status of artisans working in the medieval cultural community when he wrote, "The painter was a craftsman who performed a practical function under the direction of the Church, and through the organization of the Guilds, like any other kind of craftsman."[11] Side by side on primitive scaffolding, sculptors, glass artisans, painters, and metalsmiths collaborated to embellish monumental cathedrals.

In *Painting and Experience in Fifteenth Century Italy*, Michael Baxandall explains that painting, at the beginning of the Renaissance, was not a particularly status-laden art form. "A painting had the advantage of being both noticeable and cheap: bells, marble pavings, brocade hangings or other such gifts to a church were more expensive." He further suggests that, in commissioning a work, the client retained a heavy hand in aesthetic decisions. Baxandall quotes Fillippo Lippi's letter to his patron Cosimo de' Medici: "I have done what you told me on the painting and applied myself scrupulously to each thing. . . . I should do exactly what you wish."[12] In sharp contrast to today's independent artistic practice, medieval art was *applied* art by virtue of its physical relationship to architecture and the artist's contractual relationship to the client.

THE INSTITUTIONALIZATION OF KNOWLEDGE

The establishment of the academy along the lines of current notions of scientific knowledge institutionalized professional disciplines, placing the arts in proximity to other disciplines. Music, for example, was aligned with mathematics because of the mathematical structure of musical notation. A confluence of developing epistemological theories institutionalized knowledge in a way that would subsequently disadvantage certain objects from serious aesthetic consideration.

Cennino Cennini, writing in *The Craftsman's Handbook*, a 1437 manuscript on artistic practice, addressed the shifting intellectual climate.

[Adam] started with the spade, and Eve, with spinning. . . . [But] painting . . . calls for imagination, and skill of hand, in order to discover things not seen, hiding themselves under the shadow of natural objects, and give them shape with the hand, presenting to plain sight what does not actually exist. And it justly deserves to be enthroned next to theory, and to be crowned with poetry.[13]

Aesthetic theory articulated during the Renaissance was becoming just that—more theoretical. Why things were done became as important as what was done or how to do it. Leonardo da Vinci despised "practice without science." "Practice must always be founded on sound theory," he wrote.[14] Leonardo would eventually attempt to establish the superiority of painting over sculpture, arguing that painting was best suited to represent natural phenomena. Because sculpture did not use color or aerial perspective or depict luminosity, it was not able to display its virtuosity based on a calculated scientific theory. Yet, because of its scale, its importance to architecture, and the popularity of rediscovered classical specimens, sculpture held its place in the cultural hierarchy.[15]

The Renaissance magnified the power of human observation. Released from the bonds of a determinant blind faith, painters worked from direct experience and experimented with shadowing, *sfumato*, and atmospheric perspective. They created methods of perspective and optical effects that grew out of new approaches. Granted, glass artisans, using light, had created some of the most stunning aesthetic creations of all time, but they used an old technology. Linear perspective represented an innovative, geometric, and calculated approach to representation.

More important than the novelty of pictorial illusionism was the usefulness of depicting a three-dimensional reality in two dimensions. Indeed, the pictorial representation achieved by the painted surface must have appeared magical when first introduced. The continued development of pictorial illusionism—from perspective, advances in pigment technology, and increased opportunities for observation of natural phenomena—allowed for the production of visual stories created for an increasingly urban populace. This was serious business, rendering the official church version of a particular moral lesson. With such responsibility, image making achieved a concomitant increase in status, and its association with more theoretical pursuits would continue to grow.

THE VALUE OF INTRINSIC MATERIAL

Over the course of the *quattrocento*, the 15th century, the value of com-
missioned artworks changed. Before the Renaissance, the cost of mate-
rial bestowed value on a product, not necessarily the skill with which it
was executed. Some patrons even paid for paintings by the square foot.
Michael Baxandall explains that, throughout the period, the value of
material and skill existed in "an inverse relationship." He writes that,
over the course of the century, "precious pigments become less promi-
nent [while] a demand for pictorial skill becomes more so." An extant
written contract underscores the fact that artistic skill was not necessar-
ily the most expensive part of a commission. Botticelli was paid "two
florins for ultramarine, thirty-eight florins for gold and preparation of
the panel, and thirty-five florins for his brush,"[16] that is, the skill of his
hand. This quotation clearly demonstrates that, in this case, artistic skill
reflected less than half the cost of the commissioned work. The contract
also reveals that the price of certain colors was calculated separately, es-
pecially gold (from actual gold powder) and ultramarine (from powered
lapis lazuli). While the blue of the Madonna's robe symbolized her ce-
lestial reign, it made practical sense for the artist to reserve expensive
pigments for a rarefied application. As in the case of the *Palette of
Narmer*, the circumstances of making can again determine the final
form of the work if one considers the work from the point of view of its
making.

A centuries-old obsession with precious materials supported
alchemy, an attempt to turn base metals into gold. After Marco Polo re-
turned from a trip to the East with a porcelain pot in hand, European
aristocracy began amassing collections of the mysterious material. At
first, porcelain was not considered to be related to other ceramic mate-
rials. Its translucency and vitreous surface was so glass-like that it did
not appear to be a form of clay. Simply called "china" in reference to its
point of origin, it became known as *porcella*, a type of glossy white
cowry shell, which was believed to be its main ingredient. For more
than four centuries European craftsmen competed for the secret to the
arcanum (the alchemical recipe to produce porcelain); they would not
succeed until the 18th century. Pound for pound, porcelain was pre-
cious, guarded as carefully as gold.

In 1568 the famous goldsmith Benvenuto Cellini wrote his *Treatises
on Goldsmithing and Sculpture*. His 19th-century translator, the influ-

ential educator C. R. Ashbee, qualified Cellini's writings, apologetically.

> I may perhaps be allowed to give a few words of warning. We must not take Cellini at his own valuation, and we must remember that he did not draw that subtle distinction between designer and executant that we nowadays are wont to do. . . . The modern point of view . . . distinguishes between goldsmith and sculptor, between craftsman and designer.[17]

Ashbee's "warning" indicates that things had changed since Cellini's time. The educator upheld the well-entrenched distinctions of his century, that "subtle distinction between designer and executant" that has plagued the craft field. It remains difficult to draw a complete theoretical understanding from these early manuscripts because their authors preferred to record technological information, rather than write about their professions per se. To learn about artists, their profession, and its reception, one must eventually turn to Vasari.

A STRUCTURED AESTHETIC

At the height of the Renaissance, Giorgio Vasari wrote *The Lives of the Most Eminent Italian Architects, Painters and Sculptors*. Goldsmiths were included in the first edition (1550) of *Lives*, but were dropped from the more "complete" edition published eighteen years later. While Vasari may have intended to simply refine his study, in doing so, he removed goldsmiths from the company of fellow sculptors. In any subsequent consideration of aesthetics, the decision as to *which* forms were included was as important as *what* was being said about them. As Western Europe's first art historical voice, Vasari exerted a lasting influence on how the world would look upon artist-makers from that moment forward.

Ostensibly, Vasari set out to record the lives of his contemporaries, but he embellished them as he saw fit, providing a mythological version whenever convenient or entertaining. Perhaps without intending to, Vasari prescribed a methodology for art historical practice that depended heavily upon biography and a celebration of individual genius. Contemporary scholars, such as Thomas Schlereth and Kenneth Ames, refer to this aspect of art historical methodology as "object fetishism," "creator worship," and "primacy fascination." Robert Trent expressed

concern that the "masterpiece theory" of art historical scholarship has limited its scope. Feminist scholars have argued that defining "artistic genius" as a male attribute has fostered a limited understanding of creativity.[18] In its deification of the artist, Vasari's work influenced subsequent art historical interpretation and laid the foundation for an aesthetic pyramid that glorified the few and the famous.

Besides the authoritative voice of Vasari, other factors coalesced to form a philosophical line of demarcation that separated the Renaissance and medieval worlds and isolated painting from other crafts. Up until the Renaissance, painting did not exist as a separate art form. Certainly there was painting the *activity*, but not painting the *object*. Historically, painting occurred on the walls of caves and churches, on pottery, on polychromed wood carvings, and on paneled altarpieces. The development of a merchant class, combined with a wider acceptance of secular humanism, allowed individual wealthy patrons to commission personal portraits, which, in turn, became tangible symbols of their wealth.[19] To accommodate a patron's desire for a personalized and portable status symbol, artists adapted methods used to create traditional wood altarpieces to a smaller format, the painted panel.[20] Thus, the idea of *a* painting was born.

The increasing hegemony of theoretical scientific empiricism and the influence of merchant capitalism would come to distinguish the Renaissance from earlier times. New humanist thinkers relied upon observable phenomenon in place of a prescribed belief in the authoritative voice of faith. As Galileo explored the observable principles of the natural world and Machiavelli articulated the principles of the political world, so artists began to codify visual principles to create a highly structured aesthetic world. In the centuries following the Renaissance, the illusory magic of painting would outpace the sensory magic of the tangible object. Cartesian dualism further supported the view that mind and matter existed in separate spheres. Cerebral understanding, removed from sensory and visual perception, was elevated above tactile experience.

Thus, it was not too great a leap of logic for painting to become "enthroned next to theory," as Cennino had earlier suggested. After all, the painter shared tools with the scholar in using a brush, pen, and powdered pigments. Moreover, both painters and scholars used those tools to make marks on a two-dimensional substrate, while other artistic surfaces—stone, glass, metal, wood—remained bound to architecture and physical

process. Still other materials—particularly clay and fiber—would become associated with the home and body. Now clearly disassociated from painting, the three-dimensional arts became ideologically coupled with manual labor, domesticity, and physicality. Thus, when museums undertook the task of classifying their collections, their initial cataloging systems reflected these divisions (along with well-entrenched biases of sexism and classism). This was a most unfortunate coincidence for object-makers of today. The dutiful documentation that accompanied objects into public collections institutionalized the categorical distinctions of "fine" and "minor" arts. Such aesthetic prejudice was publicly sanctioned within rarefied repositories of material culture.

CRAFTING A SELF-CONSCIOUS IDENTITY

Edward Lucie-Smith, in *The Story of Craft*, classifies art's history into three broad stages. In the first period, all work was made by hand; the second marks the intellectual rift that occurred during the Renaissance; the third is defined by the emergence of the industrial object. He defines craft as involvement "in the whole process of design and the use of hand skills"; in contrast, the decorative artist works "under the strict control of an outside designer, even if no industrial processes are involved." Surprisingly, Lucie-Smith does not use the machine as a means of differentiation, as so many are wont to do. His concerns—like those of contemporary craftsmen—focus on matters of control rather than on mechanization.[21]

Reacting to a workplace in which labor was fractured into meaningless tasks and to an environment filled with goods of questionable quality, the Arts and Crafts Movement began in the 19th century as a counterrevolution to the Industrial Revolution. With roots in the mid-century Aesthetics Movement, English artists and writers proposed that the object, stripped of its original and intended purpose, could be given a new meditative function. The movement suggested that art serve as a spiritual guide to counterbalance society's growing dependence upon economic materialism and the harsh realities of capitalism. It represented a shift toward Eastern aesthetics, a corresponding reverence for simplicity, and an elevation of everyday experience from the physical to the spiritual, ideas that would come to characterize the English approach to craft and craftsmanship for an entire century. Applied to Western culture, this

view encouraged the isolation and contemplation of objects in the home, rather than in the church or museum, where aesthetic contemplation was already considered an appropriate response.

Critic John Ruskin gave others courage to pursue the idealization of the household object and its private contemplation when he stated, "Every artist was a craftsman and the simplest household object worthy of his serious effort."[22] Thus, one might consider English Arts and Crafts to be a *privatization* of the aesthetic experience, an experience posited at the opposite end of the spectrum from art as civic propaganda, expression of religious dogma, or tangible demonstration of wealth. Removed from the official sanction of the church and from a place of privilege among the wealthy, such a "serious" reconsideration of the object popularized the artistic experience. The "simplest household object" may have been "worthy," but by implying wider accessibility, it could not simultaneously enjoy the elevated status that accompanied rarefied elite privilege.

Ruskin's evangelical banner was picked up by a younger Englishman, William Morris; indeed, their names often appear conjoined, bound together as they were by the evolving philosophical Arts and Crafts discourse. As Ruskin's most vocal disciple, Morris was quick to echo his predecessor in a number of widely disseminated essays. Their titles alone reveal much about Morris's philosophy: "Art, Wealth and Riches" (1883), "Useful Work Versus Useless Toil" (1884), and "How We Live and How We Might Live" (1885) are but a few. Morris emphasized that art should not be limited to the elite. "Let the arts . . . be widely spread, intelligent, well understood both by the maker and the user, let them grow in one word *popular*" [original emphasis]. Morris spelled out his populist program with an effective analogy: "I do not want art for a few, any more than education for a few, or freedom for a few."[23]

Interpretation of Morris's writing has been both prolific and varied, but few would credit him with an egalitarian revisionism. However, consider this statement:

> When men say popes, kings and emperors built such and such buildings . . . Did they? or, rather, men like you and me, handicraftsmen, who have left no names behind them, nothing but their work?[24]

Through the Pre-Raphaelite Brotherhood, a group of artists and writers who modeled their association on the medieval guild system, Morris

was able to put the idea of collaboration into practice, challenging notions of individual creativity and ownership, at least in theory. Ironically, although the movement was based on a democratic application of the arts, its primary appeal was to the leisure and middle classes. Working within the capitalist system, Morris succeeded in producing finely crafted objects, which he sold through his enterprise, Liberty and Company; his work was purchased by the upper middle class, and, thus, his reformist ideals were seriously compromised.

Morris's call for a democratization of the arts has been well appreciated, but because of the movement's association with the medieval—its embrace of an age in which "all handicraftsmen were *artists*" [original emphasis]—Morris's writing has been considered regressive in the face of modernism. Yet, like the avant-garde modernists who would come to redefine 20th-century aesthetic theory, Morris was an iconoclast in his own right.

> The growth of art . . . like all growth . . . was good and fruitful for awhile; like all fruitful growth, it grew into decay; like all decay . . . it will grow into something new. . . . [The arts] are in a state of anarchy and disorganization, which makes a sweeping change necessary and certain.[25]

Together, the writings of John Ruskin and William Morris were taken up as a rallying cry by an audience eagerly awaiting a critical rationale for action to combat growing concerns regarding industrialization. English Arts and Crafts ideals spread to Europe and coalesced with similar ideas brewing on the Continent. The Viennese *Sezession*, French *L'Art Nouveau*, and German *die Jugendstil* emphasized the materiality of artwork and the unification of all forms of art. The movement was subsidized by private entrepreneurship—in Bing's atelier *L'Art Nouveau* and Morris's Liberty and Company—as well as government-sanctioned workshops—the *Wiener Werkstatte* in Vienna and the *Deutsche Werkbund* in Germany.

If the 20th century witnessed the emergence of a truly "international" style, this was it. The hand production of objects, made by a loose coalition of international makers, was created from a Ruskinian theoretical base and prototyped by his apt disciple, William Morris. Margaret Macdonald painted furniture in Scotland, René Lalique created jewelry in France, Josef Hoffmann produced metal accessories in Vienna. Even Pablo Picasso worked in clay. Worldwide, numerous educational and

exhibition societies formed to discuss and display objects and to dis-
seminate ideas via a classless society of *new art*. Innovation was part of
each group's consciously crafted identity, obvious from the name that
each nationality chose for itself, a name that translates literally into
"young" or "new" from each language. At the cusp of the turn of the
20th century, it seemed as if craft and art had finally formed an alliance
under an international banner and on a level playing field.

AMERICANIZING STUDIO CRAFT

Whether ideas migrated across the Atlantic to the New World via or-
ganized channels or whether they developed here simultaneously re-
mains a debatable question. Regardless, craft activity in America was
equally intense. In 1876 America celebrated its first hundred years via
the Philadelphia Centennial Exposition. Although the primary goal of
the celebration was to show off American goods, in actuality the expo-
sition served as an international cultural exchange. Subsequently, Amer-
ican craftsmen traveled to Europe to further a transatlantic migration of
style. In 1894 Elbert Hubbard would meet William Morris and see his
Kelmscott Press.[26] Using the English press as a model, Hubbard estab-
lished Roycroft as a private press in Aurora, New York, eventually ex-
tending production to include furniture and copperware in an enterprise
that would epitomize American Arts and Crafts in both style and
lifestyle.

In America, societies, clubs, and production centers were established
nationwide with the same fervor as those overseas: Cincinnati Pottery
Club (1876), Allanstand Cottage Industries near Asheville, North Car-
olina (1895), Boston Arts and Crafts Society (1897), and the Rose Val-
ley Community in Philadelphia (1901) were but a few. The inauguration
of the William Morris Society (1903) in Chicago is testimony to Amer-
ica's acknowledgment of English influence. The American Studio Craft
Movement spanned the turn of the century, from the pivotal centennial
celebration in 1876 to its demise as a result of economic hardships im-
posed by the Depression and two world wars.[27] Craftsmen adapted to
the fast-paced changes brought on by the Industrial Revolution to enter
into a virtual golden age of hand production that lasted half a century,
but their efforts were spent and their activity cut short in the lull that fol-
lowed.

The Depression itself was only one factor that caused the ebb in craft production that took place during the quarter-century that followed. The success of the previously profitable decades encouraged the concentration of production in ever-larger shops, rather than in individual studios. Leading craftsmen suffered economic losses at the peak of their expansion. Gustav Stickley, furniture maker and editor of the nationally distributed magazine *The Craftsman*, declared bankruptcy after opening a showroom in New York City. Samuel Yellin, whose Philadelphia blacksmithing operation had swelled to more than two hundred employees to meet the demands of massive architectural installations in the 1920s, found commissions dwindling to a trickle. However, in the long run, what most affected professional craftsmen was not a lack of work during the Depression (for this was somewhat offset by the Federal Art Project); ultimately, it was that hand skill was made entirely obsolete by a new aesthetic.

THE EBBING OF CRAFT TRADITIONS

Ironically, the demise of the American Studio Craft Movement came about through a logical extension of Arts and Crafts principles, especially the notion of "truth to materials" and the concept of "exposed construction." The concept of truth to materials, derived from Ruskin's writings and disseminated via Stickley's magazine, meant that the characteristic strength and beauty of each material should be a paramount consideration in the design and execution of an object. Thus, the natural grain of wood was allowed to show under a minimal finish, and the rich patina of copper was allowed to take its natural course rather than be polished to an artificial shine. Exposed construction was made manifest in mortise-and-tenon joinery (which refers as well to the material reinforcement of the *Palette of Narmer*). But when applied to new building materials such as steel and glass, the principle of truth to materials meant that large, sheer surfaces were appreciated for their own sake. Likewise, adherence to the principle of exposed construction meant that the graceful lattice of Samuel Yellin's ironwork could be replaced by a rigid geometry of ribbed steel reinforcement. Where did the craftsmen fit into this scheme?

What came to be known as the International Style evolved from a logical extension of the Craftsman Ideal, and, ironically, its widespread

adoption eliminated the need for craftsmen worldwide. No longer was skillfully made ornament required in an environment *decorated* by the sheer hypnotic reflections of its glass skin and the awesome, massive linearity of its steel skeleton. Architectural ironsmiths, terra-cotta sculptors, and stained glass artisans were no longer needed or desired. In all aspects of "modern" aesthetic production, form was devoid of the ornamentation and embellishment made possible by handwork.

For craftsmen working on smaller-scale objects, the situation was no brighter. As the century progressed, objects produced in a single maker's studio were not taken as seriously as those coming from an industrial research-and-design team, where production was analyzed for capitalist efficiency. An investment of time was no longer a clear measure of value. Time management and efficiency studies would take its place as means of assessing value. The steady and infinite patience required by Adelaide Robineau in the creation of her intricately carved *Scarab Vase*—purported to have taken her one thousand hours to complete—was of little consequence. In spite of the medal awarded to her at the international exposition at Turin, the art world relegated her work to the dustbin of historic artifact. Thus, the hand skill carefully cultivated by studio craftsmen, such as Robineau, was replaced by the newly defined methods of ceramic designers, like Russell Wright, whose simplified geometric aesthetic could be more easily adapted to machine technology.

Even where craft was clearly a serious profession, its value was subverted by the fact that some of its leadership was female. In Cincinnati, where art potteries were headed by women, and in Appalachia, where traditional weaving was revitalized into marketable cottage industries, craft production thrived at the turn of the century. But as the century progressed, its value declined. In 1940 Aileen Osborn Webb established an organization that would become the American Craft Council, a nationwide, all-media craft association. As Paula Owen will point out in chapter 2, "Labels, Lingo, and Legacy: Crafts at a Crossroads," the craft "establishment" adopted specific categories to define American craft and internalized a particular set of circumstances by organizing at this time. One of those circumstances would be the status of women at the close of World War II. Along with a national expectation that Rosie the Riveter would return to the kitchen came the assumption that Adelaide Robineau would be out of place alongside Peter Voulkos in the ceramics department at the Otis Art Institute.

The *domestic* aspects of pottery, textiles, and furniture fell prey to the prevailing sexism of the mid-century. The fact that women continued to create craft objects contributed to the perception that the objects themselves were *domestic*. Their creation in small, private studios, coupled with their subsequent use in the home, fostered an attitude that these were not *real-world* products after all. As America's citizens moved increasingly from farm to city, the concept of home became more physically and ideologically distinct from the workplace, as distinct as the widening separation of art and industrial design from studio craft. Thus, the conceptually linked "Arts and Crafts" would become "art" and "craft," uncapitalized, separated, and ranked one above the other. Inferior connotations where heaped upon craft, relegating it to hobby status and ignoring the fundamental value it had sustained for centuries.

By mid-century, in spite of the object-making frenzy that had occurred earlier, handcraft appeared to reach its nadir. The craft object (and its corollary component, skill) was devalued aesthetically by art history, devalued economically by industry, devalued physically by architecture, and devalued critically by academia. It survived marginally along the periphery, in the fields of education and health, serving as child's play and therapeutic method. Craft programs continued in grade schools and hospitals, but remained absent from academic discourse and the highly charged art world marketplace.

The once-popular college text *Mainstreams in Modern Art* published in 1959 exemplifies the ebbing of appreciation for object-making that was conveyed to a generation of students (myself among them). The text's author was the influential *New York Times* art critic John Canaday. Writing from within the stronghold of modernism, Canaday dispensed with the entire history of *Art Nouveau* and *Jugendstil* in a single footnote, defining the movements "as a decorative style that flourished in the decade between 1890 and 1900, not always with results that look happy today."[28] The author's conclusion—that the turn of the century was a *low* point for *high* art—was consistent with mainstream ideological and aesthetic notions of the 1950s and 1960s. On the contrary, I contend that the period was a *high* point for work defined as *low* art!

The object continued its slide from grace as we moved from the 20th century into the 21st. The century's passing was marked by a corresponding conceptual shift from the physical Industrial Age to the more ephemeral, data-based Information Age. In all businesses and trades, skill—once the hallmark of quality—became secondary to concept.

This shift is most easily understood in examining the position of craft vis-à-vis the field of design, the interface between art and commerce. With the ability of computers to create an instantaneous walk-through of virtual architectural space, for example, three-dimensional model making became an obsolete and cumbersome practice. The preference for a teapot by Michael Graves outpaced a desire for one by Marguerite Wildenhain. Moreover, the word "designer" became synonymous with "creator," while the object's making took place in anonymous third-world factories. As hand skill lost its importance to human survival, the craftsman became an anonymous component in the production process.

NAVIGATING THE IDEOLOGICAL EBB AND FLOW

Throughout history, aesthetic theory reflects a point of view, one that can elevate particular classes of objects and cast a spurious light on others. Indeed, the entire discipline of art history is based upon such qualitative analysis. But art historical texts do include craft objects as representative of certain periods, recognizing the significance of, for example, the clay figures of Catal Huyuk, the wooden *Harp of Ur*, the tile work of the *Ishtar Gate*, and the *Palette of Narmer*. But why have these objects been selected to be a part of art's history while others were not? Were they selected to represent a high point of aesthetic influence or were they a mere matter of convenience? Moreover, what are the consequences of selective inclusion in some periods and wholesale exclusion during others? A naive student enrolled in one of a thousand survey courses taught across the country might conclude that pottery was something produced in the ancient and classical worlds and, after that, pottery making completely disappeared!

Contradictions such as these lead us to question whether a history of craft should be developed apart from art history. Should craft come under the decorative arts umbrella or the broad-based field of material culture studies? Perhaps this volume will provoke discussion of such questions. At the very least, the following essays will raise new questions. Indeed, their authors have not limited their thinking to the safety and security of the dry sandy beach. Instead, through this collection of essays, they navigate the ebb and flow of change and contribute to a body of coherent scholarship needed to support and sustain an effective dialog.

NOTES

1. I prefer to use the word "object" precisely because it lies outside value-laden classification systems (at least for now). Other terms—"craft," "sculpture," "artifact," "art work"—are loaded with connotative meaning. In using the term "object," I include any human-made artifact that carries with it a creative element. This would include all works of art and craft, regardless of scale, material, style, or period. I prefer Thomas Schlereth's and Jules Prown's definitions over those more art historically descriptive. Schlereth describes the object as "concrete evidence of the presence of a human mind operating at the time of fabrication," in Thomas Schlereth, *Material Culture Studies in America* (Walnut Creek: Altamira, 1999), 3.

2. Paul Greenhalgh, "Discourse and Decoration: The Struggle for Historical Space," *American Ceramics* 1993: 46–47.

3. For an earlier discussion of evaluation based on material, see the author's "Material Meaning," *Studio Potter* Dec. 1996: 26–30.

4. Schlereth, *Material Culture Studies*, 3. Jules Prown offers a similar definition in "Mind in Matter: An Introduction to Material Culture Theory and Method," *Material Life in America: 1600–1860* (Boston: Northeastern Press, 1988).

5. H. W. Janson, *History of Art*, 4th ed. (New York: Abrahms, 1991), 99–100.

6. I am currently using the term "Craftsman Ideal" to define a set of criteria and qualifying characteristics that describe the intentions of those making craft objects. Such characteristics grow from ideologies espoused by Ruskin in the mid-19th century and culminate in the philosophy espoused by *The Craftsman* magazine in the 20th.

7. I use the words "technological" and "technology" to describe the methods and processes developed from accumulated knowledge that allowed for the production of an object with a predictable outcome. Thus, technology exists in every age and is not limited to its common usage in the electronic age.

8. John Ruskin, *The Stones of Venice*, numbered Artists Edition (New York: Merrill & Baker, n.d.), 159–163.

9. John Ruskin, *Modern Painters*, selections reprinted in John D. Rosenberg, *The Genius of John Ruskin* (Boston: Houghton Mifflin, 1963), 55.

10. "The Gilds of the Middle Ages," in *The Craftsman*, vol. 1, no. 3 (1901): 11.

11. Anthony Blunt, *Artistic Theory in Italy: 1450–1600* (1940; Oxford: Clarendon, 1970), 2–3.

12. Michael Baxandall, *Painting and Experience in Fifteenth Century Italy* (1972; New York: Oxford, 1978), 1–4.

13. Oxford was founded by 1220, with more than fifty other universities established by 1500. The "seven liberal arts" were grammar, rhetoric, logic,

arithmetic, geometry, music, and astronomy. Cennino, Cennini d'Andrea, *The Craftsman's Handbook*, trans. Daniel Thompson (1437; New York: Dover, 1954, 1933), 2.

14. Blunt, *Artistic Theory*, 27–28.

15. Certainly, there was a similar separation of craft from sculpture, but to maintain a sharp focus in this introduction, I have concentrated on the hegemony of painting over the three-dimensional arts in general.

16. Baxandall, *Painting and Experience*, 14–17.

17. Ashbee, C. R., "Foreword," in *Treatises on Goldsmithing and Sculpture* by Benvenuto Cellini (1568; New York: Dover, 1967), xi.

18. Robert Trent, quoted in Thomas Schlereth, *Material Culture Studies*, 40–41. See also Kenneth L. Ames, "The Stuff of Everyday Life," in Schlereth's *Material Culture: A Research Guide* (Lawrence: University of Kansas, 1985). See also Christine Battersby and Linda Nochlin in Diane Apostolos-Cappadona and Lucinda Ebersole, *Women, Creativity and the Arts* (New York: Continuum, 1977).

19. Penelope Hunter-Stiebel's essay "The Craft Object in Western Culture," in *Eloquent Object* (Tulsa: Philbrook Museum, 1987), provides an alternative explanation. She quotes Sir John Pope-Hennessy, who said, "Paintings were actually objects made for specific purposes like any others. It was only in the nineteenth century that they were turned into works of art." In her discussion of 16th-century tapestry weaving in Brussels, Hunter-Stiebel notes that tapestries were "the most valuable items in the inventories of princes and noblemen in this new age of personal possessions" (144–145). She also provides an interesting account of struggles between the 16th-century guilds of painters and the tapestry weavers in Brussels, in which the former tried to exert control over the designs of the latter.

20. This argument is buttressed by the fact that elaborate illusionist framing devices were often used by Renaissance painters. Such an illusionist frame, a visual reference to the highly ornamented wooden altarpiece of an earlier period, was a two-dimensional representation of a three-dimensional convention.

21. Edward Lucie-Smith, *The Story of Craft: The Craftsman's Role in Society* (Oxford: Phaidon, 1981), 11. I have subscribed to Lucie-Smith's triad of changing circumstances to order this introduction.

22. John Ruskin, *Modern Painters* (New York: Merrill and Baker, 1890).

23. William Morris, "The Lesser Arts," *William Morris*, G. D. H. Cole, ed. (London: Nonesuch Press, 1934), 496–97, 514.

24. From the posthumous publication of his collected works by his daughter May Morris to contemporary publications, interpretations of William Morris and his influence are varied. See May Morris, *The Collected Works of William Morris* (London: Longmans, 1910–15); T. Jackson Lears, *No Place of Grace: Antimodernism and the Transformation of American Culture, 1880–1920*

(Chicago: University of Chicago, 1981); Eileen Boris, *Art and Labor* (Philadelphia: Temple, 1986); Tanya Harrod, *William Morris Revisited: Questioning the Legacy* (London: Crafts Council, 1996). The Morris quote from "Lesser Arts" is from the earlier Cole, *William Morris*, 497.

25. Morris, "Lesser Arts," in Cole, *William Morris*, 499.

26. The Philadelphia Centennial Exposition exposed America to European culture, influencing subsequent American production, in particular art pottery. The 1876 exposition predates the celebrated cultural exchange fostered by the 1913 Armory Show, which introduced European Modernism to the nascent New York art world. My point here is to emphasize the transatlantic dialogue that was taking place prior to the advent of the 20th century. Hubbard did go to England in 1894, but it is not certain whether he actually met Morris. For a description of Hubbard's career and the Roycrofters, see Maria Via and Marjorie Searl (eds.), *Head, Heart and Hand: Elbert Hubbard and the Roycrofters* (Rochester, N.Y.: University of Rochester, 1994).

27. The movement also suffered from the loss of some of its most charismatic national leaders. Elbert and Alice Hubbard died on the Lusitania in 1915, and, though not so literal a loss, Gustav Stickley went bankrupt and ceased publication of *The Craftsman* the following year. In *Arts and Crafts in America*, Robert Judson Clark sets 1876 and 1916 as *terminus anti quim* and *terminus post quim* of the movement. However, in many parts of the country, the Studio Craft movement continued to thrive into the 1930s. See also Anna Fariello, "Arts and Crafts in Appalachia: The Third Wave," *Style 1900* vol. 16, no. 1, 70–75.

28. John E. Canaday, *Mainstreams of Modern Art* (New York: Simon and Schuster, 1959), 423.

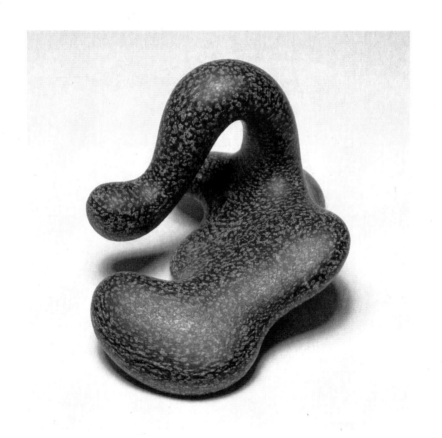

Ken Price, Jellied. *Ceramic and acrylic, 6¼ × 10¼ × 7¼ inches, 2001. Courtesy the Franklin Parrasch Gallery.*

2

Labels, Lingo, and Legacy: Crafts at a Crossroads

Paula Owen

The word "craft" has so many different definitions today that it is practically meaningless. Perhaps such ambiguity has merit, suggests David McFadden, curator at the American Craft Museum.

> No single definition of the word satisfies the range of activities—mental and manual—that craft comprises. . . . Craft is a flexible term, shifting in its common usage from verb that describes conscious action to modify or transform a material to a noun that describes a class of objects.[1]

Claudia Anne Chase, an artist in Wisconsin, sees it differently.

> These words and their often confusing definitions leave those of us who practice an art using traditional techniques without an appropriate way to name ourselves. We live in a world full of names and we are either misnamed or nameless.[2]

The ambiguity of the word "craft" is troublesome because for the majority of people it connotes hobby-level kitsch, which nullifies significant achievements and ideas. It is troublesome because many young artists have grown up in a world of cultural fusion and no longer find the classification relevant. It is troublesome because the craft establishment—associations, magazines, galleries, university departments, museums, and the like—perpetuates the ambiguity,

This essay combines and expands upon two earlier essays: "The Art/Craft Money/Value Paradox" was first presented at the 1995 College Art Association Conference. "Beyond the Visual," written jointly with Angela Adams, was published in the November–December 1992 edition of *Art Papers*.

leaving the field without a critical base, theoretical framework, or ideological principles.

Much of the craft establishment, however, shrinks from this discussion and seems comfortable using an outdated, formal method of definition by materials: wood, clay, fiber, metal, and glass. Yet we know that not all objects made of these materials can be labeled craft and that other materials like plastic, resin, concrete, and found objects are often used by craft artists. Those who make objects in these materials are claimed (but not always) by the craft establishment or may choose it (but many don't). Howard Risatti, art historian at Virginia Commonwealth University, says that "the role and identity of crafts in modern and postmodern society are probably the most important issues facing the field today."[3]

SYSTEMS OF SEPARATION

As in ethnic, religious, or political separatism, the dividing line between art and craft has been bolstered by separate social, commercial, and institutional systems. The systems—the art and craft establishments—have developed over time in response to changes in the way objects have been valued. The Yale cultural anthropologist George Kubler pointed out that objects are valued in three ways: 1) market value, 2) aesthetic value, and 3) social value.[4] Whether created for intellectual or sensual pleasure, for the glory or appeasement of God, for domestic use, for political persuasion or symbolism, or any other reason, almost all art objects produced in any culture fit into Kubler's model.

Since the industrial revolution, there has been little art historical attention to and certainly no scholarly consensus on the value of aesthetic objects. Alternately objects of status and objects of humility, they have been classified into the decorative arts, the applied arts, the minor arts, the design arts, material culture, or the craft arts. These overlapping categorizations demonstrate the lingering questions that were first addressed by John Ruskin and William Morris, who were driven by the desire to secure the value of skilled workmanship in the machine age. Eileen Boris, in the book *Art and Labor*, writes that their ideas appealed to a "wide spectrum of the late-Victorian public. . . . Through the practice of craftsmanship, they hoped to reunite art and labor, mental effort and manual achievement, work and play, countering the fragmentation

of social life endemic to the emerging corporate order."[5] The theories, based mostly upon these social and moral ideas, survived the industrial revolution and beyond, but are only vaguely related to the field today. In fact, as T. J. Jackson Lears says in his study of antimodernism, *No Place of Grace*,

> These social functions of the craft movement epitomized its drift toward accommodation. Despite its origins as a reaction against modern overcivilization, the craft revival served to intensify the modern preoccupation with individual fulfillment.[6]

William Morris, curiously, had been one of the new theorists for a new age when the roots of avant-garde thought were introduced. Peter Selz notes that "at the end of the nineteenth century many artists and writers, among them William Morris, Leo Tolstoy, and Vincent Van Gogh, were disappointed with the indifference and rejection of the bourgeoisie or were troubled by the constantly widening gulf between the artist and society."[7] Avant-garde painters, poets, musicians, and other radical thinkers of the period, however, were not so much interested in preserving the value of workmanship as was Morris, though they were all interested in retaining the human dimension in a changing world. However, the avant-garde painters were more interested in changing the way the world was seen and experienced. Paul Cézanne wrote in a 1905 letter to Emile Bernard, "Now the theme to develop is that—whatever our temperament or power in the presence of nature may be—we must render the image of what we see, forgetting everything that existed before us."[8] Even today, it might be said that breaking the rules is a driving force for the artist, while following the rules (traditional techniques and values) is important to the craftsman. Morris and Cézanne, though both moved by the same social and aesthetic upheaval, came to different conclusions. Cézanne espoused breaking the rules, proposing new theories about the nature and value of the artist's impression, while Morris defended the old ways.

Cézanne and other avant-garde artists of the time were also responding to new market conditions. It was becoming essential for artists and critics to develop a new aesthetic theory in the changed environment of easily produced consumer goods in order for art objects to retain market value. It became necessary to communicate how and why market value was only incidental to the true worth of a work of

art, a value that was much more abstract, timeless, and significant. This was a distinction that had not been needed before because both material and workmanship could be generally quantified by accepted standards based on real time or real goods. In the book *Pot of Paint*, Linda Merrill pieces together the famous *Whistler v. Ruskin* trial of 1877, during which the painter James McNeill Whistler tried to prove that the art critic John Ruskin libeled him by denigrating his abstract style. The end result was that

> Ruskin, with his idealistic devotion to the past, was called the Don Quixote of art, Whistler, the artist of the future. . . . *Whistler v. Ruskin*, a story of trial and error, marks a critical hour in the evolution of modern art."[9]

The changes in art at this time were one facet of a complete shift in the overall frame of reference. The dialectic of physical and metaphysical forces that had occurred throughout history was heightened by radically new ideas about reality, which emerged independently in science, philosophy, and art. The Renaissance relationship between man and nature gave way to a more complex understanding of existence and an acceptance of an unseen reality. In science, Einstein's theory of relativity introduced an abstract understanding of time. In art, the great painters lost interest in the observable reality, and as art historian, Werner Haftmann says, their interest "shifted from the static nouns, tree—flower—streams, to the dynamic verbs behind them: to grow, to flower, to flow." The external image of the thing was "no longer adequate of itself to carry the weight of the artist's experience and sensations."[10]

While the avant-garde advanced the notion of an abstract reality, crafts people were determined to retain the human goodness of certain skills and traditions and remained anchored to a more concrete view of the world, even founding utopian colonies to preserve their values and lifestyles. An abstract reality did not attract those who were dedicated to the tangible integrity of their materials and their traditional view of value and workmanship. Even today some craftspeople reject a society dominated by progress and industry and favor a lifestyle and worldview that is often counter to big business. "To choose crafts is to declare a political position," is the way art critic John Perreault puts it.[11]

Paradoxically, in the craft establishment, marketing and commerce are preeminent, and many craftspeople have capitulated to the demands

of the marketplace. In truth, almost all artists today have some sort of relationship to the marketplace, and though many craftspeople reflect Perreault's observation, many do not. Different ways of valuing art objects and different ways of doing business, nevertheless, remain important to the dynamics of the separate systems.

Two other influential and intertwined factors related to establishing value emerged in the modern era: (1) The art museum became an important force in developing societal attitudes, and (2) innovation, so important to the burgeoning industry, became prized as an end in itself. The social and commercial values of the upper classes, whose profits depended on invention and innovation, became the values of the art museum since it was the wealthy industrialists who founded most of them. In considering the formation of two of our nation's most prominent museums, Stephen Weil notes that there was a

> symbiotic relationship between this country's social elite and its major art museums. . . . By the very manner in which they deal with works of art, those museums have provided a metaphorical model for a particular ordering of society, an ordering in which what is rare and beautiful is given a position far superior to what is useful. . . . What an object looked like was, of course, important. But so too was a firm attribution to a highly regarded artist, preferably one who might be considered a genius.[12]

Avant-garde theory, too, adopted innovation as that which differentiated a serious artist—the individual genius—from all other types of artists and by extension increased the market value of "cutting edge" work. Craft objects, by drawing meaning from traditional techniques and materials, rather than from innovation, had no place in the new art world.

Nevertheless, the 20th-century craftspeople who embodied Morris' ideals carried on, and the objects that they made became highly prized (though not prized enough for the major art museums). Aileen Osborn Webb founded the Handicraft Cooperative League of Craftsmen "to develop markets in metropolitan areas for rural craftsmen"[13] in 1940 and the Museum of Contemporary Crafts in 1956, canonizing important works that were undervalued at the time, while helping home-based businesses. But with the beginning of the American Craft Council in 1943, she also institutionalized the separate systems for art and craft.

This served to isolate certain artists, objects, materials, and skills from the ideas, practices, and critical discourse of mainstream art. And

the unfortunate isolation, erroneous even then, was based on the use of specific materials, rather than on unifying principles. Only a decade later, Peter Voulkos and others on the West Coast received critical attention because they departed from the fundamentals of craft by "breaking the rules" in clay. Their activity was not enough, however, to call the growing craft establishment into question. Voulkos, claimed by the craft establishment because he worked in clay, was clearly not motivated by traditional values. He was driven by a desire to build up a "tempo of experiment" at Otis Art Institute, where he taught, says Garth Clark, author of *A Century of Ceramics in the United States.*

> There was no common style or ideology—other than the tacit agreement not to have any common style or ideology. The group was freely, almost purposely, eclectic. They drew from myriad sources: Haniwa terra-cottas, Wotruba's sculpture, Jackson Pollock's paintings, music, poetry, and the brash, inelegant Los Angeles environment.[14]

Voulkos and his circle, as well as others who worked in "craft materials," such as Lenore Tawney, were motivated by the same forces as other artists of the period, but became encapsulated by the emerging definitions of their medium. The transcendent and innovative qualities of works in "craft materials" hardly registered with art historians because the new craft establishment had circumscribed artists working in certain materials, whether they wanted it or not, and tied their work to the elements of tradition—technical skill, materials, and function.

Coincidentally, this differentiation by materials occurred just as American colleges and universities, responding to new expectations of prosperity and the influx of GIs returning from WWII, expanded their art departments to include classes in weaving, ceramics, metals, and the like. Marcia Manhardt has observed, "Through federal support, the university enrollment became not only the headquarters for art education but also the great patron of the arts and artists."[15] The burgeoning numbers of art graduates who went on to teach throughout the country took with them and furthered the proscribed divisions between craft and art. Add to this the support Mrs. Webb and the new American Craft Council gave to the development of craft exhibitions, craft guilds, craft fairs, craft schools, and craft magazines, and the craft establishment was firmly planted.

The craft establishment might not have taken root, however, if it had not also continued to espouse the compelling social values of William

Morris and other reformers. Art critic Janet Koplos observed almost half a century later that the craft world is built upon a sense of "community."[16] Spawned in part by social reformists reacting to the convulsions of a newly mechanized society, this community (with a few notable exceptions) has tended even today to avoid making critical judgments about quality or aesthetic value so as not to ostracize anyone. The resulting lack of an ideological or critical base has severely limited the ability to assess the merit or significance of craft world endeavors—objects, exhibitions, or scholarship—though individual artists and works are occasionally admired.

What a pity. For want of an articulated ideology, a significant movement has been obscured by the mechanisms of capitalism and separatism, even though fragments of such an ideology remain: (1) preserving traditional skills and ways of working, (2) bringing people together around shared experiences over time, and (3) providing ways for ordinary folks to interact with the creative, handmade object. These values, however, are no longer confined to craftspeople. Many artists in all media ascribe to them in their life and work, and many so-called craft artists do not.

CROSSOVER: THE OBJECT IN A NEW CONTEXT

Adding to the confusion has been the emergence of *crossover art*, which blends art and craft, both formally and intellectually, and is produced by artists in all disciplines. We have passed out of the time in which the exploration of an abstract reality is held above the human dimension or social values in art. The blending of ideas around renewed interest in life issues and shared experience—social, political, cultural, personal—are routes to meaning in all art forms.

Our age requires that we recognize multiple realities, and our art reflects it. Artists like Faith Ringgold, Martin Puryear, Ann Hamilton, Ken Little, Anne Wilson, Elaine Reichek, Liza Lou, Michael Lucero, Beverly Semmes, and many others draw from both art and craft. The art critic and curator John Beardsley even wrote recently about bridging "the phenomenal and conceptual dimensions" in reference to landscape architecture, calling artistic hybridization the "frontiers of culture."[17]

Artists from all disciplines who share a desire to connect with the viewer on a sensory level, who believe in the expressive essence em-

bodied in process, and who grapple with personal or sociopolitical issues have more in common, no matter what their medium, than do those who are artificially linked by materials, business plans, or academic camps. Indeed, tactility, materiality, interactivity, and the underlying procedural precepts of the craft arts have been informing the larger visual arts world for quite some time.

Though the visual-cognitive properties of art are still dominant, the boomerang need for sensory experience brought on by the technological explosion has prompted crossover artists to incorporate a physical interaction between their works and the viewer. They are exploring a new form of aesthetic consciousness—synesthesia, what Diane Ackerman, author of *A Natural History of the Senses*, has described as "a thick garment of perception [that] is woven thread by overlapping thread."[18] Synesthesia in art exploits the communicative link between the rational and nonrational, the verbal and nonverbal, the analytical and the sensuous. Joanna Frueh, artist and critic, calls it "the conflation of senses and of senses and thought that is experience."[19]

There have been outbursts of experiential and multisensory art throughout the 20th century. But today, increasing isolation from direct experience, plus chronic visual overload, compels crossover artists to defy the proliferation of mediated experience and virtual experience by creating tangible objects and/or physical experiences. Formerly taboo subject matter, materials, and ideas have become the norm, mostly due to the influence of non-European cultures and the Feminist Art Movement. Experiential and interactive art of all kinds—performance art, public art, environmental art, installation art, and functional art—incorporate many of the social and aesthetic values of the craft arts.

The *New York Times* published an article in 1999 in which critic Roberta Smith introduced another perspective by suggesting that the Conceptual Art Movement (along with Feminism and Multiculturalism) made it possible for anything to be art. As Smith said,

Conceptual Art has encouraged the assumption that every object, every picture, even every abstract painting tells a story—that it carries within it some kind of narrative meaning or *subtext*. Equally ingrained is the more limiting expectation that all this meaning is primarily intellectual and easily reduced to language, that art as an entity is completely explainable. . . . This condition has caused a permanent confusion of content with subject matter, to the continuing detriment of both content and form.

She continues that the "dematerialization" of art has prompted the grad-
ual "rematerialization" of art. "The challenge," she says, "is to embed
concepts, ideas, and critique in material and form."[20]

Smith's observations are echoed by the observable increase of tactile
objects in artists' studios and exhibitions. Some of them are of the in-
tentionally careless, candy-colored variety, loaded with postmodernist
skepticism and reflecting the rampant consumerism to which they react.
An equal number of them are drawn from the natural world and remind
us of craft objects, though they are not functional. Often, they too, sub-
vert the consumer culture by reflecting the skills and time required to
create them or because of the intrinsic properties of their process or ma-
terials. These crossover objects honor tradition—some are crocheted,
stitched, carved, or precisely painted—but they intentionally undermine
function and narrative in order to arouse abstract responses by provid-
ing a locus for contemplation. Dave Hickey, the well-known art writer
and critic, has observed that his students "wanted to make things. There
was a paradigm shift about a decade ago. In 1989 most of my students
were into Bruce Nauman. By 1991 most them were into Kenny Price."[21]

Obviously, "making things" is central to the craft arts. The abstract
responses generated by crossover artist Kenny Price's biomorphic ce-
ramic sculpture and other similar objects can be cognitive or sensual or
both, but they thwart the easily articulated. This kind of work relates to
the viewer on an intimate or personal level, so that we are drawn into
them rather than being repelled by them, inferring an interactivity of
subject (the viewer) and object—what the critic Michael Fried called
"mutual inflection."[22] The experience of them is engaging and mean-
ingful without function or subject matter. Other crossover art resists
rampant consumerism by insisting upon connectedness to the natural
world or by co-opting consumer culture for unexpected ends. But fore-
most, crossover art combines attitudes, techniques, and materials from
more than one discipline.

These hybrid works depart from what we think we know about art
and craft. They suggest that the distinctions between art forms are less
clear than ever and that the historical precepts of the craft arts are of
more significance than ever. But without a credible and unambiguous
theoretical basis, the craft establishment is doomed to drift between
commercialism and romanticism, while young visual artists remain un-
aware of their craft antecedents. By espousing ambiguity and limiting
the definition of craft to formal properties, the art world has been able

to ignore and will continue to ignore a complex and influential force in contemporary art. Attempts to establish such a framework have been made. Rob Barnard and Howard Risatti, for instance, have called for a redefinition around function as a unifying principle. Risatti writes,

> to stay within the crafts field and ignore function (whether in its practical or conceptual/metaphorical sense) is to abandon the field's single most important element. The origin and identity of crafts as a discrete artistic practice is intricately bound to function. Function is so crucial that it gives crafts their identity, an identity that not only links the physical form of traditional objects to sources in nature, but also becomes the raison d'etre that links them to the human body.[23]

This rationale is clear and defensible, but unworkable for the craft establishment, which now encompasses a huge variety of functional and nonfunctional work, as well as people with very different standards, values, and lifestyles. Unfortunately, we cannot put the genie back in the bottle.

Turf protection will impede other theories, too, but they are critical to establishing the integrity of the field. The labels, lingo, and legacy of the craft arts need thoughtful reconsideration and scholarly documentation. We have moved beyond the industrial age into the information age and beyond, and we must examine our motives, definitions and structures in light of new realities. People who value the craft arts stand at a crossroads, and it looks like we might scatter in different directions.

NOTES

1. David Revere McFadden, "Artifice and Authenticity: Defining Craft," *Defining Craft I, Collecting for the New Millennium* (American Craft Museum, 2000), 9, 11.
2. Claudia Anne Chase, "What's in a Name?" *Fiberarts* (Spring 1996).
3. Howard Risatti, "Metaphysical Implications of Function, Material, and Technique in Craft," *Skilled Work: American Craft in the Renwick Gallery* (Washington, D.C.: Smithsonian Institution Press, 1998), 34.
4. George Kubler, *The Shape of Time: Remarks on the History of Things* (New Haven: Yale University Press, 1962).
5. Eileen Boris, *Art and Labor* (Philadelphia: Temple University Press, 1986), 3–4.

6. T. J. Jackson Lear, *No Place of Grace* (Chicago: University of Chicago Press, 1981), 83.

7. Herschel B. Chipp, *Theories of Modern Art* (Berkeley and Los Angeles: University of California Press, 1968), 456.

8. Chipp, *Theories,* 22.

9. Linda Merrill, *A Pot of Paint, Aesthetics on Trial in Whistler v. Ruskin* (Washington, D.C.: Smithsonian Institution Press, 1992), 6.

10. Werner Haftmann, *Painting in the Twentieth Century* (New York: Praeger, 1965), 1

11. John Perreault, comments from an address at the Virginia Museum of Fine Arts, State of the Craft Conference I, 1988, sponsored by the Hand Workshop Art Center.

12. Stephen E. Weil, "Courtly Ghosts and Aristocratic Artifacts: The Art Museum As Palace," *Museum News* (November–December, 1998), 45, 48.

13. American Craft Council, untitled chronology (New York: American Craft Council, 1993).

14. Garth Clark, *A Century of Ceramics in the United States, 1878–1978* (New York: E. P. Dutton, 1979), 133–34.

15. Marcia Manhart, "The Emergence of the American Craftsman—à la BA, BFA, MA, MFA," *A Neglected History of 20th Century American Craft* (New York: American Craft Museum, 1990), 23.

16. Janet Koplos, "Considering Craft Criticism," *Monograph* (Deer Isle, Me: Haystack Mountain School of Crafts, 1992), 3.

17. John Beardsley, *Our Heritage Imagining Futures*, exhibition catalogue celebrating 100 Years of Landscape Architecture at Harvard (Cambridge, Mass.: Harvard University Graduate School of Design, 2000).

18. Diane Ackerman, *A Natural History of the Senses* (New York: Random House, 1990), 25.

19. Joanna Frueh, "Speakeasy," *New Art Examiner* (Summer 1991): 13.

20. Roberta Smith, "Conceptual Art: Over, and Yet Everywhere," *New York Times* (April 25, 1999), Section 2.

21. Dave Hickey, "A Conversation with Alexi Worth," *Art New England* (April–May, 2000): 19.

22. Michael Fried, "Art and Objecthood," *Artforum* (Summer 1967): 21.

23. Risatti, *Skilled Work,* 34.

Lia Cook, Point of Touch: Bathsheba. *Linen, rayon, oils, and dyes, 46 × 61 inches, 1995. From the Oakland Museum collection, California. Copyright Lia Cook. Photo by the artist.*

3

Critical Approaches: Fragments from an Evolution

Patricia Malarcher

For most of the late 20th century, the silence of art critics on the subject of contemporary objects was lamented within the craft community. The gap between the craft movement and the larger world of visual arts was nowhere more apparent than in the lack of critical attention to work in materials associated with crafts. The 1990s then brought forth a substantial increase in the volume of writing on clay, glass, fiber, and other craft mediums. This was partially due to a change of climate in the art milieu. The emphasis on the context of art, the dominant thrust in the 1990s, allowed social and political content to override formal and aesthetic concerns. Causing a general erosion in the old hierarchies, this trend opened new perspectives on craft, especially when craft skills were applied to cultural concerns. However, behind the critical shift there also is a subtler, less-acknowledged factor. Like new growth hidden under dead brush, a body of critical writing on craft has been evolving slowly and quietly. Finally, this is making its impression on the critical landscape.

The situation might be appreciated best by reviewing the uneasy relationship between art critics and craft. As an example, Mildred Constantine remembers when Harold Rosenberg, a prominent New York art critic, visited *Wall Hangings*, a 1969 exhibition at the Museum of Modern Art (MoMA). An international survey that featured 28 major innovators in the burgeoning field of fiber art, the exhibition filled the entire first floor of the museum. Constantine, then a curator in MoMA's De-

This essay was based on research conducted by the author as a James Renwick Fellow in American Craft at the Smithsonian Museum of American Art in 1989.

partment of Architecture and Design, and Jack Lenor Larsen, the prominent textile designer, had organized the exhibition. When Rosenberg had finished touring the galleries, Constantine asked him what he thought about the show. She recalls that he answered with unreserved enthusiasm, saying, in effect, that it was all very new and exciting. When she asked if he would review it, however, he answered that he wouldn't know how.[1]

Rosenberg's admission, as Constantine tells it, is rare for a critic not only because of its unabashed honesty, but also because it allows a possibility of value that is not understood. The usual case, well documented in art history, is critics' resistance to adjusting their theoretical lenses to accommodate newness. Recent manifestations of this resistance have profoundly inhibited the thoughtful discussion of contemporary objects.

A few months after *Wall Hangings* opened, *Objects USA*, a comprehensive overview of contemporary crafts at the end of the 1960s, made its debut at the Smithsonian Institution in Washington, D.C. The exhibition was to travel around the United States under the sponsorship of the Johnson Wax Company. The company had commissioned Lee Nordness, a New York gallery director who had exhibited the work of Wendell Castle and other innovative "artist-craftsmen," to acquire the collection with assistance from Paul Smith, director of the Museum of Contemporary Crafts (later renamed the American Craft Museum). In his introductory essay to the book published in conjunction with the show, Nordness discussed the status of craft criticism: "There is a dire need for serious critics to review [these] works. New York, as the contemporary art center of the world, still has not one critic to assess the merits of new objects."[2]

Over the next two decades, variations on Nordness's concern were repeatedly expressed by curators, dealers, and artists. Complaints intensified as critics' indifference to works derived from object-making traditions helped maintain the distinctions of high and low art. And those distinctions were reflected in marketplace values. At the same time, the handful of galleries representing contemporary crafts were presenting them as fine art rather than as objects with reference to the history of utilitarian things.

Craft Horizons, published by the American Craft Council since the 1940s, for almost a quarter of a century was the only magazine in the United States devoted to the subject of craft. Its section of brief reviews was generally limited to formal descriptions of works. When the mag-

azine was reconceived as *American Craft*, reviews were limited to one or two in-depth commentaries supplemented by a visual summary of shows.

In response to the field's growing hunger for recognition in print, magazines that focused on specific mediums—*Fiberarts, Metalsmith, American Ceramics, Surface Design Journal*—emerged in the mid-1970s. Although their reviews and articles were usually written by artists or other insiders, a few critics with philosophical perspectives— for example, Betty Park in fiber and Matthew Kangas in clay and glass—began to develop critical perspectives from which to approach the field. The dearth of response from established art critics, however, continued into the 1980s.

Exemplifying a gathering frustration, David Huchthausen wrote in the catalog essay for *Americans in Glass 1984,* "The lack of relevant criticism has fostered a starvation for input and furthered an alienation from the art community. What we need is not the development of critics who specialize in glass [one could substitute clay or fiber or wood] but the cultivation of art critics who are willing to evaluate glass from a fine arts perspective."[3]

Ironically, when *Americans in Glass 1984* was granted the coveted review in *Art in America*, art historian Robert Silberman's article, under the heading of "Decorative Arts," threw the medium back to its craft origins. Apparently stimulated as much by Huchthausen's essay as by the show, Silberman agreed with Huchthausen that "while the studio movement has rewritten the history of glass, it has had virtually no impact on the history of art." However, he questioned "the implied notion that the studio glass movement ought to be fully assimilated into the fine arts." In Silberman's view, "the distinctive history of glass, as well as its craft and commercial aspects, are important strengths that should not be recycled out of hand in the pursuit of fine art status."[4] Huchthausen's and Silberman's opinions illustrate the asymmetrical relationship between a craft world seeking status as art and an art world telling it to stay in its place. Nevertheless, while Silberman had not accepted the challenge to review glass as art, his considered response to Huchthausen's charge could be read by an optimist as the start of a critical dialogue.

As the art scene became more complex at the end of the 1980s, questioning intensified regarding the boundaries of craft. At that time, artists with fine art as well as craft affiliations were producing objects in a wide variety of materials. The range of work had evolved to include ex-

pressive forms in craft materials that were unquestionably sculpture (the clay works of Robert Arneson and Stephen de Staebler), functional objects rooted in craft traditions (pottery by Karen Karnes and Warren McKenzie), and objects that referred to functional objects, but were not designed for use (ceramic constructions by Bill Daley and Wayne Higby). Furthermore, material-based categories had expanded to include new substances as expressive mediums such as handmade paper and new genres such as the book arts. By attracting artists from both fine arts and crafts backgrounds to the same workshops and exhibitions, those developments marked an authentic departure from conventional divisions.

Also emerging was hybrid "crossover art," exemplified by works like Faith Ringgold's painted quilts that incorporated both fiber art and painting. They were emblematic of a body of feminist work by women who turned to craft materials and processes for their female and/or ethnic connotations. Here the tendency was not to employ craft as a necessary way of making an object, but, rather, as a cultural statement. Then there were things like an ordinary woven wicker dog bed by Robert Gober, handmade in a traditional craftsmanlike way, but with subversive implications that distinguished it from straightforward craft. Within this cultural climate, the media attention given to work often depended on the artist's self-identification as a fine artist or a craftsperson. It also became evident that craft-related work received more notice when it was shown outside of the stratified art environment of New York City.

TWO PIVOTAL EXHIBITIONS

Hoping to clarify some of the issues, as well as to gain some insight into the cultural biases against craft, I spent most of 1989 researching articles written about exhibitions of contemporary objects. With the support of a James Renwick Fellowship and residence at the Smithsonian Institution, as well as with assistance from the publicity departments at many institutions, I gathered a substantial sampling of writings from newspapers and art periodicals, as well as exhibition catalogs and brochures. My study was framed within a 20-year period between the opening of *Objects USA* and the end of the American tour of *Craft Today: Poetry of the Physical*, which opened at the American Craft Museum in 1986. Although the project originally focused on eight definitive traveling exhibitions, my research led me to writings on other

significant shows and to resources in other areas. All this verified that the journalistic coverage of craft had increased exponentially in quantity, but not in critical quality, over two decades. Among the surprises was the discovery of more coverage of craft in art magazines than I had expected.

Clippings in the *Objects USA* file at the Smithsonian included picture spreads from *Newsweek*, *Life*, and other popular magazines, as well as newspaper reports. However, those articles offered little comment on the issues Nordness had raised. While calling the works in the exhibition "art objects," Nordness had stated that a major problem was to determine where the work and its creators could be placed in the "arbitrary hierarchy" that had separated fine arts and crafts. The existence of that hierarchy was confirmed in many of the articles that tracked the exhibition on its American tour. Even as they acknowledged that these new works had departed from handmade objects of the past, many writers alluded to craft's lowly status by referring, for example, to expectations of "needlework by little old ladies" and the artists' "artsy-craftsy" predecessors. Most of the articles picked up two observations from the book: (1) craft has been liberated from function, and (2) diversity is the American style.

In *Craft Horizons*, however, 26 pages were allotted to reproductions of work in the show, plus a glowing commentary by Robert Hilton Simmons. He stated, for example:

> The crafts in America today, it is said, have undergone such a change in their economy that they have taken a seat beside the fine arts. . . . Financial success and critical acclaim are no longer confined to the lions of the fine arts. . . . Nearly everything that has happened in the fine arts—pop, op, abstract expressionism, hard edge, funk, porno—is happening in the crafts today. The border line between the arts and crafts is, in fact, as precarious as that between madness and genius.[5]

Citing the influence of Bauhaus refugees on the thinking of American craftspeople, Simmons noted their intentions of removing distinctions between the fine arts and crafts. He observed that a common element in many of the works was deliberate distortion. "If the spirit most commonly manifest in the products of traditional crafts over the past thousands of years is quiet and balance, it is perhaps appropriate that movement and distortion are typical of the far-out present."[6] Notwithstanding its zealous overtones, Simmons's article was knowledgeable in regard

to the sources and intentions of contemporary crafts and matched the self-perception of the field.

Yet, when the exhibition reached the Museum of Contemporary Crafts, its final venue, Ed Rossbach, one of the artists represented, wrote a reflective critique that also appeared in *Craft Horizons*. With a trace of regret, as if something had been lost, he noted that the word "object" had come to mean "museum object" and questioned the "ill-defined nature" and "uncertain role" of craft.[7] Earlier in the life of the show, such provocative comments set against those of Simmons might have sparked the sort of dialectical climate that Nordness had hoped for but that never came about. Belated though they were, Rossbach's sentiments proved to be prophetic. Since then, the notion that craft has its own validity as "other" than art has been a theme running parallel to the insistence that craft is fine art.

In contrast to the thin file of clippings on *Objects USA*, those generated by *Craft Today: Poetry of the Physical* filled a large carton. They came from publications across the United States even while the show was still in New York. The fact that the new craft facility was the world's first condominium museum provided an extra promotional angle that extended coverage to architectural as well as art publications. The level of sophistication and technical mastery in *Craft Today* far exceeded that in *Objects USA*. Yet, there still were references to "knitting grannies" and to craft as "the stepchild of the fine arts." There were glib accounts of the history of craft, placing its origins in periods as diverse as prehistory, the Renaissance, and the Great Depression. But there also were numerous articles indicating thoughtful considerations on the state of craft. Some of the coverage offered genuine insights, and a number of articles were written by outside observers familiar with the craft field and its concerns. Still, much of the discussion served to inflame the art/craft controversy.

The sprawling character of *Craft Today*, a massive survey of everything being produced in the name of craft under four categories, discouraged in-depth reviews. Most of the writers who actually saw the show—as distinguished from those who relied on press releases or reviews by other writers—found something positive to say about some of the works. Nevertheless, the consensus from both sides of the argument was that craft had strayed from where it belonged. Echoing Rossbach's earlier concern, many expressed doubts about the dominance of "sculptural objects" over "functional crafts" and remarked on confusion re-

garding the field. For example, art critic John Zeaman wrote, "Judging by *Craft Today*, American craft needs to rethink its own traditions and establish its independence from the influence of contemporary art."[8]

Writing from a pro-craft perspective, Helen Giambruni, then editor of *Craft International*, stated that many of the "art" pieces in the show would not pass muster in a quality show of painting and sculpture and criticized the craft establishment for not working harder to establish the validity of functional crafts. She wrote, "If functional purpose other than pure aesthetics is no longer the criterion for definition, then how is it decided what belongs in a craft museum?"[9] At the opposite end of the spectrum, Neal Benezra's *New York Times* article gave high praise to works like Peter Voulkos's clay sculpture and Claire Zeisler's monumental fiber forms, but expressed disdain for artists who had succumbed to "the pitfall of function."[10]

CRAFT CRITICISM

While there remained a clear divide between those holding to "art" as the operative term and those who wanted to retain the integrity of craft, the work itself continued to challenge categories. And, by the end of the 1980s, cracks were appearing in the wall of critical resistance. Works in glass and clay, in particular, were drawing attention from critics writing for mainstream art publications. While not denying the material aspects of the work, their reviews indicated that they could respond to what a material was able to say, but were not concerned with how the work was made. By contrast, reviews in craft publications often emphasized the significance of process and materials to the aesthetic effect.

Postmodern art critics of the 1980s were receptive to things like the fusion of material and content, as in the work of Bonnie Biggs, an artist who was well established in the glass community. For example, an *Artforum* critic responded to the work with an extended metaphor: "Bonnie Biggs dives headlong into that transformational sea of conflicting desires and free floating expectations that threaten to engulf . . . the use of glass as a correlative of water suggests a symbolic allusion to constant flux within stasis."[11]

In the case of Jon Clark's figurative sculptures, critics responded not so much to the physical properties of glass, but to the sense of arrested

life implied in its frozen fluidity. For example, a Houston critic wrote, "When viewing sculpture made of glass, it is usually difficult to divorce the pieces from the fragility and preciousness of glass as a material. Jon Clark's work takes us beyond the medium to a place of images which present the human condition, good or bad."[12]

A review of Richard Shaw's work in *Art in America* referred to "imagistic porcelain sculptures [that] fool the eye just enough so that you look harder to recognize what's really there and to see how impeccably the sculptural images match the real thing."[13] Porcelain is perhaps the only material in which the variety of Shaw's forms and surfaces could be made. However, the work's trompe l'oeil quality, which provided an art historical context, was given more importance than the physical substance.

In its coverage of exhibitions from different sections of the country, the *New Art Examiner* was exceptionally evenhanded in its treatment of works reflecting both fine art and craft orientations. Exemplifying this attitude are reviews of Jane Sauer's basketry sculpture in two St. Louis exhibitions two years apart. According to the first, "The controversy of art versus craft, or even utilitarian versus non-utilitarian art, are non-issues in the case of Jane Sauer's work."[14] While denying its importance in regard to this work, the reference to the controversy implies that it was alive. The second review, however, never mentioned craft: "There is no question that sculptor Jane Sauer is producing some of the strongest work on the St. Louis contemporary art scene. Sauer has strengthened the sculptural identity of her work by increasing the size and sophistication of her shapes."[15] One can doubt Sauer's meditative work, small in scale by comparison with that of sculpture showing up in Soho, would have attracted the same attention in a New York–based publication.

Reviews of work in materials related to craft by artists who neither identified themselves as craftspeople nor showed at craft galleries often suggested that an artist's fine arts resume could overcome critics' bias toward craft materials. In fact, some critics actually praised the very features of work that allied it to craft. For example, when Carol Hepper, a sculptor, showed a group of skeletal forms in natural materials that resembled giant baskets, one review described the construction in detail, remarking on its labor intensity and respectfully summing it up as "straightforward virtuosity."[16] A year later, when Hepper's work took

another turn, the "craftsmanlike method of construction" of the earlier work was recalled.[17]

Dale Chihuly is among the exceptional artists whose exhibition careers started out in craft galleries, but eventually claimed art critics' attention. A comparative look at reviews of his work in the 1970s and those from the 1980s suggests that the commentary matured with the work. For example, a 1971 review in *Craft Horizons* described an installation by Chihuly as "fluent forms and pulsing lines of light bulbous monochrome transparencies searching space with tenuous antennae . . . eerie arabesques . . . sensuously bulging bases."[18] The writer was obviously visually stimulated, but offered no interpretation. In 1979, Lee Hall reviewed Chihuly's work in the same magazine and found ambiguity in its suggestion of "materials totally different from glass." After discussing similarities and differences between the basket forms and the cylinders inspired by Navajo blankets, Hall invites the reader to "consider glass as a skin" and sees the work "healing the wounds between art-as-symbol and craft-as-skill."[19] Two years later, Linda Norden noted in an *Arts* review that Chihuly's larger, shell-like forms were "more conceptual, more abstractly related to the forms they evoke than his earlier efforts." She saw that they "imply protection and an early inhabitation by living forms." Although these later works were heroic feats in glass, the universal implications of their abstract content were given priority over their material aspects. Norden also speculated that when Chihuly began to show with Charles Cowles, a fine art dealer, that meant "contending with the kind of criticism more familiar to artists in the heavily trafficked galleries."[20]

It often appeared that work in craft materials was reviewed more harshly when it was shown in fine art venues rather than in craft galleries. This did not bear out in the case of Lenore Tawney, another artist who has been recognized in both art and craft publications. Her 1985 mini-retrospective at the Mokotoff Gallery in the then trendy East Village prompted a feature by Henry Gerritt in *Art in America* and a lengthy review by Amy Winter in *Arts*. According to these writers, the show comprised a mix of Tawney's works in cloth and thread, plus her collages and assemblages. Both writers found substantial content in Tawney's work. For example, Winter saw "a thread of great continuity on both conceptual and formal planes" and observed a connection between the artist's pen lines and linear threads.[21] Gerritt noted that, although her collaged boxes showed the influence of Kurt Schwitters and

Joseph Cornell, "Tawney has left her own distinctive mark on the style."[22]

In contrast, when the American Craft Museum mounted Tawney's retrospective exhibition in 1990, Roberta Smith's *New York Times* review gave it scant praise. While she credited Tawney's technical breakthrough that had freed loom weaving from rectangular restrictions, Smith stated, "It would be wonderful to be able to say that Ms. Tawney's achievement transcends the craft-art distinction, adding an important chapter to 20th century art . . . on the contrary, Ms. Tawney's work exists in a limbo that is endemic to much contemporary craft: it has departed from craft and function without quite arriving at art." Of the artist's collages, Smith wrote, "The artist is little more than an inspired amateur whose mystical slant often tapers off into sentimentality."[23]

Those opposing opinions on Tawney's work evoke questions that are often raised about critics' responses to craft. Although Smith was addressing a different show than Henry and Winter, the works were not strikingly different. Was the opposition simply due to different eyes? Or were the critics more receptive to work on view at an art venue than in a craft museum? Or had they come to the work with predetermined biases—either positive or negative?

While certain artists claimed by the craft world were gradually being accepted by the art mainstream, others were not. And occasionally, the gap between the worlds of fine art and craft was starkly evident, as when an exhibition of wood-turned bowls was held at the Cooper-Hewitt Museum in Manhattan. Its quirky timing—the show had opened in August when the New York art scene had moved to the Hamptons—perhaps explains why it was the subject of a *New York Times* review. (It was published on Labor Day weekend, the nadir of the art season.) In a more conciliatory tone this time, Roberta Smith wrote, "It is always refreshing to come across a category of art objects that is new and unknown, that reaches one's field of vision relatively unencumbered by big reputations, advance publicity, critical theory or plain old word of mouth." Smith's statement underscores the asymmetrical, majority/minority status of the relationship between craft and art. (It is well known that a minority group is always more aware of what is going on among the majority than vice versa.) Thus, the enormous reputations that wood turners like Ed Moulthrop, Melvin Lindquist, and Bob Stocksdale enjoyed in the craft world were outside the range of lenses attuned

to fine art. From a craft perspective, Smith's naïveté regarding the fame of the artists was equivalent to a neophyte's appraisal of, say, Francesco Clemente as an undiscovered artist. Smith did manage to express enthusiasm for the bowls—again, perhaps it was the season that permitted the luxury of time "to nail down whether you like your shapes plain or fancy, and your wood surfaces polished or dull." Nevertheless, she admitted reservations about the "decadence in pushing an ancient craft to such extremes of refinement, technical finesse and functionlessness."[24]

Michael Welzenbach had reviewed the same show when it was installed at the Renwick Gallery, but looked beyond the formal attributes of the works. He wrote in the *New Art Examiner*, "That commonplace objects such as bowls and vases retain and refine forms originally inspired by organic phenomena—gourds or seashells, for example, would seem to point to a deep-seated archetypal belief in the perfection of nature."[25]

In considering the language of form and content and how it is understood, Hans-Georg Gadamer, the aesthetician and phenomenologist, wrote, "We cannot understand without wanting to understand, that is, without wanting to let something be said."[26] Of the above-mentioned two reviews of *Wood Turned Bowls*, Welzenbach's seems to reflect a receptiveness that allowed communication with the forms themselves.

WRITING ABOUT FUNCTION

Throughout the 20-year period I investigated, what I found most consistently lacking in reviews was a critical approach toward objects made for use. It is reasonable to protest that a cup or bowl does not invite the same kind of critical analysis that is appropriate for a painting that embodies meaning in a different way. Nevertheless, some sort of mirror reflecting the works' intersection with the culture at large was a profoundly felt necessity.

A major problem was the lack in the late 20th century of a philosophy regarding the values inherent in objects for use. While the modernist tradition encouraged experimentation with materials, this was not aimed at establishing connections with craft traditions. In his book, Nordness had placed the post–World War II craft movement in a unique historical context. Unlike the Arts and Crafts Movement in 19th-century England and early 20th-century America, this was not driven by theory

but, rather, by an intuitive search, particularly among military veterans, for life-affirming work to counteract the negative experience of war. For some who had served in occupation units, exposure to different cultures like that of Japan expanded their views of the options available in life and in art. With the support of the GI Bill of Rights, many veterans found their way into college and university art departments, whose course offerings expanded to meet the requirements of their presence. Similarly, two decades later a number of Vietnam veterans seeking a humanistic way of life were drawn into craft. Although hard-core theorists might regard this as merely therapy, and therefore "soft" underpinning for an art movement, this foundation of meaning is valid for those who own the experience behind it. However, neither individual nor collective experience and the psychological responses they elicit can be transmitted to other generations. Bereft of other forms of cultural validation, many artists who have not found a niche in academic life have been drawn to the marketplace and its system of values as the *raison d'être* for making objects. In effect, this contributed to the removal of their work from the art conversation.

A segment of my research was devoted to finding points of view from which functional crafts might be examined in a critical way. While arriving at no theoretical conclusions, I did find some interesting perspectives pointing to a rich potential for further exploration.

An aspect of handcrafted objects that art critics often overlook is the connection to a history of styles and techniques. For example, a specialist like Paul Hollister, who wrote on glass for the *New York Times* as well as for craft publications, could look at an exhibition of Paul Stankard's paperweights and appreciate them fully as innovative, content-laden departures from historical antecedents. This, of course, allies the work with decorative arts, a connection that craftspeople seeking fine art status have resisted.

In an interesting chapter called "From Function to Expression" in his book *Toward a Psychology of Art*, Rudolf Arnheim wrote that "functionality, the fitness of an object for a nonaesthetic purpose, enters the realm of art by way of visual expression." His point was that *every* visual entity has expressive form. "Function plays the same part in the aesthetics of the useful object as subject matter does in painting and sculpture." To demonstrate the coexistence of both function and expression in a single form, he used the illustration of a wooden clothespin, which clearly speaks of its function, but also can be per-

ceived as a representation of a figure. "Our reminder that applied art is representational art might help to break down the artificial barrier between designers and craftsmen on the one side and painters and sculptors on the other."[27]

Donald Kuspit, the influential postmodern critic, discussed function in a positive light from a wide-angle perspective in a closing address to the 1987 National Conference for Education in the Ceramic Arts (NCECA). Later appearing in print in the *New Art Examiner*, the lecture stated:

> The character of an object can make its use a sacrament, that is, can make us contemplate it as an end in itself. The use becomes charged with profound existential import . . . it seems to me important that the ceramic object not lose its mundane function. For in becoming contemplatively significant without losing its functionality it elevates the mundane activity of life it serves into an object of contemplation itself.[28]

Although he was not discussing contemporary crafts, Nelson Goodman, the prominent philosopher, offered a provocative approach to looking at function in a small book, *Ways of Worldmaking*. Examining ways of viewing things such as found objects that did not originally function as art, but later were presented as art, he changed the question from what is art? to when is art? His argument turns on the notion that being a work of art is a function. In one controversial section of the book, he proposed that "a work of Rembrandt, although it remains a painting, may cease to function as a work of art when used to replace a broken window or as a blanket. . . . "[29] Conversely, he suggested that an inert or purely utilitarian object may come to function, symbolically, as art. Goodman takes the sort of imaginative leap that jerks the mind away from habitual patterns and suggests a plethora of fresh ideas waiting to be tapped.

A final thought: in the object-making universe, the vessel form, whether of wood, clay, glass, metal, or fiber, and whether functional or not, seems to persist out of some deeply rooted resonance with archetypal roots. For example, the phenomenon of spiraling construction is common to vessels in clay, glass, metal, wood, and fiber. Many artists, including Katherine Westphal, a basketmaker, have spoken of the importance of the spiral in their work. Even prior to the identification of the DNA molecule, the spiral was universally perceived as an image of life and growth. Might not the degree of liveliness communicated by a vessel be an aspect of evaluating it?

FRESH CRITICAL APPROACHES

Aside from whether objects are functional or not, their characteristic tactility can be problematic for critics not familiar with the language of particular media. For example, the seductive texture of fiber or the shininess of glass can deflect attention from the content of objects in those materials. John Perreault is one critic who overturned this conventional bias in stating that the tactile, as well as the haptic, character of craft objects increases their value as art by contributing perceptual and conceptual complexity. (In so doing he overrides the bias against touch, which classical aesthetics ranked near the bottom in a hierarchy of the senses. This bias has influenced the primacy of painting in Western art history and has denied the capacity of touch to communicate knowledge.) In his essay for *The Eloquent Object*, the book that accompanied the exhibition, Perreault wrote:

> [M]ost craft objects have a more balanced relationship between their haptic and optic qualities than paint-on-canvas art or non-craft sculpture . . . seeing and touching merge or contradict each other. This is the purest art quality of objects made in the craft tradition and the one unique to them.[30]

Another characteristic that sets craft apart is a rate of change that tends to be slower than that of other art forms. Therefore, as stylistic changes in mainstream art accelerated, craft was sometimes regarded as anachronistic. Although the craft movement rarely was mentioned in general studies of 20th-century art, scholar Roger Lipsey in *An Art of Our Own* not only noted its existence, but also viewed craft's different pace and other characteristics in a positive light. Tracing the relationship between 20th-century art and spirituality, Lipsey discussed the notion that the paths of the artist and that of the student of designated spiritual disciplines have been separated in our time. Questioning whether art, by itself, is really self-sufficient, he wrote:

> An interesting light is shed on the question by the craft tradition . . . craftspeople often grasp, at least in theory, that the stages through which a work must pass to reach completion parallel the maturation of the human being and so shed light on our own needs and possibilities . . . the myth and reality of the apprentice is better preserved in the crafts than in painting and sculpture, which have gradually adopted the antithetical myth of the athlete who reaches peak performance early in life. In sum, below the super-

heated world of 20th century art is this cooler, more modest world of craft,
preserving an alternative view of creativity that is closer to nature and in
general less vain, although no less expressive in the works of its accom-
plished masters. The craft tradition at its best confirms [that] the arts are
teachings in themselves.[31]

Lipsey seems to have made an honest attempt to place 20th-century
craft, on its own terms, in the larger art picture. Nevertheless, his ap-
praisal seems based on a retrogressive vision of craft that is more
aligned to the spirit of William Morris of the Arts and Crafts Movement
than to that of William Morris, the contemporary glass artist.

Now, at the start of a new century and millennium, the critical climate
allows a more egalitarian attitude toward craft materials. For example,
Roberta Smith in the *New York Times* and Janet Koplos in *Art in Amer-
ica* now are regularly writing about work that their publications proba-
bly would have bypassed a decade ago. Furthermore, fresh theoretical
approaches are broadening and deepening discussion of craft, as well as
steering it in some new directions. Since my focus shifted from craft in
general to fiber in particular in the mid-1990s, I will cite two examples
from that discipline.

The work of Chelsea Miller Goin represents the sort of rigorous in-
vestigations some writers have undertaken in the search for meaning in
contemporary objects. Prior to her untimely death, Miller Goin had pre-
sented a way of moving beyond the art versus craft impasse. A fiber
artist with a Ph.D. in anthropology, she provided a persuasive example
of her strategy in an article in *Fiberarts*. In "Lia Cook Revisited," she
analyzed Cook's works by examining them from an anthropological,
rather than a strictly art historical, viewpoint. This perspective allowed
her to incorporate the language of textiles as artifacts in relation to the
culture in which they were produced, as well as to their own history,
which predates Western civilization. In Miller Goin's own words:

> By briefly reviewing aspects of the prehistoric and historic records, by ex-
> amining the evolving linguistic expressions of textile production, and by
> redefining the concept of weaving as both a technical and a philosophical
> process, the work of Lia Cook can be examined from a dynamic new per-
> spective.[32]

Although Miller Goin's absence has left a void, other writers are com-

ing forward. Some are probing the past in order to uncover the unacknowledged influence of craft works on other art forms. Virginia Gardner Troy, for example, has done extensive research on the cultural resources and environment in Germany at the time of the Bauhaus. In an essay published in the *Surface Design Journal*, Troy argues that the Andean textiles, which were accessible through exhibitions and books, embodied formal values that influenced not only weaving at the Bauhaus but, as well, the development of modernist thinking and abstract art. For example, Troy wrote:

> An analysis of [Paul] Klee's work indicates links with ancient American textiles. *Pastorale*, 1927, is composed of registers, bands, repeated patterns, inversion and flipping; the white overdrawing in *Mural*, 1924, resembles openwork or embroidery; *Ancient Harmony*, 1925, is a weave-patterned painting that echoes the repetition of woven thread.[33]

Troy's essay has been incorporated into her book, *M. Anni Albers and Ancient American Textiles*.[34] By taking a proactive stance toward the issues involved in evaluating objects, researchers like Miller Goin and Troy have provided solid intellectual support for the practice and meaning of craft. Their work heralds a new generation of writers seeking not just to shed old biases but, as well, to confirm craft's contribution to the cultural stew.

NOTES

1. Mildred Constantine referred to this incident in a talk at a seminar, "The Critical Eye," at the Banff Center, Banff, Alberta, Canada, August 1986.

2. Lee Nordness, *Objects USA* (New York: Viking Press, 1970), 14.

3. David Huchthausen, *Americans in Glass 1984* (Wausau, Wis.: Leigh Yawkey Woodson Museum, 1984).

4. Robert Silberman, "Americans in Glass: A Requiem?" *Art in America* vol. 29, no. 6 (March 1985): 47–53.

5. Robert Hilton Simmons, "Objects USA: The Johnson Collection of Contemporary Crafts." *Craft Horizons* vol. 21, no. 6 (November/December 1969): 27.

6. Simmons, "Objects," 66.

7. Ed Rossbach, "Objects USA Revisited," *Craft Horizons*, vol. 32, no. 4 (August 1972): 39.

8. John Zeaman, "A Celebration of the Object." *The Record* Hackensack,

N.J. (Nov. 9, 1986): E 6.

9. Helen Giambruni, "ACC's New Museum: Functional Craft to the Back of the Bus?" *Craft International* vol. 6, no. 1 (April–June 1987): 20–21.

10. Neal Benezra, "But Is It Art? The Always Tenuous Relationship of Craft to Art," *New York Times* (Oct. 19, 1986): II, 1:5.

11. Nancy Stapen, "Reviews," *Artforum* vol. 22 (December 1983): 85–86.

12. Meredith M. Jack, "Figures That Stand for Themselves," *Houston Arts*, Houston, Texas, June 1988.

13. B. Berkson, "Richard Shaw," *Art in America* vol. 77 (March 1989): 157.

14. N. Newman Rice, "Jane Sauer," *New Art Examiner* vol. 14 (September 1986): 60.

15. C. F. Shepley, "Jane Sauer," *New Art Examiner* vol. 16, no. 1 (September 1988): 56.

16. Robert Maloney, "New York in Review," *Arts*, vol. 63, no. 5 (January 1989): 101.

17. "New York in Review," *Arts*, vol. 64, no. 5 (January 1990): 94.

18. Dido Smith, "Dale Chihuly—Sam Herman," *Craft Horizons* vol. 31 (October 1971): 52.

19. Lee Hall, "Baskets and Cylinders: Dale Chihuly," *Craft Horizons* vol. 16, no. 1 (April 1979): 26.

20. Linda Norden, "Dale Chihuly: Shell Forms," *Arts* vol. 55 (June 1981): 150–51.

21. Amy Winter, "Lenore Tawney," *Arts* vol. 60, no. 5 (January 1986): 108.

22. Gerritt Henry, "Cloudworks and Collage," *Art in America* vol. 74 (June 1986): 116–21.

23. Roberta Smith, "Lenore Tawney's Work in Fiber and Beyond," *New York Times* (May 18, 1990): C24–25.

24. Roberta Smith, Review, "Reviews," *New York Times* (September 1, 1989): III, 15:1.

25. Michael Welzenbach, "Simple Forms, Complex Questions," *New Art Examiner* vol. 14, no. 2 (October 1986): 37.

26. Hans-Georg Gadamer, *Philosophical Hermeneutics* (Berkeley: University of California Press, 1976), 101.

27. Rudolf Arnheim, *Toward a Psychology of Art* (Los Angeles: University of California Press, 1966), 192–209.

28. Donald Kuspit, "Ceramic Considerations," *New Art Examiner* vol. 15, no. 2 (October 1987), NCECA supplement, D.

29. Nelson Goodman, *Ways of Worldmaking* (Indianapolis: Hackett Publishers, 1978), 67.

30. John Perreault, "Craft Is Art: Notes on Craft, on Art, on Criticism," *The Eloquent Object: The Evolution of American Art in Craft Media Since 1945*

(Tulsa: Philbrook Museum of Art, 1987), 201.

31. Roger Lipsey, *An Art of Our Own: The Spiritual in Twentieth Century Art* (Boston: Shambhala, 1988), 469–70.

32. Chelsea Miller Goin, "Lia Cook Revisited," *Fiberarts* vol. 22 (January/February 1996): 43–47.

33. Virginia Gardner Troy, "Andean Textiles at the Bauhaus," *Surface Design Journal* vol. 20, no. 2 (Winter 1996): 36.

34. Virginia Gardner Troy, *Anni Albers and Ancient American Textiles* (Hants, England: Ashgate, 2002).

Rob Barnard, Vase. Stoneware glaze over white slip, 13 × 6 inches, 2001. From the collection of Rob and Joseline Wood.

4

Paradise Lost? American Crafts' Pursuit of the Avant-Garde

Rob Barnard

The field of contemporary crafts as we know it today is barely fifty years old. Yet in that short span the visual and conceptual changes affecting contemporary crafts have been enormous. These changes reflect not only the technological advances and social shifts in our culture, but also the feelings of uncertainty and ambivalence we have about those changes. Our advances in science and technology, for example, far outpace our ability to absorb and understand how those advances might affect our lives. The crafts field has not been immune from these phenomena. Questions about what exactly contemporary crafts is, what it is trying to say, whom it is speaking to, and what language it is speaking hang like a cloud over contemporary crafts' institutions. Crafts, of course, is not alone in this problem. What Peter Plagens wrote about modern sculpture in 1993 seems even closer to the heart of contemporary crafts: "A big problem with sculpture these days is that practically anything can call itself sculpture and get away with it. . . . It is a form increasingly bereft of a convincing convention."[1]

How did contemporary crafts reach this point, and what did it lose getting here? Two things occurred after World War II that put contemporary crafts on its present course. First was the emergence of abstract expressionism. Suddenly and for the first time, American art became a force in American culture. In the early 1950s the international art world turned its focus from Paris to New York, and American artists, beginning with

This essay is based on two articles by Rob Barnard: "The Ambiguity of Modern Craft" in *New Observations*, issue 98, November–December 1993, and "Use and the Art Experience" in *Ceramic Art and Perception*, issue 5, 1991.

Jackson Pollock, became recognized figures in American culture. Artists no longer expected to spend their lives laboring in poverty and obscurity; they could now be part of the American success myth. In her book, *The New York School*, Dore Ashton noted, "For American youth dreaming of a career in the arts, success was as necessary a goal as it was for the youth planning a career in business. And success carried with it the idea that only those capable of competing could ever know it."[2]

The second circumstance influencing the course of contemporary crafts was the GI bill, which gave returning veterans, who, prior to the war, might never have considered or could not have afforded a college education, access to the country's university system. This bill transformed academe. Art departments, which included crafts, sprung up in universities across the country and with them the need for instructors to teach the ever-growing enrollment. It was during this boom period that what we have come to think of as contemporary crafts began to take seed. Academe became a greenhouse for the arts as well as the crafts, a place where they not only could be protected from the harsh judgments of culture, but also could be nourished by the economic security and social status found in university teaching positions and the funded studios that accompanied those positions. With the establishment of these university art programs, the goals of craftspeople shifted away from the economic uncertainty of living as an individual maker whose work might find recognition and reward in the commercial marketplace, to the more lucrative and secure position of a university instructor. In this new position, though, craftspeople suddenly found themselves competing within the university system with their new colleagues—painters and sculptors—for academic and cultural recognition, in other words, for success. Painting, which had brought unprecedented attention to the arts and created cultural heroes out of its practitioners, became the yardstick for that success.

Rose Slivka, the editor of *Crafts Horizon*, was one of the first in the crafts field to make a formal argument for a shift away from crafts historical language to the language of modern painting, writing,

> It is corollary that the potter today treats clay as if it were paint. A fusion of the act and attitudes of contemporary painting with the material of clay and the techniques of pottery . . . Today, the classical form has been subjected and even discarded in the interests of surface—energetic, baroque clay surface with itself the formal "canvas."[3]

Slivka goes on to present three extensions of clay as paint in contemporary pottery:

> 1. The pot is used as a "canvas"; 2. The clay itself is used as paint three-dimensionally—with tactility, color, and actual form; 3. Form and surface are used to oppose each other rather than complement each other in their traditional harmonious relationship—with color breaking into and defining, creating, destroying form.[4]

In a footnote, Slivka states, "The writer does not wish this article to be interpreted as a statement of special partisanship for those potters working with new forms and motivations." This point appears to be contradicted by statements in the body of her article, such as "The fact that the validity of the 'accident' is a conscious precept in modern painting and sculpture is a vital link between the practice of pottery and the fine arts today."[5] Such conceptual links made it clear to American craftspeople that the critical framework under which their work would be examined and discussed in *Crafts Horizon*, the field's leading publication at the time, had changed.

John Coplans, editor of *Artforum*, in a catalogue essay for an exhibition called *Abstract Expressionist Ceramics*, echoed this perspective five years later:

> In modern art all conventions including this hierarchy of media have been under attack. What distinguishes a work of art from that of crafts is qualitative. A work of art is not concerned with the utilitarian, the rational, and the logical. Its purpose is expressive, that is to aim new questions about the nature of existence. In short, it is concerned with the aesthetic experience in its purest form.[6]

Coplans quoted a 1932 Herbert Read passage about the abstract nature of pottery. Read argued that pottery was "pure art" because it was freed from any imitative intention, labeling it "plastic art in its most Abstract essence."[7]

But Coplans's lack of understanding of pottery's unique history caused him to mistakenly conclude that the works in this *Abstract Expressionist Ceramics* exhibition were pottery and therefore "abstract." They were not, in point of fact, pottery, but rather ceramic forms that were *about* pottery. According to Read's theory, therefore, they were neither abstract nor "pure." One could even argue that the work of Pe-

ter Voulkos, the ceramicist who was leading the charge for crafts' eman-
cipation from tradition, had much more in common with Impressionism
than Abstract Expressionism. Coplan's equating "qualitative" with not
being "rational," "logical," or "utilitarian" provided a moral overtone to
his point. The fine arts world had been heard from, and it became even
more evident to craftspeople which way the wind was blowing.

The schism in American crafts resulting from these early writings and
others like them left the field divided into two predominant factions that
are still with us today. One group was composed of craftspeople who
made so-called functional crafts, which were repetitive in nature and
made for a domestic environment. More often than not, they marketed
their work at crafts fairs, sold wholesale to crafts shops, and measured
their success by their sales. The other group of craftspeople included
university instructors, who started to refer to their work as "fine" crafts.
This group saw themselves as the avant-garde of crafts and made one-
of-a-kind work for exhibition in university galleries. Though both
groups were trained, for the most part, in the university system, there
was a marked prejudice within academe to hire those in the "fine" camp
to fill the new teaching positions and to select graduate students who
were committed to the idea of fine crafts.

Unlike their colleagues in painting and sculpture, though, who eval-
uated each other in terms of where they exhibited, "fine" craftspeople
tended to measure each other in terms of where they *taught*. While they
did exhibit, their exhibitions were almost always reciprocal affairs in
each other's university galleries (*Abstract Expressionist Ceramics*, a
case in point, was held at the Art Gallery at the University California at
Irvine). And because they were subsidized by university salaries, mate-
rials, and studio space, fine craftspeople were sheltered from the kind of
critical scrutiny applied to painters and sculptors who exhibited in com-
mercial galleries. They were also free from the need to interact with the
messy and demanding commercial marketplace of crafts fairs and
shops, upon which functional craftspeople were forced to depend.

These two groups do, to some degree, overlap and have maintained,
over the years, an uneasy relationship—attending conferences, compet-
ing in the same category for fellowships and sharing the same publica-
tions. There are even a few functional craftspeople left in academe, but
they are an exception. Nevertheless, there is a certain amount of antipa-
thy between these two groups. Fine craftspeople often view functional
craftspeople as romantics who are more involved in lifestyle issues than

artistic issues. Functional craftspeople, on the other hand, sometimes see fine craftspeople as dilettantes who live in the proverbial ivory tower.

While fine crafts in the 1960s and 1970s was out to "break boundaries," functional crafts focused on making useful objects by hand that were meant to be seen and appreciated in the home rather than in the museum. Potters, most of them disciples of English potter Bernard Leach, for example, believed that the making of pottery by hand was a way in which one could establish a new domestic order where mundane aspects of life might be elevated and transformed into meaningful artistic expression. This movement, which reached its peak during the late 1960s and early 1970s, was fueled by the attractiveness of alternative lifestyles that rose out of a resistance to the Vietnam War and a rebellion against the "Sunday dinner" chinaware culture of the previous generation. Once the war ended, however, the moralistic fervor of these potters seemed to wane. The philosophical idea of creating a domestic art was all but abandoned when potters realized that the buying public, on whom they depended for their livelihood, was more interested in pottery that was *blue* than it was in aesthetically challenging ideas about art in everyday life. These factors combined to cause a glut of uninspired, but technically sophisticated, work designed to unabashedly appeal to the taste of its buying audience. As a result, functional crafts lost most, if not all, the moral and intellectual credibility it once had.

Fine crafts, on the other hand, became the main force behind the rush for cultural and economic parity with painting and sculpture. The strategy in the campaign to gain recognition from the fine arts world seemed to center around two precepts. First, an object cannot be useful because *use* is what the fine arts disapproves of most. An object, however, can look like a teapot as long as it is not actually functional. Second, an object should reflect fine arts trends, but employ recognizable crafts techniques and materials. Fine craftspeople thought that their work was the most relevant and viable form of crafts in modern culture and represented the direction in which contemporary crafts should evolve. In contrast, they argued that functional crafts were out of touch with modern sensibilities and were either unable or unwilling to address contemporary issues and concerns. This argument about functional craft's inefficacy in modern culture was not based on any kind of intellectual or philosophical examination of the possibilities this form of expression offered. Its rejection had more to do with the fact that the idea of func-

tional crafts ran contrary to the values manifested in the postmodernist, avant-garde, market-oriented climate of the fine arts world—a world on which fine crafts had modeled itself. Survey exhibitions in the 1980s like *Poetry of the Physical, The Eloquent Object,* and *Clay Revisions: Plate, Cup, Vase* celebrated how far fine crafts had come in realizing the goal to become like painting and sculpture. In their catalog essay, *The Widening Arcs,* Marcia and Tom Manhart, the organizers of *The Eloquent Object,* articulated a fine crafts view of the future. "The old limits, old channels for expression having broken down, we need new descriptive categories and new standards: without them, in this world of flux, critical analysis—even simple conversation—is almost impossible."[8] In the catalog essay for *Clay Revisions,* curator Viki Halper wrote that the artists in *Clay Revisions* adopted the ceramic vessel for a variety of purposes: "for sheer love, for dismissal, for metaphor, for comment, for play, for structure—but not for use."[9] And in a review of *Poetry of the Physical,* Neal Benezra, then associate curator of 20th-century painting and sculpture at the Art Institute of Chicago, wrote in the *New York Times*:

> Contemporary work in other materials has generally been less ambitious. Craftsmen working with glass regularly produce vessels, woodworkers generally create furniture, and metal workers frequently fashion jewelry. Beyond ceramics, the only material to consistently yield works of art rather than objects of function has been fiber. . . . Similar to Voulkos, Price, Arneson and Mason, Zeisler and Hicks have avoided the all-to-common pitfall of making functional objects, a decision that has broadened the imaginative horizons of each and that has been essential to their growth as artists.[10]

In spite of fine crafts' attempts to appear more like the fine arts, artists, critics, curators, and gallery owners in the fine arts world have not been terribly enthusiastic about fine crafts on the whole. When confronted with this new fine arts/crafts hybrid, they inevitably complain that it seems to be nothing more than elaborate and complicated technique masquerading as artistic concept. From the fine arts perspective, both fine and functional crafts look like a small, self-satisfied club, unconcerned with issues outside their own world. There is some truth to this perception. Contemporary craft, in general, has always tried to have its cake and eat it too. Its continued insistence that craft is art, but that it is special and cannot be judged by fine art standards, has not been supported by the kind of intellectual and

aesthetic criteria that can provide a context in which the unique aspects of craft might be read and understood. This is an area contemporary crafts-people seem reluctant to explore. An argument for functional crafts would have to go beyond the current commercial rationale for measuring success. Further, they would have to develop cogent arguments that not only begin to address, in a critical way, what elements make significant craft compelling, but also show how functional handmade objects might carry meaning in modern culture. From a fine crafts perspective, it is necessary to explain why craft's historical language has been abandoned. A new history and language for crafts would have to be believable and hold up to critical scrutiny. By now, it should be obvious to both groups that neither the strategy of abandoning *use* and imitating fine art trends, nor the passive commercial approach of functional crafts, will make contemporary craft an important and influential voice in American culture in the 21st century.

The present position of craftspeople, though, is not unlike the predicament of American painters and sculptors in the 1930s. Dore Ashton noted that until World War II "most wealthy patrons regarded the painter and sculptor as embellishments of culture, basically non-essential."[11] The strategy for gaining recognition of the abstract expressionists, known as the New York School, however, was markedly different from the ones later chosen by both groups in contemporary craft. The New York School aggressively pursued an intellectual dialogue with not only writers and composers, who were the predominant artists of their time, but also philosophers, critics, psychiatrists, and scientists. Ashton remarks that the purpose of this legendary group was:

> to confirm their widening audience among the educated strata of the society and to establish the visual artist as a member of the intelligentsia on equal footing with writers and composers. No amount of nostalgic disclaiming can disguise the interest the visual artists displayed in attracting other intellectuals to their bailiwick, and putting them in their place, so to speak.[12]

Contemporary craftspeople, on the other hand, have not fostered a climate sympathetic to the kind of intellectual discourse where the crafts' possible role and relevance in modern culture might be analyzed and debated. They have, instead, chosen to explain craft's ineffectual position in modern culture by falling back on the argument that American culture for the last two hundred or so years has devalued handwork and the

useful, domestic nature of crafts in favor of the heroic and purely visual appeal of painting and sculpture. There is no question that this prejudice exists, but at a time when the validity of modernist and postmodernist painting and sculpture, which are at the root of this prejudice, is being questioned, both groups should be mounting cogent arguments that challenge, rather than reinforce, the given hierarchy. Such arguments could demonstrate the unique role crafts can play in addressing the separation of the art experience from our everyday lives. Contemporary craftspeople appear reluctant, though, to risk the benefits, comfort, and relative safety of the insular world they have created for themselves by openly challenging the fine arts and claiming for crafts the same kind of philosophical and moral imperative to which painting and sculpture have laid claim.

In 1948 John Cage wrote that music, in order to be distinguished from pure noise, must have structure. He argued,

> We are left with the question of structure, and here it is equally absurd to imagine a human being who does not have the structure of a human being, or a sonnet that does not have the relationship of parts that constitutes a sonnet. There may, of course, be dogs rather than human beings—that is, other structures—just as in poetry there may be odes rather than sonnets. There must, however, as a sine non qua in all fields of life and art, be some kind of structure—otherwise chaos. And the point here to be made is that it is in this aspect of being that it is desirable to have sameness and agreed-upon-ness. It is quite fine that there are human beings and that they have the same structure. Sameness in this field is reassuring. We call whatever diverges from sameness of structure as monstrous.[13]

Cage insisted that music comprised three other elements: form, method and material. To continue the analogy with human beings, while each one of us shares the same structure, the form of our lives—what we do with them—varies with individuals. Method in life is, at its most simplistic level, eating, sleeping, and working. How one goes about these tasks varies. The last element, material, is physical. Within a common structure humans have physical differences and accommodate, even accentuate, those differences. Historically, these elements have varied in music, Cage said, but structure is fundamental. Cage went on to argue that the common denominator of music throughout all of its history and in all cultures is that it has a beginning and an end and that its sound is punctuated by moments of silence. Cage argued that there can be no

right making of music that is not structured from the very roots of sound, silence, and their duration.

If one were to use Cage's methodology to examine the field of crafts, one would find that form, method (technique), and material are all evident aspects of crafts, as in other disciplines, though they vary in their application. The underlying element, though, the thread that runs through all crafts throughout history, is *use*. The structure of crafts, that element that makes its form, method, and material interact as a whole and separates it from other structures like painting and sculpture, is *use*. A critical reinvestigation of crafts' historical language and its structure can offer crafts a direction from which it might be able to assert itself as a meaningful part of American culture. *Use* is what makes crafts accessible to us; we recognize its forms and relate to its limitations, which are reflections of our own physical and spiritual limitations. But more than that, crafts allow us to move art outside the cold, impersonal and retinal world of the museum and into a personal or domestic space where we are free to interact with it and be nourished by craft on a daily basis. Philip Rawson suggested in the conclusion to *Ceramics*:

> [A]nother revolution in art may well demand that work be addressed to the whole multi-sensuous man, hands and all, to awaken those important and intensely valuable regions of feeling and sensuous order which pure visual-abstract work ignores, or even affronts.[14]

If the idea that there can be art that addresses the whole body and not merely the eye was accepted, then old arguments about whether crafts can be art will become moot. The question, then, will not be whether or not something is useful, but whether or not it speaks eloquently of the human condition. Joseph Campbell in his book *The Power of Myth* suggested, "If mystery is manifest through all things, the universe becomes as it were, a holy picture. You are always addressing the transcendent mystery through the conditions of the actual world."[15] It is the effort to communicate this idea of mystery through *use* in the actual world that can give a seemingly mundane object like a cup the sort of impact that can lead the sensitive user to a previously inaccessible area of awareness.

Crafts are inexorably linked to our very development as a species, and each of us, whether we appreciate the idea of art or not, will always be drawn to a handmade cup, bowl, or plate. Our technological ad-

vances have not curbed our desire to ride horses, sail boats, hike and sleep outdoors, hunt, play sports, grow vegetables, and cook over an open fire. These activities, like crafts, can give us joy. No one can deny that the role of crafts has changed in postmodern culture. Human beings, on the other hand, have changed very little. We still desire solace and comfort at certain moments and celebrate special occasions in our lives with useful objects created by the hand of another human being. One cannot explain this phenomenon within the narrow parameters of current art criticism.

NOTES

1. Peter Plagens, "Sculpture to the Point," *Newsweek* (5/31/93): 58.
2. Dore Ashton, *The New York School, A Cultural Reckoning* (New York: Viking Press 1973), 153.
3. Rose Slivka, "The New Ceramic Presence," in Garth Clark, *Ceramic Art, Comment and Review 1882–1977* (E. P. Dutton, 1978), 136.
4. Slivka, "Ceramic Presence," 137.
5. Slivka, "Ceramic Presence," 133.
6. John Coplans, "Abstract Expressionist Ceramics," in Clark, *Ceramic Art*, 158.
7. Herbert Read, *The Meaning of Art* (London: Faber & Faber, 1931), 41–42.
8. Marcia Manhart and Tom Manhart, *The Eloquent Object* (Tulsa: The Philbrook Museum of Art, 1987), 45.
9. Vicki Halper, *Clay Revisions: Plate, Cup, Vase* (Seattle: Seattle Art Museum, 1897).
10. Neal Benezera, "But Is It Art," *New York Times* (10/19/96).
11. Ashton, *New York School*, 7.
12. Ashton, *New York School*, 198.
13. John Cage, "Defense of Satie," in Richard Kostelanetz, *John Cage* (Westport, Conn.: Praeger Publishers Inc., 1970), 77–78.
14. Philip Rawson, *Ceramics* (Oxford: Oxford University Press, 1971), 206.
15. Joseph Campbell, *The Power of Myth* (New York: Doubleday, 1988).

Scott Burton, Lacquered Steel Chair, *32 × 17 × 15¼ inches, 1979. Courtesy the Max Protech Gallery and Artists Rights Services.*

5

Crafts Is Art: Tampering with Power

John Perreault

Art, because it is often pleasurable, is disruptive of order. . . . Therefore it is necessary to keep art under control. Art is dangerous. It must be defined so it cannot be part of everyday life. It must be confined to museums, for its own protection certainly, but also to protect the body politic from discord, self-indulgence and desire. It must be made of special art materials; it must be precious and useless.[1]

The crafts should be approached with caution, for the terrain is full of booby traps. As a critic conversant with what might be called avant-garde art for the last twenty years or so and as a partisan of art that was perceived as at the cutting edge,[2] I now find myself at a slightly different edge, but one that is no less cutting. Although I retain my passion for paint-on-canvas art and noncraft sculpture, these forms at present seem tired, uninspired, and strangely commercial. More of a challenge to me is an analysis and defense of ceramic art, fiber art, glass art, metalwork, woodwork, and the like, as art. It is here that the art spirit is still in force and not yet totally compromised.[3]

The following sections—chunks, blocks—represent a continuous attempt presented discontinuously to grapple with crafts-generated issues. Although interrelated, these remarks or thoughts do not pretend to present a seamless argument. That they are contradictory, that they are unashamedly present tense, that they refrain from mentioning particular artists or craft objects is intentional. They are thus at a level of abstrac-

This essay was first published in an altered form under the title "Crafts Is Art: Notes on Crafts, on Art, on Criticism" as one of several essays in the catalogue *The Eloquent Object* in 1987.

tion scarce in crafts criticism; logic is at the service of insight, as is taste. We will gain no intellectual or aesthetic advance if we back away yet again from the confrontation that is just beneath the surface of the art/crafts interface or exchange; world-ordering philosophies are at stake. Thus, severe anxiety, often expressed by wit, surfaces at every turning. To tamper with categories, even if the categories are painfully inadequate, is to tamper with power.[4]

THE STATUS OF CRAFTS

Not so long ago it was easy to tell crafts from art. The criteria of materials and the criteria of techniques of fabrication functioned as fairly reasonable guidelines. . . . None of this is necessarily so anymore.[5] Surely the material criterion for art no longer applies.[6] If art could be limited to certain materials then aesthetic consciousness could be controlled and limited to certain occasions and contexts, instead of belonging to the world and thereby getting in the way of reason and action.[7]

Coming into a new consciousness about the time of abstract expressionism, continuing through pop and minimal, persisting throughout the pluralist period, and now rising above the instant neo- and post-X "style" clusters (X equals anything in the history books) that clutter up the art world, a radical change has occurred: crafts is art. It is accurate to use the word "radical" to describe this development, for the crafts are probably the roots of art, historically and spiritually. In the crafts the practical is magical.[8] In some sense, the foundations for this remarkable shift were laid in the last century. But we are not talking about an Arts and Crafts revival (or even something as logical as a Bauhaus ideal). Since the 1950s there has been a seepage, an interchange, an interface between once mutually exclusive realms of art production, or, more fashionably, a series of appropriations—some achieved by stealth, some accomplished by bravado. Slowly but surely, the dividing line between so-called fine art and crafts has became a dotted line.[9]

Although insights can be gained by cataloguing instances of crossover—some of them irritating, some of them spectacular—what once could be seen as a dialectic between art and crafts has dissolved into the bewilderment that signals a change of paradigm. There is no need here to list examples of artists trained in painting and sculpture suddenly using crafts media or crafts artists assimilating fine art

strategies and styles. These were scouting actions or forays into the unknown territory ahead. The time-tested categories have broken down. One way of understanding this is to proclaim that significant differences between fine art and crafts no longer exist. One could also adjust one's stance by deeming most visual production "art" and then creating a subcategory called "art in crafts media." Some, too, have proposed "alternative media" as a new rubric for crafts. This has the virtue of eliminating the odious term "crafts," but implies that these media—clay, glass, fiber, and the like—are inferior or secondary to the main business of art, which many still believe to be paint-on-canvas art and noncraft sculpture.

What I propose is something more flamboyant. It is not that crafts (as traditionally understood) and art (i.e., fine art) are blurred, are overlapping, have merged. These concepts represent an easy way out of the dilemma and fail to dramatize serious aesthetic issues. Everyone is relieved of responsibility; we are one big happy family. People working in clay, as well as those dabbing oil on canvas, are all making art, and the world is a better place for it. Go tell that to a painter.[10]

Nor do I wish merely to propose that crafts and fine art have switched places.[11] This in itself might be mind-boggling enough to be productive—productive of satire. Surely all the derogatory things said of the crafts, in part helping to define them as second-class pursuits, can now be said with more truth about paint-on-canvas art and noncraft sculpture. New art of the East Village sort[12] prided itself on lack of originality and on quotation, repetition, appropriation. It was made to please a specific market; it was made to sell. It was usually portable, always "decorative"—that is, could be placed over a sofa or on a coffee table—and it certainly eschewed ideas. Furthermore, production ware has long been the downfall of attempts to conceptualize craft as art, art-for-the-people idealism notwithstanding. But what about fine art production ware, those dreary photolithographs or even offset prints cranked out by the thousands to pad the coffers of both the dealers and the artists involved? By comparison, craft art is involved with sincerity of expression, originality, and formal values.[13]

To summarize: (1) Crafts and fine art are one; it is only quality that makes a difference. There is no such thing as a good craft object, for a good craft object is an art object. (2) Crafts and fine art have switched places; it is paint-on-canvas art that is the middle-class mode, not pottery. It is "fine art" that is kitsch.[14] Some insights may be gained by

adopting either one of these ways of looking at our current predicament, but both delay a more difficult insight. Crafts—meaning art in craft media, in other words, ceramics, glass art, fiber art, and the like, can now be caught in the act of replacing so-called fine art or art in art media, that is, paint-on-canvas art and noncraft sculpture.

Of course it all depends upon one's priorities for art or what one expects or hopes art can accomplish (or at least stand for). Here I am a traditionalist. I expect art to address, express, and add to human experience through material or conceptual forms that embody the spirit. This can be done with love, with wit, and even with fury, but it cannot be done with both eyes on the cash register. Hemmed in by the distribution context and by the economics of living and working, artists must nevertheless follow their own light. It is in the craft art area that I see these principles expressed, and less and less in the high-power, high-money art world, per se.[15] Craft art is replacing art; crafts are art, and perhaps no other art exists.[16]

CRITICISMS

> Ceramics, it seems to me, suffers from a lack of criticism. It is still too much a folksy club, though a very large one indeed.[17]

An examination of crafts criticism is not difficult. After stating that most of it is puffery, description, biography, or technical tips, there is little left to say. But to proclaim that there is something wrong with crafts criticism and that this has ever been the case is not enough. In fact, something is wrong with criticism in general: it has not been thought through. I am referring to criticism of the visual arts. Art criticism itself—where there have indeed been attempts made to blend description, evaluation, and philosophy—is not in a very creative period. Here too we have puffery, description, biography, and marketing tips. Confined to the promotional mode by commercial interests, burdened by uninspired language conventions that are reinforced by mediocre editors, weighed down by sloppy thinking, and compromised by the rush to embrace the latest French ruffle, art criticism currently has little to offer as a model for evaluative writings about craft art.[18] Like the crafts criticism that it always prided itself on being above and beyond, art criticism has now excluded the negative. Criticism cannot be defined as negation, ordinary usage of the term notwithstanding. Nevertheless, positive rein-

forcement as a critical tactic be damned, criticism without the threat of
negation is criticism without impact. The critic must smile, but carry a
whip.

Criticism, of course, does not exist in a vacuum. Criticism is written
(or spoken) by persons for other persons—or at least is so addressed—
about the art production of other persons. Where criticism is published
is another factor, for the print media involve still other persons: pub-
lishers, editors, copy editors, and, above all, advertisers. Money is in-
volved, but before we assume venality and greed, it should be known
that most critics are paid a pittance for their labors. It is glory that oils
the machine. Money in larger amounts does come into the picture. Crit-
icism is exposure for the artist. Even an attack is of commercial value.
Existence in print is historical existence and often leads to the artist
earning more money, or some money, along with the larger amounts
usually earned by those dealers and collectors who have a stake in the
art and the career.

Criticism, as now practiced, is largely composed of a series of hidden
agendas, even when—particularly when?—the critic is trying to focus
on specific objects. Sometimes the critic is not influenced by envy, un-
examined prejudices, historical knowledge or its lack, a bad stomach (or
an empty one), but there are always people involved, looking over the
critic's shoulder. Criticisms like artworks are mainly social. This can be
a debilitating truth, for it is impossible to parse all vectors of the social
dynamic. If criticism in its highest form has something to do with ana-
lyzing, discovering, and creating values, then what we are really deal-
ing with is a triangulation: aesthetic value, economic value, and social
value interact. Perhaps if art criticism itself were not in such a bad state,
it would be easier to claim that crafts criticism need not differ signifi-
cantly. Values and methodology should be the same. Crafts criticism is
merely art criticism applied to craft objects. Surely both kinds of writ-
ing share the difficulties presented by language. Language is linear; art
or craft objects are not.

Writing about craft art, however, is more difficult than writing about
paint-on-canvas art or noncraft sculpture. Beyond what can be adapted
from established critical vocabularies, the proper discourse for crafts
criticism is still in the process of being formed. We are dealing with un-
charted areas of visual production usually confined to the cataloguing
mode of the decorative arts template or to oral culture. We must also
factor in the understanding that craft objects present experiences that

more effectively balance, play with, or set in contradiction optic and haptic forms of perception than either paint-on-canvas art or noncraft sculpture.

In the meantime, there is the enormous task of straightening things out, for confusion reigns. What we call crafts now is different from what used to be called crafts. Craftspeople as well as outsiders are confused, causing enormous difficulties for all concerned. Many who find crafts anathema have never really looked at craft art with open eyes and are in reality thinking of the horrors perpetuated by well-meaning high school teachers and handmade ashtray vendors. What we call crafts now in the United States are artworks, or, if one prefers, art propositions made with some reference to nearly extinct, preindustrial craft traditions, even if only by virtue of the materials, forms, and techniques employed. Most of these artworks are not made by humble untutored folk, but by people who have studied their métier in universities and art schools, having taken studio classes in ceramics, fiber art, glass art, paper making, metalworking, and the like. That they have had to set themselves upon an academic track to learn their craft is telling.

Ideally, craftworks, like all artworks, are made to express the inexpressible or discover new forms and new thoughts. Craftworks factor into the aesthetic mix particular material and technical traditions along with function and/or decoration. On the practical level, however, craftworks, unlike artworks, are earmarked for several different market contexts. First of all, there is the populist marketplace of studio sales, crafts fairs, and crafts shops; this area, with luck, offers sane artisans a chance at making a living. Secondly, there is the craft gallery network featuring unique items, higher prices, and more prestige. Finally, there is the fine art market previously reserved for paint-on-canvas art, works on paper, and noncraft sculpture. This market, now slowly being infiltrated by craft art, offers even more financial reward, but only to a small number of artists. However, it is probably the chance at being included in art history that makes the fine art market so desirable, for the two other markets offer this not at all. Immortality is seductive.

CRAFT ISSUES ARE THE REAL ART ISSUES

Art and utility need not be at odds; they may dovetail. The esthetic does not preclude the practical, nor the practical the aesthetic.[19]

Sacrificing the tactile and kinesthetic directness of the utilitarian vessel—the pot for "sculpture" may cut ceramics off from its historical, cultural, popular and esthetic roots. I am all for experiment. I am all for an art/crafts interface, I am all for sculpture in clay. But a real pot, vase or plate . . . can be a beautiful and even a moving thing.[20]

Why have we separated art and use? Is there a valid distinction to be made between art and crafts? Since, as I have already pointed out, the material criterion for art no longer applies, why is there a stigma attached to media historically associated with crafts? How does art through the eyes affect the hands and the body? Can these effects happen the other way around? Is there a perceptible affective difference between a handmade object and a machine-made one? If two objects, one handmade and one machine made, were visually identical, could we still somehow feel the difference? If so, how?

Bearing in mind that although the crafts field has been weighed down with decades of romanticism, anti-intellectualism, antimodernism, and anti-industrialism, the notion of the artist as important and perhaps crucial to human life has been held to with a steadfastness that flies in the face of normal evidence. When this idealism is not sentimentality, it is a powerful creative force. This idealism has been lost in the fine art field, one hopes only temporarily. Perhaps the crafts, because they are rooted in some kind of physical exertion, are less susceptible to self-deception. Skill and patience are required. Yet crafts are looked down upon because they are associated with manual labor and, thus, with poverty. The general tendency in modern Western civilizations has been to consider physical labor demeaning. Those who work with their gray matter are thought of as better and better off than those who actually touch and lift the awful stuff of matter. It is all right to make things as a hobby or as therapy, but to make them for a living or to satisfy a necessity is brutish.[21]

There is, too, a minor tradition—perpetuated by the genteel—that physical work is purity itself and spiritually transformative. I think we should not romanticize physical work; only if it is approached with the correct attitude is it spiritually nourishing, and it should not be debilitating, as it often is in peasant societies. We must also remember that mentalwork can be boring and debilitating too. Nevertheless, the handmade, while acknowledged as having some charm, is almost universally thought of as for those who cannot afford the mass-produced.

As the world of work becomes universally computer dominated, forcing upon one's mental life a space that is no space, a space that is without hue, substance, texture, or poetic resonance, art has two choices: capitulation to the no-space, exploiting the speed, efficiency, and boredom of bits and bytes, or balancing the no-space with the intense tactility that art in crafts media alone can provide. When one is working with a computer—even if only for word processing, as I am now doing—the body disappears.[22]

MORE QUESTIONS

As far as I can tell there are only two real distinctions to make between art and crafts. You are allowed to touch and handle crafts before you buy them. Also crafts always cost less than art.[23]

How may a work, an art object or art proposal, be placed in either a crafts category or a fine art category? Why do we want to categorize this work? Convenience? Salesmanship? Illumination of particular qualities? Honor? Purposes of comparison? Toward what end? Why can't an object be in two or more categories at the same time? Why can't an object be a craft object and an art object simultaneously? Is the distinction between art and craft object relevant, productive, useful? Why are the categories maintained against all evidence? Who has gained, will continue to gain? Why do some of us want to abolish the categories?

Changing what things are called can only be successful if this reassignment functions as an acknowledgment of a shift of meaning that has already taken place. Calling a kettle white when, as the pot knows, the kettle is entirely black does not make the kettle white. If the kettle is gray, calling it white might emphasize its difference from the pot; however, if the kettle is indeed gray, calling it so may be difficult but is proper and just and helps avoid false conclusions.[24] But before we begin changing the names of things—if that is indeed what we must do—we should give some thought to what art objects are usually called and, more importantly, to why they undergo categorization. In a world that is governed, rather than illuminated, by classifications, taxonomy is destiny. It is tempting to think of groupings and labels as merely instrumental, but ease of reference is also ease of manipulation. Efficiency disguises control.[25]

The area of visual production usually called crafts has changed enormously. The old precepts and concepts do not apply. A preponderance of conundrums, mishaps, misunderstandings, and general messiness prevails. Nevertheless, the shift from crafts as pre-art or subart to art in crafts media has already taken place. It has not been adequately acknowledged. The old definitions and prejudices linger because they are comfortable. A change in definition is a change in thought; new thought is painful. Should we abolish the word "craft"? Would that we could. Old words die hard. They usually survive by adopting new meanings.[26]

Great numbers of people still make things by hand and sell them or try to sell them: uninspired scarves, belts, candles, wooden boxes, wallets, cups and saucers, ashtrays, teapots, vases, and costume jewelry. Most of these products are either inept or dull. They are generally inferior to mass-produced counterparts of a similar price and have as little aesthetic value. They are almost always dusty rose, powder blue, or violet.[27] True artists and artisans sometimes appear at the crafts fairs where these wares are peddled, but they are soon squashed by the rigors of the marketplace. Craft fair crafts make hippie crafts, therapy crafts, and hobby crafts seem artistic by comparison. What we look at when we gaze at the photographic reproductions in the crafts magazines and books is something very different: it is art. Should we stop calling it craft? Or is it the crafts fair items that we should stop calling craft, reserving the term for the better things? It won't work. The term "crafts" draws customers at the high end of the market as well as the low. Most crafts artists have decided for convenience to take advantage of the already existing crafts system until the larger art system can absorb their work. They play both ends against the middle.

In the meantime, the artification of crafts continues—preserving and sometimes enlarging endangered crafts disciplines and forms; helping artists to earn their livings; encouraging the more talented by virtue of the potentially greater feedback, honor, and financial reward. But there are drawbacks. The art market, because it is so commercial, may inhibit freedom of creativity and force compromises of media-specific traditions and techniques. The process of aiming one's work for the fine art context may co-opt the nonart energy of crafts and corrupt the true art spirit.

For the art world, there are positive aspects of the crafts invasion. Markets and audiences will expand. Art critics, as the demands of the markets force them to deal with art in crafts media, will find that dealing

with these strange objects creates a remedial dislocation of language. The old patterns of thought and the dreadful clichés simply will not fit the new information.[28] The artification of the crafts tends to involve the elimination of the utilitarian and a downplaying of the decorative. But divorcing crafts objects from use—putting them on a pedestal, as it were—is dangerous. Use factors often control key aspects of form and meaning. If the craft object has not been made for actual use, this lack of intention will show. Viewers will know that the spout or the handle will fall off the teapot, the vase will leak, the colors of the fabric will bleed or transfer to the skin. The work in question will then become merely an image that stands for or refers to craft objects of one or another kind.

Eliminating use makes form symbolic, denying the full force of the chief aesthetic virtue of craft objects: their perceptual and conceptual complexity. Most craft objects have a more balanced relationship between their haptic and optic qualities than paint-on-canvas art or noncraft sculpture, thus allowing a doubleness of being. Seeing and touching merge with or contradict each other. This is the purest art quality of objects made in the crafts tradition and the one unique to them. It is such a strong duality that objects that look like or represent craft objects partake of it through association.[29] Experiencing craft art that retains and celebrates utilitarian forms requires the ability to receive, perceive, and process more than one constellation of sense data at a time. By extension this means that one must also be able to think more than one thought at a time. If we can simultaneously manage seeing and touching and using, we have accomplished something quite miraculous.[30] Only craft art allows us this.

The Eloquent Object was the catalog for an exhibition that debuted at the Philbrook Museum of Art, Tulsa, Oklahoma, in 1987. Although I had nothing to do with the content or the concept of the exhibition, I am of course grateful that my essay was included, but here offer the original version and include annotations. I have restored the section divisions and the lead-in self-quotes, which are integral to the text. These quotations underline important themes and, pointedly, track my own development in terms of a critical involvement with craft as art. Thus, they demonstrate the kind of discourse that, through time, is the most illuminating aspect of art criticism. It is this implied dialogue that teaches readers how to look at art and how to think about art. Art criticism, like philosophy, is about argument, rather than conclusions. That argument can, as in my original essay and in these annotations, take the form of a

polemic. These annotations are clarifications, expansions, corrections, updates, and further complications of my initial exposition. After twelve years, some aspects of the craft problematic have changed, but, alas, some have not. The struggle to have craft-based art accepted as full-fledged art has not yet been won.

I would also like to note that the plural of craft (crafts) used as a singular in the title is intentional. It is meant to startle and signal that this is no ordinary essay and, more importantly, that craft as a field is itself plural. One would think that the multiessay, multiauthor exhibition catalogue would serve the plurality of craft well. This has not proved to be the case; the plurality of craft is not necessarily mirrored by a plurality of aesthetic and/or historic perspectives. This kind of publication was, at the time of *The Eloquent Object*, favored by government and foundation funders, perhaps as a way to subsidize scholarship and critical thinking, but also a way of covering all bases. History, however, cannot be written by committee. Multiple points of view often end up canceling each other out.

A more dramatic example of this canceling effect is provided by the "catalogues" for the American Craft Museum's three centenary exhibitions. As senior curator of The American Craft Museum at that time, I myself participated in the conceptualization, but not the editing, of the first three and, as of this writing, only volumes of the Craft Museum's so-called Centenary Project. This project was intended to create the history of 20th-century American Craft. I agreed with and favored starting with the American version of the Arts and Crafts Movement as the foundation of the American Craft Movement, noting that it too represented a synthesis of the idealistic and the entrepreneurial. It was my idea to treat the time between the two world wars in two separate volumes: one focusing on the craft revivals, which would thus write into the history the African-American, Hispanic, Native American, and Southern revivals, as well as the obvious Colonial revival. The second installment was meant to treat craft in relationship to modernism and design. Nevertheless, because these volumes were edited without a consistent point of view, the history of American craft has yet to be written.

NOTES

1. John Perreault, *Usable Art*, Myers Find Arts Gallery, State University College, Plattsburgh, N.Y., 1981. I also traveled to The Queens Museum, New York

City. Taking my cue from what artists were actually doing, I decided to probe the lively production of what I called usable art—not quite craft, not quite design, but something else: sculpture that has a function. It was a trend that came mostly out of the Patterning and Decoration (P&D) Movement, but not exclusively since two of the artists in the exhibition (Chris Burden and Eduardo Costa) would be more at home in a dada context and a third (Tal Streeter) looks to constructivism. I had previously curated *Pattern Painting* at P.S. 1 in 1977, for which I had selected works by twenty-five painters who were using repetitions of "decorative" or geometrical motifs to enliven large flat surfaces, filling in the grids of minimalist paintings, as it were, with color and content. The three-dimensional version of the same impulse shortly became evident. Painter Joyce Kozloff began collaborating with potter Betty Woodman; Robert Kushner had already insisted that his painted fabrics were decorations when hung on the wall, but art when they were worn during performances. Sculptor Scott Burton moved his furniture performance props out on the street, into galleries, and into homes as real-life furniture that was also meant to be seen as sculpture.

This quote from my catalogue essay is sarcastic. Sarcasm can be serious. In this case, these words expose usable art's relationship to constructivism, dada, and futurism. In retrospect, my interpretation was probably not at all what the P&D artists in the exhibition had in mind. I was not identifying a movement, however, but identifying the usable as a theme running across several styles. The exhibition came out of my probe mode.

2. To provide some context, current readers might find it interesting to note that I was the first critic to write about earth artist Robert Smithson, one of the first to track conceptual art in a favorable way, and participated in the creation of Streetworks and Performance Art in the late 1960s, as an artist as well as a critic. I was also an early supporter of feminist art. It was through feminism that I regained my interest in crafts. Miriam Shapiro, Joyce Kozloff, Judy Chicago, and others were appropriating craft forms through honoring them. It took only the collaborations between Kozloff and Woodman—represented in my exhibition *Usable Art*—to open my eyes to Woodman's accomplishment and, thus, to the American Craft Movement. Thus, for a time my critical subject matter changed, as did my career. I had opened Pandora's box. The new question was, if it were permissible for artists to make art out of rubber, neon, excrement, lard, and dirt, which is indeed the case, then why couldn't an artist make art out of clay or glass? Craft-identified materials are still shocking to me. They are so ordinary and yet can be used for extraordinary results. It is this shock that makes art possible.

3. I am no longer sure that the art world has a monopoly on commercialism. For various reasons it now seems the American Craft Movement, time-bound like all art movements, but with a greater longevity than most, may be dead. Craft fairs have become big business, galleries peddle kitsch, and support for

new craft artists is virtually nonexistent.

At the 1999 Ausglass Conference in Wagga Wagga, Australia, I delivered a paper titled "New Glass Sculpture Theory and the End of Craft," which was subsequently published by Ausglass in the conference papers titled *The Artist's Voice* (The Australian Association of Glass Artist Limited, McKinnon, Victoria). I had expanded upon what I mentioned in my American Craft Museum presentation the previous fall:

> I recently had the insight that the reason craft has not moved ahead is that the American Craft Movement—a very distinct movement in the States at least—is over after a long five decades. The energy has disappeared along with the ideology. Cross-media fertilization, such as that between ceramics and glass in the early sixties, has ceased. Clear lines of succession have halted. The craft consensus no longer holds; it is no longer us against them, but me for myself. It is amazing that the American Craft Movement lasted as long as it did.

The American Craft Movement may be dead—or, as I said, has "folded up its tent, leaving seven or eight smaller tents behind"—but craft itself is far from finished. The American Craft Movement may be Balkanized and gerrymandered, but the objects are alive. Handmade art has an aura that other art does not. The technical, the practical, and the tactile still fill needs. Paradoxically, craft is now an elite rather than a populist pursuit. Connoisseurship has replaced activism.

4. If I were to select one summary quote from this essay, this would be that quote. It reveals that it is more about power than it is about craft, and thus it is about art in general. It is also obviously a critique of either/or ways of looking at the world.

5. "Crafts or Art?" *Soho Weekly News*, Issue #7, 1977, 22. This works in both directions. Sculptors take up clay and fiber with impunity. Conversely, basket makers use metal strips or knot metal strands. Ceramists weave coils of clay. Turners turn stone as well as wood.

6. "Fear of Clay," *Artforum*, April 1982. The material criterion for craft no longer applies either. When I was at the American Craft Museum, the institution was locked into the sacred five craft media, as expressed by the cataloguing system for the permanent collection: clay, fiber, glass, metal, wood. Where does the registrar put baskets made of metal strips? Metal is not fiber. Where does a necklace without an ounce of metal go? I was able to add a category for jewelry, thus establishing once and for all that functions and forms—as well as the sacred five craft media—can be used to track craft objects. I wanted to demolish wood entirely and substitute furniture (some new furniture is not made of wood) and turned wood. Furniture and turned wood bowls have nothing in common but some trees. I would have separated quilts as well as baskets from fiber. Where do we put craft objects made of plastic? They are craft objects be-

cause they use a craft form and/or a craft technique, but if materials are the way we classify craft objects then they are not craft. The labels on all the shelves no longer apply as strictly as they once did. Mixed-media craft thoroughly disturbs the order of things, at least within the museum.

7. "Fear of Clay." To some, crafts are synonymous with art therapy and this is anathema to most crafts practitioners (or collectors, curators, and critics). Therapy, however, is an honorable part of the crafts tradition from the Arts and Crafts Movement (the Marblehead pottery) through the various GI programs, one of which was run by the Museum of Modern Art in New York. One might think that the one craft media immune to contamination by the therapeutic is glassblowing. As someone who runs a glass center (UrbanGlass in Brooklyn), I can testify to the therapeutic effects of glassblowing. It is not in spite of the danger, but because of the danger, that glassblowing is calming. Concentration is absolutely necessary, and there is the likelihood that, as in high-risk sports, endorphins are produced. Woodturning, which I have also tried, has a milder, but nevertheless similar, effect. Another craft taboo is amateurism: craft as hobby. One should remember, however, that craft techniques such as black-smithing and wood turning would not have survived without the dedicated hob-byist. Wood turning, descended from the hobby of royalty, the manual training class, and then the do-it-yourself craze, has now blossomed as a completely new art form. The Far Eastern tradition of the gentleman scholar and the scholar artist needs to be recalled, wherein the aesthetic is totally divorced from the commercial. The art making that is a hobby is the art that is free.

8. The magic is created by a union of the beautiful, the spiritual, the con-ceptual, and the useful through the conjunction of the visual and the tactile. Craft, in so far as it is grounded in use, is the art form that demonstrates that an object can be several apparently contradictory things at once.

9. The dotted line at this point appears only to be visible from the craft side of the border. From the paintings and sculpture side, the border is a Berlin Wall. Craft artists have experimented with installations and conceptual modes and, for some time, political and social content, but the art world sees imitation rather than innovation.

10. From my point of view, I still think this is true. But painters and sculp-tors and their allies are stubborn. Is it still because there are too few seats at the table?

11. Art is art. But art is larger than what painters and sculptors and their supporters—out of vested interest—will allow. The problem on another level is simply a matter of logic. Art is the larger category and painting, photogra-phy, performance art, and crafts, all subcategories, are therefore all art, just as pears, apples, grapes, and oranges are all fruit. Comparing or opposing art and craft would be like comparing or opposing fruit and pears. What can be com-pared is three-dimensional craft and sculpture; two-dimensional craft and

paintings. In other words, you can compare apples with oranges, but you cannot compare apples with fruit or craft with art. We are then left with ranking plain and simple. You can only say a pear is better than an apple if you set up some criteria. Therefore, is sculpture better than craft because it is more expensive, has more content, is collected by more powerful people, is capable of greater expressive power? Is craft better than sculpture because more people can understand it? Is glassblowing better than conceptual art because it is verifiably more therapeutic?

12. There is no longer a category that might be referred to as "art of the East Village sort." The galleries have all closed; the limousines have disappeared, as have most of the artists. Key appropriationists have survived, and I now hold them in high regard, whereas graffiti-based art, with the exception of Haring, is still not to my taste. Just as categories are not eternal, neither is taste.

13. If only this were so. I will stay with formal values as general art values, that is, values that apply to crafts as well as painting and sculpture. Sincerity of expression enters the swamp of good intentions. I meant to save is not the same as saving, whether one is saving money or a drowning child.

14. Turn the world upside down. Put, let us say, ceramics at the top of the art hierarchy instead of painting. Such a world already exists in Japan. But let us imagine this happening in the United States and Europe. Will someone then say that painting is for women? Would there be a Mary Boone of ceramics? Would ceramic artists have retrospectives at the Museum of Modern Art?

15. Although craft artists are certainly more generous with sharing their techniques and formulae for art making and tend to be more available to the general public, I am relieved to report after several additional years of experience in the field that they are no more idealistic or less self-centered than painters and sculptors. Developing a product, market research, marketing, and filling orders are what all artists do; painters and sculptors have different names for these tasks. It would be too idealistic on my part to assume that craft artists would be any less competitive than painters and sculptors. Making a living through making art—any kind of art—for most artists is a living hell.

16. Now craft is being subsumed or replaced by design.

17. "Clay Feats," *Soho Weekly News*, March 5, 1980, 47. Does the carpenter sometimes think of carpentry as well as of wood? The potter of throwing? Of course. So too the critic must think of criticism. But unlike artists, the critic has no object as a product. The product is the process of criticism. Here I did not mean to say that ceramists should also be critics—backbiting and in-fighting are not criticism—but that the field did not seek or encourage critical thought.

18. Nor, in 2000, does criticism have much to offer painting and sculpture. It is not just that evaluation is left to the market, but that the art myth has been so deconstructed that very little belief is left. Art is a belief system. So is craft.

19. *Streamline Design*, Queens Museum, New York, 1984. The practical *is*

the aesthetic. This is modernist design theory in a nutshell. Should it be attacked? Now I wonder if the impractical and the extravagant, more in tune with the Patterning and Decoration Movement, their predecessor, and their recent revivals, may not be equally aesthetic. Perhaps we can say that the aesthetic has two faces: restraint and generosity.

20. "Clay Feats." The question persists. Why do we separate art and use? We know that in the past this was based on class. Nonutilitarian art—most painting and sculpture—requires special time and special space for delectation, removed from the hubbub of war, sport, sex, and even spirituality. Only the powerful can afford the time and the special spaces required and, therefore, become privy to pleasures, perceptions, and even knowledge above the common herd. But in fact, anyone can stop time, and the only space one needs is inside one's head. As I have hinted elsewhere, this, I think, unnatural separation is economic as well as political. If everyone went around in an aesthetic perception mode, dull work might not be possible and society might collapse. Aesthetic pleasure might distract the workers from their appointed tasks, from reproduction, from their prayers. The reverse is more likely. Aesthetic perception transforms the dull.

21. Craft is not the only art form that can unite the mental and the physical, that materializes the invisible worlds of intelligence, emotions, and spirituality and/or conversely spiritualizes the physical. Look at dance. Architecture may be frozen music, but craft is frozen dance. Here is an example: I had long thought of glassblowing in teams, now the prevalent technique, as performance; it is trance-like for the participants and dance-like for the audiences. As editor of *GLASS Quarterly*, I commissioned Eileen Fox, executive director of the Dance Notation Bureau, to record two glassblowers at work, using the Labanotation graphic dance notation system, also known as Kinetography Laban. The resulting diagrams, aesthetically interesting in themselves, highlighted the glassblowing process as dance. To the extent there is an object produced, that object is frozen dance.

Painting of the "expressionist," gestural sort, Chinese or Japanese ink painting, and Arabic calligraphy also qualify as art forms that unify the visible and the invisible, as does gardening.

22. I am not against alternative, etherealized worlds, but as far as I know, they are all linked to and generated by physicality. If the physical dies, so do they. Of course, the disappearance of the body is exactly what happens in sleep. Only the reawakened body can stop bad dreams.

23. Glass Art Society Conference, Corning, New York, May 1984. This has become known as Perreault's Rule. As a joke in front of an audience, it always works. What it really says is another matter: the distinction between craft and sculpture has to do with tactility and economics. Touch includes the textural component of taste, that is, the difference between whole cooked potatoes and

mashed potatoes, and the difference between mashed potatoes and whipped. Another example would be the difference between apples and applesauce. Touch also includes temperature—the skin, like touch, is also the sense organ— but it does not include weight, one of the overlooked senses. Weight belongs to the constellations of qualities that are perceived through the muscles and the sense of balance. Jasper Johns's two ale cans, a contemporary classic, is composed of one empty can and another that is inordinately heavy. Certain of that genius, George Ohr's paper-thin vessels make weight into an art quality. Dance too has something to do with weight: jumping, lifting, and falling are weight made visible.

Another aspect: how is looking at a pot like looking at a painting? Realist or naturalist paintings from the Renaissance to the present utilize the contradiction between vision and tactility for aesthetic purpose. We are not allowed to touch the painting, but if we could, we would not feel the apple depicted; instead, we feel the texture of the apple through our eyes via the mind's eye. After a certain point, unless you own them, vessels are out of bounds to touch and life. It is then, in museums and galleries, that they become realist paintings. You can only touch them with your eyes.

24. The easiest way to appear to change reality is to change language. But real change can only occur if language is used to stop language. The question becomes, can there be perception without preconception?

25. Hierarchy is hegemony. The question of hierarchy is central to the craft/art discussion, for even within the craft world, hierarchies, although usually unacknowledged, hold sway. Listing craft venues and then the craft exhibitions according to material will reveal that craft media are ranked according to institutional preferences, which are created by perceived popularity or the ability to draw visitors, collective collector largesse, and even history. Since the 1970s glass has replaced clay at the top of the hierarchy, commercially and in terms of prestige. Commercial success and prestige are linked. Craft artists also participate in ranking. It is amusing to ask craftspeople to rank the craft media other than their own. Here as elsewhere it is appalling how self-interest and personal preference dominate. The questions to ask about rankings are, For whom is this hierarchy constructed, for what purpose, and against whom? Who will be excluded?

Look to history. Hierarchies are not eternal but historical. Hierarchies are not discovered; they are imposed. To sort is to control. Hierarchies are created to maintain power. When potters look down on basket makers, they are hoping to maintain their greater access to grants, residencies, galleries, critics, and collectors. When sculptors look down on potters, they are doing the same.

26. At this particular time, there is a trend toward downgrading craft to the academic/museum/auction category of the decorative arts. I join the three terms for a reason: the three arenas are interlocking when it comes to what I prefer to

call antiques, rather than decorative arts. Academics appraise and confirm authenticity for the auction houses; museums provide ideal examples and touchstones. Craft curators—and some dealers—often have decorative art rather than fine art backgrounds. So this collusion may be natural rather than conspiratorial. We must resist. The American Craft Movement and the Arts and Craft Movement before it—and all the international branches of both—were about having craft objects accepted as equal to fine art, not as design or luxury housewares, giftware, or decor.

27. Brown for mugs and pots, but cobalt blue for glass. Craftspeople are now pressed to try to figure out the color of the year through marketing research firms and tip sheets. Forest colors this year, oceanic next year.

28. How does one go about learning how to write about craft? First, learn how to write. But if you are not passionate about craft, even that won't help.

29. I still believe that this is the most important, if not the totally defining, characteristic of craft as art. This is its strength as well as its handicap. The strength of the marriage of touch and sight in a digitized environment is obvious. The handicap is that this interplay cannot be digitized. To be salable—perhaps even to be inserted into art history—a craft object must be photogenic, which means it must look good as a flat image. This is true of sculpture and design objects too. A third dimension is sacrificed, but since tactility is usually not very important for design and sculpture, the representation can suffice. Design objects absolutely must look good in a single-image flat representation for that is how they are sold. Isn't this also true of sculpture and increasingly of craft? One of the best artists to come out of the American Craft Movement, Betty Woodman, consciously plays with a dialogue between photographic flatness and ceramic volume. The world's most famous glass artist, according to some reports, refused to look directly at student work, but insisted that he review and critique color slide projections only, since this is the way most art is communicated.

30. Design can do this also. The best design involves seeing, touching, and, obviously, using. Nevertheless, craft offers something that design does not: the imprint of the maker's hand, the aura of the eye-to-hand transfer, the suggestion of sweat. So, there is really a fourth factor that operates simultaneously for craft. For some this will forever remain, a bit too intimate, a bit too unsanitary, even a bit too sexual.

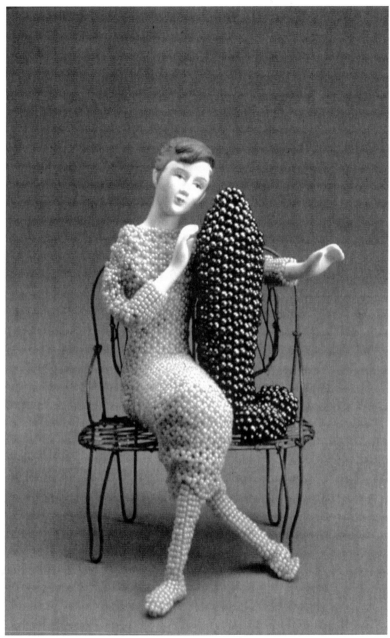

Joyce J. Scott, Cuddly Black Dick #3. *Beads, porcelain doll head and hands, and wire thread, 7½ × 4½ × 5 inches, 1995. From the collection of Francine Tiloff. Photo by Kanji Takeno.*

6

Moving Beyond the Binary

James H. Sanders

In questioning the common beliefs about art and craft it is important to consider the differences in how each maker takes into account her or his lived experience, the objects the maker forms and the material traditions from which his or her works emerge. These indeed are personal and political choices that continue to be undertheorized and/or fail to be discussed in serious art theory circles. Craft and its aesthetic experience, grounded in human need, are largely trivialized in primary and secondary education as *lesser art*. Separate from serious forms of studio-based instruction in *fine art*, craft is rarely considered within studies of art history, aesthetics, or criticism. I argue that separations are in the interest of those seeking to sustain class, race, and gender domination by means of formalist and traditional aesthetic theories that marginalize the craft experience and craft maker's subjectivity.

Grant Kestner contends, "[T]he capacity for aesthetic experience is common to all, but that the ability we have to regulate that experience is social."[1] The challenge then is to determine (1) how and why the enjoyment of art and craft has been socially regulated, (2) the end to which aesthetics are employed, and (3) whose interests its regulation serves.

Paul Mattick notes that in the thirteenth century art was used to describe "possession of specialized skills, without the sense of an autonomous realm of value." By the fifteenth century, Italian painters "demanded to have their craft placed among the 'liberal,' as opposed to the

This essay is based upon a paper delivered at the 2000 College Art Association conference and on a performance presented at the 1999 annual conference of the *Journal of Curriculum Theorizing*.

'mechanical' arts." In the eighteenth century, art's meaning shifted again, as artists were no longer considered bound to imitation of natural beauty. Thus, the modernist notion of artistic creativity, later conceptualized by Kant as "the expression of genius ruled only by the internal compulsions of its creator,"[2] came to be known as artistic labor. In "Some Aspects of Art and Philanthropy in the United States," Mattick outlines the shifts of meaning for the socially constructed term "art." He notes that artists' escape from patronage into the freedom of the market produced a

> paradoxical dialectic uniting the independence of the entrepreneurial creator and his dependency on those who purchase the luxury goods called art. . . . Worship of art came to express the claim of capitalist society's highest orders to rise above the confines of commerce as worthy inheritors of the aristocratic culture of the past. . . . Appreciation for the Beautiful and Sublime as embodied in works of art provided a reconciliation of opposites, at once embodying strictly bourgeois virtues and transcending them.[3]

This tension created in the marketplace is sustained as patrons, critics, and historians objectify both makers and the works they create, reflecting the Cartesian-era reading of the craft text. Such a reading largely ignores the classed, raced, gendered, and sexualized identifications embedded in these forms. Indigenous expressions and avant-garde works alike are valued on formalist Eurocentric (white, heterosexual, male) aesthetics, absorbed as coded forms into the mainstream of the art-commerce industry. I argue for the development of a craft aesthetic and critical valuation process that is grounded in a social theory of the maker. This theory recognizes that a craft artist reflects multiple subjective identifications that may (or may not) be readily identifiable in objects created by a maker. This disquieting and messy theory is equally fitting for contemporary craftspeople as it is for those emerging from traditional craft media—for both may be understood as creating within and commenting upon a web of social regularities[4] that contain and are exceeded by their physical expressions.

Visual art in its applied craft form has remained a lesser art as a result of the codified devaluation by museums, trade journals/critics, and art historians, whose hierarchical distribution of aesthetic merit has defined and secured privileged status for the elite patrons and marketing institutions they serve. In this light, forms of expression accessible to

the larger population are, by their sheer accessibility, deemed of lesser value than rarified works designed and/or produced for a wealthy elite. Contemporary American craftspeople have certainly not escaped, but have been absorbed into this art market/publication/museum collection continuum—a part of a new class of collectibles consisting of works that both challenge and deny function in order to be ascribed with the mantle of *art*. Such practice continues to reinscribe class and gender hierarchies and denigrates traditional expressions.

John Dewey notes, "Craftsmanship to be artistic in the final sense must be 'loving'; it must care deeply for the subject matter upon which skill is exercised."[5] I suggest that to sustain its own social interests, the ruling class and its fine artists have long denied the "loving" images and creative output of folk artisans and contemporary craftspeople, marginalizing objects of beauty that function in order to claim some cultural superiority and allegiance to a mind-body split. The trivialization of "folk" art history and ongoing attempts to define and limit notions of exemplary craftsmanship are a class issue not only sustained by individuals, but recirculated by the modern museum and the aesthetic theories that have emerged from the academy of the late 19th to mid-20th centuries.

Stolnitz defines the aesthetic as separated from the rest of life, "disinterested and sympathetic attention to and contemplation of any object of awareness whatever, for its own sake alone."[6] This aesthetic theory is founded on a dualistic notion, pitting mind against body and separating consciousness of the external world from the sensed and lived history and cultural tradition(s) of art/craft makers. As Arnold Berleant asserts, "contemporary art [and traditional art/craft] . . . frequently insist on experiences of engagement by provoking us into movement or action or by forcing us to adjust our vision and imagination."[7] Mikel Dufrenne and Maurice Merleau-Ponty both argue for a theory of aesthetic perceptual unity, a synthesis involving "the body as the field of perception and action," further suggesting that an aesthetic object, as both a thing and its meaning, exists interdependently—requiring the viewer to "enter into the work in an intimate fashion, active not as a pure spectator but as an involved viewer."[8]

Preziosi[9] submits that our challenge is to reckon with our visual environment in all its ideological givenness—a call for the reconstruction of multiple readings of art history, theory, and criticism. Rather than assert-

ing a proper reading of craft's meanings, the work of craft aesthetics and history could thus be reconsidered as a social and dialogical process that proliferates new possibilities and considers varied visual languages and multiple makers' values. Artists and craftspeople working in the field have needed no authorization to pursue this line of reckoning—they do it to survive—creating works of beauty and utility that speak to their identifications or submerge these signs and symbols in a playful cat-and-mouse game of meaning. Neither art nor craft can ever be separated from ideology or interpretive frameworks. Contemporary craft's utility-coded context may both contain and exceed that codification and disrupt classifications of higher and lesser art forms. Unlike the fine artist whose

> aesthetic refinements . . . bear no relation to their people's concerns and aspirations . . . the concept of a popular and functional art is . . . poised against that of an intellectual and aesthetic one . . . an attempt at fusion of the self and the other, of art, ideology, and life.[10]

What is at stake is thus both the defining of what passes as aesthetically significant and how such work or experience is used politically by its makers, the critics who recount such works' meanings, and the historians who chronicle its place in the continuum of objects and time.

CRAFT AS SOCIAL CRITIQUE

Western aesthetic theory has constituted a form of social regulation that has denied the embodied sensing (*aesthetikos*) of untutored viewers. More than merely defining aesthetic values of art or craft, these regulations were established in the interest of industrialists who founded many of the first U.S. museums and sought to dictate the spiritual, moral, and social behavior of the working classes through their collections, installations, and re-presentational choices.[11] With the industrialists' values in mind, museums served as vehicles and forums for manipulating sign systems. Such regulatory mechanisms established the official voice of aesthetic worth, (re)authorized the legitimacy of art and craft collected by this same elite, and limited the range of objects ascribed with economic value or historic significance.

Contemporary craft, as an agentic form of social critique, questions such valuations.

> The notion of Quality has been the most effective bludgeon on the side of homogeneity in the modernist and postmodernist periods. . . . Based on an illusion of social order that is no longer possible (or desirable) to believe in, we now look at art within the context of disorder. . . . Ethnocentrism in the arts is balanced on a notion of quality that "transcends boundaries" and is identifiable only by those in power.[12]

I hold we must first rearticulate and redefine aesthetic theory, considering a plurality of values, before craft can have an impact on artistic discourse. I call for more than craft's simple inclusion within the range of objects considered as art, seeking instead a valuing of craft and art studio practice as models for policy analysis, research, and pedagogical performance. These include explorations of craft as metaphor, as theoretical process, and as a foundation for liberatory curriculum. In short, I seek an aesthetic theory of craft that challenges the raced, gendered, classed, and heteronormative[13] notions that have imbued fine art with surplus economic and cultural capital and denigrated craft's functional and social embodied meanings in all their splendidly varied forms.

Studio artists confront problems as forms of creative exploration and imaginative revisioning. In considering the social problems art education seeks to address, studio production practices open up a broad range of metaphors and sense(abilities) which help reframe these issues. As a weaver, potter, or woodworker, ideas are not simply imposed on materials, but the maker enters into dialogue with the material. If a maker carefully "listens" to the grain of wood and considers its qualities, concepts are merged with material. This notion of data informed by or grounded in research methodologies is increasingly considered one of the characteristics of well-designed qualitative research and ethnography. Beyond mythical claims of objectivity, such practice recognizes that the maker or researcher's role in any study necessarily must forefront the markings of the author/maker and acknowledge the agency of the subject studied, abandoning the omnipresent-absent authorial voice for the author/craftsperson's "I" and the media/material's self-evident presence.

No matter what our checks and balances, measures, or safeguards are, we cannot escape our own subjectivity. A handwoven cloth gives testi-

mony to the emotional state of the weaver—for while threads beaten on subsequent days may follow the same patterns within the mechanical confines of the loom, they are never packed exactly the same way. I hold that like the weaver/craftsperson, the researcher/theorist or critic shapes materials (subjects studied), unavoidably divulging his or her hand in any published report. The thoughtful researcher and critical theorist thus knows that a subject is more than raw material for intellectual manipulation and candidly reflects on the subject's self-defining interests, limitations, and possibilities. Understanding the role of emotions in research and knowing how to stretch and work within the subject/material's characteristics to bring new meaning and forms to life are hallmarks of both the accomplished craftsperson and researcher.

Dissanayake[14] asserts that artistic and aesthetic acts and perceptions are universal human traits. While her position supports the inclusion of craft as objects that "make special," I am nonetheless reluctant to embrace her metatheory. She not only dismisses the political and ideological nature of art, but attacks postmodern art theorists who forefront a political problematic. Craft, or art, like any other language, is not neutral, even if, as Dissanayake suggests, it appears naturally in the human species. I hold that questioning the assumed or *natural* premise is one of the hallmarks of the inquiry-based process shared by craftspeople, artists, and critical theorists of feminist, race, or class focus. New craft aesthetic theories are needed that attend to such critical concerns, theories that disrupt the status quo.

Integrating craft works into the fine arts halls, rather than assigning them to decorative art wings, could serve as a means of decentering the traditional canon and the elitist interests it serves. This practice might encourage the development of hybrid art forms with liberating potential for everyday citizens and classroom students visiting the galleries. As a subversive strategy, this could extend what Henry Gates calls "changing the joke and slipping the yoke."[15] For example, Fred Wilson's curatorial provocations jar the viewer into reconsideration of and reflection on the value-laden decisions of the museum as an institution, subverting and/or challenging the social practices of the institutional aesthetic and its social/historic collection and exhibition practices. Comparably, Joyce Scott's installations at the Baltimore Museum of Fine Art call into question the craft makers' perspective within the history of fine art, as this fearless beader's voice and vision become juxtaposed with the revered canonical form.

CRAFT AND WOMEN'S STUDIES

The struggle I now turn to is one that has been unduly borne by women. While fearing I may be seen as another white guy trying to control and rename a feminist discourse, I proceed modestly, asserting that like class and race inequalities, women's oppressions are, at their foundation, a white man's problem. For the past thirty years women have been framing craft arts as a political movement (Chicago, Shapiro, and others). The devaluing of women's work (needle crafts, weaving, china and decorative painting, quilting, etc.) has been a way to sustain the dominance of male-controlled visual art production. This differentiation has been a tool for asserting that sculpture and painting (media that claim to give form to concepts and ideas) are valued above work tied to the body or its function (vessels, utensils, garments, etc.). Crafts, as art forms that emerge from functional necessity, have thus extended the feminist tenet that the personal is political.

Traditional aesthetic hierarchies have limited what has been legitimated as art and devalued as women's craft works. These hierarchies have served the male-dominated arts professions, and in their interest, craft and art education have been defined and controlled. Our economy is in part dependent on a visually illiterate or unconscious public to fuel consumer markets, as corporations can thus more effectively manipulate buying trends through their media campaigns, while simultaneously shaping social practices. With such manipulation in mind, I hold these same interests support the election of officials promoting educational "back-to-basics" schemes that exclude craft/art education and divert attention from economic and social injustice. Craft/art education and the handmade (craft) product threaten the efficiency of the male/producer-dominated marketplace by teaching students to critically deconstruct received messages, use their imaginations, and question the vacuous and mindless repetition of objects that supposedly define their lives and worth.

Craft both clamors for and exceeds the categories of art and commerce. Ever on the margin of aesthetic and economic worth, it is poised to be swept into the center or cast out of the critical frame. The tensions and alignments between craft artists' forms/images and their gendered/political standpoints echo the dynamics of the craft maker's resistance and/or conformity within multiple social and professional contexts and economic/educational markets. How craft artists identify their work or

consider their role in education and cultural (re)production are political decisions. For as Judith Butler notes, "Identity categories tend to be instruments of regulatory regimes, whether as the normalizing categories of oppressive structures or as the rallying points for liberatory contestation of that very oppression."[16]

Like most modernist art forms that challenge the status quo, craft has been co-opted into the arts market by (wo)men eager to capitalize on new trends. Feminist artists, like Chicago and Shapiro, accepted into the canon, claim to affirm the value of women's crafts, but may be read as doing little more than positioning themselves within male patriarchy. As these artists recontextualize craft as a fine art vehicle, the works are (com)modified and at times devalued. In one reading, Chicago's *Dinner Party* and *Birthing Project* exploit the very women whose traditions she brings into focus. She does not practice these forms, but rarefies them for nonuse, rendering these women invisible and altering the context of their creative discourses. At times she largely ignores the narrative and oral histories linked to their cultural practices. Shapiro's work equally appropriates the quilts and traditions of countless unnamed women. By transforming these personal historic markers, they are removed from a personal value system and subjected to formalist analysis foreign to their intimate origin.

A second reading of Chicago/Shapiro's work holds that if these artists hadn't brought undervalued skills and traditions into critical examination, then these legitimate forms of aesthetic expression might continue to be isolated and ignored. This tension surrounding the craft field's (in)visibility always involves an element of risk—for in seeking recognition for new or undervalued traditions, one always runs the risk of appropriation into the art/aesthetic/commerce mechanisms that have defined craft's marginality in the first place.

Beyond first wave feminism's inversion/recirculation of simplistic binaries like man/woman, black/white, heterosexual/homosexual, or art/craft, (re)constructed aesthetic theories may take into account the multiple concerns of a postmodern subject moving within/against a constantly shifting web of social regularities. I argue that by working within and against existing aesthetic theory, we may begin to understand how craft and art works are inseparably a part of both political and aesthetic discourses. In this pursuit, feminist thinkers may be the next generation of cultural translators, who guide our way through this tangled web, helping to unravel aesthetic constructions in ways that value craft as a

process of personal and political mooring, a connection to work, the body, and the aesthetic process.

Male domination in the writing of art history has rendered women's artistic contributions largely invisible, neatly categorizing makers into craft media, thereby defining value and merit. Aesthetic border-crossers like Faith Ringgold, Joyce Scott, and Karen Stahlecker, who may (or may not) present their work for consideration within both craft and fine art venues, disrupt these categorizations. Such craft works by women, largely overlooked in art history texts, juxtapose decorative works of multiple cultures within/against contemporary feminist, racial, and environmental concerns, jarring the viewer's understanding of what constitutes "women's work." These makers encourage new readings of craft, expanding its political and aesthetic meaning.

I contend that the overpowering voice of historic artistic authority must be questioned and that every user/reader of objects should be considered a part of the (re)evaluation of aesthetic theory. Readers/users should be encouraged to trust their senses and their voices. Those participating in a crafts discourse, be they critical theorists, creators, or craft consumers, should use their own aesthetic sensibilities in accepting or challenging the practices that have sustained binary distinctions like craft/art or aesthetics/ideology.

RACIAL IDENTITY AND AESTHETIC SUBJECTIVITY

In the global marketplace, new art is systematically appropriated by the fine arts world and enshrined as a new standard. While some may hold that this is a form of oppression maintained by the male-dominated art establishment, it simultaneously allows new voices and expressions to be heard. This is a problem that operates across racial, ethnic, and cultural boundaries, rendered even more complex when artists linked to a particular "identity" become marked/limited by that identity.

Works of non-Western artists attain ranking in the U.S. art marketplace by being reinvented or recontextualized. As Coutts-Smith in Lucy Lippard's *Mixed Blessings: New Art in a Multicultural America* argues:

> The fashion for collecting various forms of native, indigenous, and folk artifacts has contributed to more than a simple co-optation of their values. In subsuming the specificity of peripheral indigenous cultural value into

the generality of central artistic culture (under the judgmental aesthetic of absolute stylistic formalism) a clear process of the redevelopment of peripheral culture is initiated.[17]

Considered on their own terms, works by non-European artisans challenge Western values, epistemologies, and aesthetic sensibilities. By placing these works in an anthropology museum, or in separate wings of art institutions, cultural disdain and contempt for the *other* and craft have been silently articulated. Lucy Lippard cites Paul Kangawa's *Other Sources* to confirm the alienation of historicization and cultural objectification.

> Something strange is going on here. Why is "ethnic" art in major institutions portrayed only as ancient relics of past civilizations? Why do I (an Asian-American artist) feel as though I am intruding in some rich man's trophy room when I tiptoe through the cool, dark labyrinth of the Asian Art Museum? How is it possible that I feel out of place among the well-crafted artifacts of my ancestors? Why does the museum make me feel even more cut off from my cultural heritage than when I stroll through the Modern?[18]

The creations of non-European cultures resound with spiritual subtexts and specific ceremonial purposes. When stripped of their meanings and considered only by standards of Western notions of art, they are incorporated into the art-commerce market. But if craft's value lies within its contained social meaning(s), those specific to the peoples who use and create them, then it constitutes a valuation system largely un(der)theorized and outside of the art economic marketplace. An aesthetic theory for valuing craft as performative object is still wanting. This theory might involve a formalist art aesthetic informed by personal, religious, and social performances through which forms are given social meaning. Shaped by the myriad cultural influences that give rise to craft's varied forms, such a theory might gesture toward a respect of difference and embrace cultural plurality.

TOWARD A QUEER CRAFT THEORY

Theories of aesthetics and sexuality rarely are seen lying on the same page. Yet, like sex outside of procreation, craft retains its (re)productive

functional history, while claiming the fertile space of pleasure for its own sake. Sex is seemingly a subject foreign to polite discussions of *American Craft* magazine even though craftspeople have been exploring issues of sexual identification for over three decades. Largely without critical coverage by traditional presses or aesthetic theorists, craft artists, liberated from the constraints of function, may question the social constructions of normalcy and desire.

A craft critic, responding to a paper I presented at the College Art Association Conference,[19] noted that a ceramist actively protested when mention of his gay identity and queer sensibility was proposed as an informing discourse in a feature review in *American Craft*. The editor conceded to the maker's request, silencing the queer critic's insights, and as in most coverage of gay and lesbian craftspeople, making their difference invisible. A more recent feature in that same publication not only "outed" a fiber craftsman, but did it without his consent, interpreting a piece of his work as depicting a middle-age man lusting after a younger male figure. Such a portrayal reinforced homophobic stereotypes and could be read as a form of violence against the artist. The tension between invisibility and naming of difference is a difficult issue that perhaps can never be satisfactorily resolved; nonetheless, I contend that it is a productive tension and an important problematic that must be considered within a postmodern aesthetic theory.

In my research with gay men whose formal education in the arts was grounded in fiber traditions, I found multiple identifications of gendered, raced, and classed beings informing their work. Simultaneously, 83 percent of these makers actively resisted being defined by such identifications and questioned the way gay or racial labeling limited multiple readings of their work. With the increasing frequency of portrayals of gay, lesbian, and bisexual characters in the media, one might be lulled into the assumption that these groups no longer face social stigmatization; yet, hate crimes against such groups continue to rise. It is little wonder then that contemporary homosexual craftspeople are reluctant to take on the "cross of queer."

My interest in promoting theories of craft that are concerned with issues of social justice and bisexual, gay, lesbian, and transgendered makers' plight may be received suspiciously by those within the socially oppressed group. One gay craftsman confirmed that, socially, both gay and black clubs and communities were important to his sense of identity. Yet, he discouraged such associations in discussions of his work, con-

sidering them identity labels and signifiers that limit other readings of his work. In short, he suggested that queer tags are not welcomed and that critics, theorists, and art historians should carefully examine their own objectives in naming others. While acknowledging his position, I nonetheless question how such a response might reflect an internalized homophobic fear, thus critically reaffirming the importance of theories of craft that dignify the multiple experiences of the maker. Clearly, this requires some "queering" of aesthetic theory to reflect the nature of the subject.

In considering the methodologies and measures of legible homosexual content, I have argued[20] that no one rule or method of reading or naming is possible or desirable. For as Cooper asserts:

> Almost intrinsic to queer culture is that it is fleeting and unpredictable, it cannot be encouraged or promoted in any regular or routine way, but must exist in the cracks and rips. If this is something which artists in the past have made use of, then this is something to be celebrated rather than denied.[21]

But such assertions would limit craft theorizing to reclamation of past makers and, only in revisioning of past invisibility, make queer that which was assumed straight.

If theories regarding (homo)sexualities are aimed at making audible the voices of silenced communities and speak to a revisioning of social justice, then how, at times, do they come to be received as trendy social markings? I contend that in most portrayals of gay or lesbian craftspeople, their subjectivity is defined in opposition to a presumed straightness and is thereby contained in the latter's normalizing definitions. Still, to deny the mantle of queer, as to deny the label of craft, is to reinscribe the hierarchies of art and heteronormative performance as preeminent expressions. As in earlier standpoints regarding the postmodern feminist aesthetic, I argue again that historians must strive to move beyond the binary in discussing gendered differences that exceed our namings and, perhaps through craft, find a way to queer such labels and subvert existing hierarchies.

Deborah Britzman notes:

> Queer theory proposes to think identities in terms that place as a problem the production of normalcy and that confound the intelligibility of the apparatuses that produce identity as repetition. . . . The concern here is in thinking the cost of narrating identities and the cost of identity itself.[22]

But can a craft aesthetic be created that affords a respect for difference and explicitly calls for nonexclusionary aesthetic practices without causing economic or social difficulties and hardship to those we name? If so, where and how? As one of my research subjects asserts,

> If I'm going to be talking about sexuality, being, y'know, a black male and gay . . . there has to be some other individuals there . . . that support team. Otherwise, you feel like you are like abandoned, and it's just difficult. I think it's the same as racism—it's difficult for people to really sort of go there because I think a lot of individuals have not resolved those issues within themselves—heterosexuality or homosexuality or whatever.

Craft theorists, historians, and critics must grapple with these issues and seek out communities and networks that support the questioning of artistic/aesthetic prejudices and elitist/heteronormative interests.

Another fiber craftsman whose same-sex imagery has garnered international acclaim maintains his work is not concerned with gay identity. Contradistinctively, his craft colleagues consider same-sex desire central in their readings of his technically exquisite weavings. This tension between the intent and the meanings that others construct from the work echoes the larger social contexts through which any body of work is known. I contend that there is an assumed mandatory heterosexuality that defines both image and maker. In the safe space of queer craft collegiality, gay identity is revered, but faced with economic and critical survival in the art/craft marketplace, the craftsman wraps himself in the robes of heteronormativity in order to claim a mythical universality.

Craft's near invisibility in most fine arts discussions is repeated in recent writings on queer representation in visual culture. Even in their formalist work on queer imagery in ancient genealogies,[23] Koehl, Devries, and Halperin ignore craft as a medium while discussing the ceramic surfaces and forms (kantaros, cups, amphoras, etc.) that give rise to these images. I hold such marginalization of craft is intrinsically linked to the valuing of mind over body and a classist devaluation of aesthetic expressions linked to utility, tactility, or work. This ignoring of functional forms, even within discussions of the queer social practice, reaffirms the need for craft theories that question the heteronormative aesthetic foundation of visual representation as an intellectual concern removed from physicality or function.

RETHEORIZING AESTHETICS

Fundamentally, craft aesthetic theory must consider the body's role in aesthetic perception and argue for an interested engagement that recognizes the social construction of the viewer, maker, and object. This (re)theorizing of aesthetic enterprise considers crafts both as contained within and exceeding the exclusionary and elitist traditions of art, necessarily involving the unthinking of assumptions about universal values linked to sexual desire, class, race, or culture. A robust craft aesthetic must rigorously and repeatedly reflect on the ways ideology plays into the constructions of individuals' and communities' aesthetic epistemologies.

Can a craftsperson or artist control readings of her or his work after it leaves the studio and enters the marketplace of ideas and commerce? Can any theory escape ideological attachment? Does the critic or historian have any duty to the maker? Should craft theory limit its concern to visual culture and its interpretation? These may be unanswerable questions, but they can serve as productive tensions that incite an ongoing inquiry into the links between aesthetic and historic significance, artistic merit, political and social identity, and an embodied experience of craft.

An aesthetic that concerns itself with multiple values will better serve the cause of scholarly discourse than mindless recirculation of the formalist values handed down by traditional aesthetic theories. Such an aesthetic will reflect a social consciousness that takes into account the conflicting and contradictory aims of the myriad makers whose works are considered. This theory will question the aesthetician's role in the construction of meaning and (un)intentioned redistributions of merit.

I have asserted that traditional aesthetic theory, criticism, and art history have been socially constructed and reflect Eurocentric, masculinist, heterosexual, and upper-class interests. This essay calls for a craft aesthetic that reads works emerging from histories of function within and against contemporary critical, race, feminist, and queer theory. Further, it suggests that unless aesthetics are fundamentally retheorized, craft will continue to be marginalized in discussions of cultural significance—reflecting the biases of those who record art's appearance and meaning and the social and economic interests of publishing and exhibition entities upon whom such writers are dependent for their

survival. Finally, I propose a less comfortable craft aesthetic theory, one mindful of the theorist's role and function within the economic, social, erotic, and cultural dynamic. Through embodied knowing, craft/art viewers may come to appreciate the humanity we share, embrace the plurality of expressions that surround us and the traditions from which they emerge, and delight in the potential that our democratic experiment has yet to fully realize.

If craft, as a personal and political choice, is to be a critical social, as well as aesthetic, concern, both makers and recorders of craft must grapple with the normative values that surround them. Contemporary craft and its aesthetic experience, grounded in function and working within/against these constraints, may communicate the rich expressions of human need and desire. To achieve such status, educators must join in the process of fundamentally rethinking craft's history and its current role within the marketplace of ideas and commerce. No longer separable from studio-based instruction in fine art, or from other forms of gendered, raced, classed, or sexualized expression, craft must be considered in studies of art history, aesthetics, and criticism within the larger framework of cultural studies and social theory.

NOTES

1. Grant H. Kestner, "Aesthetics after the End of Art: An Interview with Susan Buck-Morss." *Arts Journal* vol. 65, no. 1 (1997): 42.
2. Paul Mattick, "Some Aspects of Art and Philanthropy in the United States," in *Alternative Futures: Challenging Designs for Arts Philanthropy,* Andrew Patner, ed. (Philadelphia: Grantmakers in the Arts, 1994), 23.
3. Mattick, "Philanthropy," 23–24.
4. James J. Scheurich, "Policy Archaeology: A New Policy Studies Methodology." *Journal of Education Policy* vol. 9, no. 4 (1994): 289–316.
5. John Dewey, *Art As Experience* (1934; New York: Perigree Books, 1980), 47–48.
6. Jerome Stolnitz, *Aesthetics and Philosophy of Art Criticism* (Boston: Houghton Mifflin, 1960), 35.
7. Arnold Berleant, *Art and Engagement* (Philadelphia: Temple University Press, 1991), 15.
8. Arnold Berleant, *Art and Engagement*, 17.

9. Donald Preziosi, *Rethinking Art History: Meditations on a Coy Science* (New Haven: Yale University Press, 1989).

10. Trinh T. Minh-ha, *Woman, Native, Other: Writing Postcoloniality and Feminism* (Bloomington: Indiana University Press, 1989), 13.

11. James P. Gee, "Postmodernism and Literacies," in *Critical Literacy: Politics, Praxis and the Postmodern*, Colin Lankshear and Peter McLaren, eds. (Albany, N.Y.: SUNY Press, 1993), 271–296.

12. Lucy Lippard, *Mixed Blessings: New Art in a Multicultural America* (New York: Pantheon, 1990), 7.

13. For a more in-depth discussion of homophobia and heteronormativity, see Michael Warner, ed., *Fear of a Queer Planet* (Minneapolis: University of Minnesota Press, 1993).

14. Ellen Dissanayake, *Homo Aestheticus: Where Art Comes from and Why* (Seattle: University of Washington Press, 1995).

15. Lisa D. Delpit, "Acquisition of Literate Discourse: Bowing Before the Master?" *Theory into Practice* vol. 31, no. 4 (1992): 300.

16. Judith Butler, "Imitation and Gender Insubordination," in *Inside/Out: Lesbian Theories, Gay Theories*, Diana Fuss, ed. (New York: Routledge, 1991), 13–14.

17. Lucy Lippard, *Mixed Blessings*, 183.

18. Lucy Lippard, *Mixed Blessings*, 13

19. James H. Sanders, "Queer Identity/Discourse and Contemporary American Craft" (paper presented at the Annual Conference of the College Art Association, New York, February 24, 2000).

20. James H. Sanders, "Reclaiming Silence: Sexual Identity and the Art History Curriculum" (paper presented at the annual meeting of the National Art Education Association, Miami, Fla., March 2002). "Queering the Craft Frontier" (performance presented at the Annual Conference of the *Journal of Curriculum Theorizing*, Dayton, Ohio, October 1999).

21. Emanuel Cooper, "Queer spectacles," in *Outlooks: Lesbian and Gay Sexualities and Visual Cultures*, Peter Horne and Regina Lewis, eds. (New York: Routledge, 1996), 26.

22. Deborah P. Britzman, *Lost Subjects, Contested Objects: Toward a Psychoanalytic Inquiry of Learning* (Albany, N.Y.: State University of New York Press, 1998), 82.

23. See Robert B. Koehl, "Ephoros and Ritualized Homosexuality in Bronze Age Crete"; Keith DeVries, "The 'Frigid Eronemoi' and Their Woers Revisited: A Closer Look at Greek Homosexuality in Vase Paintings"; and David M. Halperin, "Questions of Evidence: Commentary on Koelh, DeVries and Willians," in *Queer Representations: Reading Lives, Reading Culture*, Martin Duberman, ed. (New York: New York University Press, 1997), 7–56.

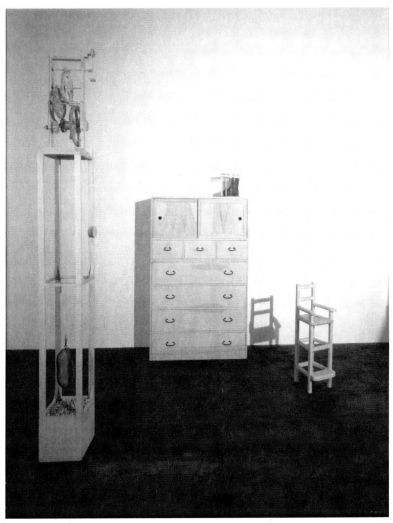

Kazumi Tanaka, The Chocolate Boot. Wood, stone, string, and chocolate: clock is 101 × 17½ × 12 inches, stool is 35⅜ × 11¾ × 13 inches, and dresser is 77⅜ × 41⅞ × 15¼ inches, 1994–95. Courtesy Kent Gallery.

7

A Labor of Love

Marcia Tucker

"I BELIEVE IN YESTERDAY . . . "

As the millennium approaches, individuals like the Unabomber, antigovernment terrorist cells like that of Timothy McVeigh and Terry Nichols, as well as assorted militias, antiabortion rings, and white supremacist groups, operating out of a variety of motives, seem determined to turn back the clock to a time when the West was wild, women were tame, men were manly, and the good guys were always white.

These kinds of longing also characterized the previous turn of the century, which was in no less of a state of flux and uncertainty than our own times—hardly the "good old days." To the contrary, a veritable tsunami of change and upheaval followed in the wake of the Industrial Revolution. As folklorist and historian of material culture Eugene Metcalf has observed, the nineteenth-century desire for a so-called return (or, more accurately, retreat) to the past resulted from the fact that the present had become increasingly uncomfortable; what's more, it was hardly the "real" past that people were nostalgic for, but a greatly simplified and romanticized view of it.[1]

A disproportionate number of whiners and moaners kvetched constantly and publicly about the decline of the family, women's rights (pro and con), the growing numbers of immigrants and socialists, and the dangers of "race suicide," all smothered in a thick porridge of domestic idealism.[2] Individual welfare was stressed at the expense of broad social

This essay was written for the catalog that accompanied the exhibition *A Labor of Love*, presented by the New Museum of Contemporary Art in New York City in 1996.

reform. The belief in the inevitability of progress and the reassertion of bourgeois values were accompanied by a search for "authenticity" and the revival of mystic and transcendental beliefs. The result was a pervasive spiritual escapism in which the twin concepts of selfhood and irresponsibility tiptoed off into the woods hand in hand—narcissism bedding down with a "higher" power, be it God or one's personal astrologer, who was privileged to make all individual decisions in the social realm.

"I CAN'T GET NO SATISFACTION . . . "

Does all this sound familiar? Along with the Unabomber and rightist terror tactics, the millennium brought to the forefront a singularly unimaginative, but loud, chorus of woe. Racist, misogynous, homophobic radio talk programs, TV tell-all shows, and the proliferation of twelve-step programs and self-help books are only the superficial manifestations of a spiritual crisis. Many of the previous fin de siècle's rallying cries parallel our own era's complaints against "big government," affirmative action, women's reproductive rights, "lax" immigration laws, and taxpayer support of the arts. There's a mad scramble on the right to return to "basics"—to the land, to so-called family values, and to the traditional Western core curriculum of writers and thinkers.

This is not to mention the outspoken insistence on the part of many government officials and candidates that the only valid art is an art that we can all understand—one that doesn't disgust and offend the American public with what former Secretary of Education William Bennett calls its "homosexual and lesbian self-celebration; Marxism; neo-Marxism; radical feminism and multiculturalism; deconstructionism; and various manifestations of political correctness."[3] According to Republican presidential candidate Patrick Buchanan, "culture is the Ho Chi Minh trail of power; you surrender that province and you lose America."[4] The crisis of cultural authority is clearly still with us. In public as well as private life, antimodern longings are expressed politically by a resurgent neoconservative movement, which, talking out of both sides of its mouth, promotes capitalism through the return of traditional "values" such as rampant corporate expansion and military campaigns waged under the banner of moral regeneration.[5]

How did yesterday's cucumber become today's pickle? What does *A Labor of Love,* an exhibition of handcrafted works that challenge the

categories and distinctions that privilege some forms of art making over others,[6] have to do with terrorist acts? Is there really a connection between the extremist political activities of late 1990s Aryan separatists (or the frenzied pieties of the Christian Coalition) and conditions brought about by the Industrial Revolution a century earlier; between the internecine quarrels of the contemporary art world, folding in on itself as government funding is pulled out from under it, and the antimodernist sentiments of the early 1900s; between art and politics; between art and everyday life? And are artists who are making labor-intensive, handcrafted work, whether in a craft, folk art, or fine arts setting, doing so with a different end in sight than their nineteenth-century counterparts?

"I'LL TAKE THE HIGH ROAD AND
YOU'LL TAKE THE LOW ROAD . . . "

There's a venerable history for such constructs as "high" and "low," fine art and popular culture, and for the separation of "folk" or "outsider" art and "craft" into distinct arenas, each with its own rules, values, aesthetic judgments, practitioners, critics, and supporters.

Whether or not this history begins in Europe with the birth of the Rococo style around 1730,[7] or with Enlightenment aspirations toward "high culture,"[8] or even a great deal earlier is open to debate. The distinction between high and low may also have originated with the different values accorded unique and mass-produced objects in the late nineteenth century.[9] As Lawrence Levine points out in *Highbrow/Lowbrow*, his remarkable study of the popular culture of that period, things that were mechanically reproduced were considered "inauthentic" by the cultural arbiters of the time, a view reinforced by their unhappiness with the impact of the Industrial Revolution.[10] But it was really in our own century that high art and popular art became firmly established as distinct categories, class markers intended to keep elevated or educated tastes distinguished from "lowbrow" or unrefined ones.[11]

"LEADER OF THE PACK . . . "

Other assumptions underlying both art history and conventional museum practice are a residue of late eighteenth- and early nineteenth-century

ideology, when Western culture configured the artist as an outsider, doomed by relentless romantic mythologizing to a position along a narrow spectrum of roles ranging from hero, mystic, genius, seer, and saint to eccentric, misfit, rebel, outcast, or lunatic. In my own grad school scenario, Still was located at one end of the spectrum, Graves at the other.

Historically, no matter which of these roles an artist was pigeonholed into, he (and rarely, she) was seen as someone whose activities were different, or as curator and writer Joanne Cubbs puts it, "consigned to a place outside ordinary experience and beyond the bounds of normal social discourse."[12] The emphasis on the force of individual genius and agency, a holdover from an earlier time, has become part and parcel of the way in which much folk and outsider art is packaged today. A focus on "authenticity" necessitates the presence of colorful artists' histories. These narratives include overcoming adversity, turning to art making after an epiphany, troubles with the law, "divine inspiration" as a motivating force, poverty, lack of education, and the like, and they can be found scattered liberally throughout the wall labels, exhibition catalogues, and public discussions that accompany most exhibitions of folk or outsider art.

The romantic vision of the artist in society enshrines the myth of Truth and Beauty. Work that is "purely" aesthetic, untouched by mundane concerns and uncontaminated by the "natural"—that is, by the baser instincts and senses—can only be apprehended through proper distancing and objectivity. The mind/body dichotomy set in motion by the Enlightenment was typified in the writings of Immanuel Kant, who insisted that "the pleasures of the senses [are] tyrannical; only in the contemplation of the aesthetic [can] people be free. The object that insists on being enjoyed threatens ethical resistance to it, and denies the distancing required by the aesthetic."[13] Simply put, the reasoning goes something like this: that which is associated with the mind is of a higher order, of a purer and rarer form, than that which is associated with the body. Bodily experience threatens to unsettle "pure" taste, which has been hard won through intense mental discipline and training. What the bodily senses ("mere" sensuousness) have to offer is natural, therefore "low" and impure, reduced to being only appealing. Dispassionate pleasure, the very best kind, is produced only by the experience of true beauty.[14]

It's no wonder that crafts and decorative arts, particularly those that are detailed and labor intensive—a sure sign of the body at work—came

to be considered inferior, capable of immediate visual appeal, but lacking in higher purpose. And the influence of Kant's writings has continued down to the present to separate the formal from the informal, the sublime from the decorative, thinking from feeling, the intellectual from the corporeal, high art from kitsch.

"DON'T FENCE ME IN . . . "

Throughout the 1960s and 1970s particularly, art critic Clement Greenberg's delineation of "high" (a self-referential, nonobjective, and reductive focus on the formal qualities intrinsic to painting or sculpture) and "low" (popular arts, decoration, pleasurable and accessible figuration) put Kant's theories into critical practice, defining for an entire generation what was, and what was not, "the authentic art of our time." Interestingly, "Avant-Garde and Kitsch," arguably Greenberg's most famous essay, was published much earlier, in 1939, at the peak of Hitler's rise to power. While Hitler's nationalism was built on the foundation of an ideology that emphasized the common man, or *volk*, Greenberg's confused socialism promoted what Robert Storr calls "a retreat and retrenchment on higher ground,"[15] that of "art for art's sake." Here, pure aesthetics and the continuity of tradition marched side by side at the forefront of the long, unbroken line of Progress.

In the essay, Greenberg's description of kitsch clearly marks it as the Black Plague of modern times. He describes it variously as "ersatz," "a gigantic apparition," rear-guard, content-driven, and appealing only to the masses who have always been indifferent to culture. It is full of "devices, tricks, [and] stratagems"; it "draws its life blood from a reservoir of accumulated experience," reaping enormous profits that are a source of temptation to the avant-garde, who are scarcely able to resist them; it has "flowed out over the countryside, wiping out folk culture," showing "no regard for geographical and national-cultural boundaries." It is "virulent" and "irresistibly attractive," but not "genuine." In summary: "Kitsch is the epitome of all that is spurious in the life of our times."[16]

If this view seems to be a bit over the top, it may simply be because vernacular forms in art are quite familiar by now. They no longer strike terror in the hearts of the cognoscenti, having been appropriated widely by very well-known artists. Greenberg's idea of a singular painting style, in which form and content are so thoroughly dissolved into each

other that only pure form remains, doesn't seem particularly viable in our postmodern world. But Greenberg's antikitsch diatribe hides a more problematic underlying attitude, one that he sees developing logically from a Kantian perspective. Greenberg puts it succinctly:

> There has always been on one side the minority of the powerful—and therefore the cultivated—and on the other the great mass of the exploited and poor—and therefore the ignorant. Formal culture has always belonged to the first, while the last have had to content themselves with folk or rudimentary culture, or kitsch.[17]

Many critics, curators, and collectors of art today remain wedded to some variation of this view; witness the relief with which the supposed return to "pure" painting was heralded last year as a welcome change from years of didactic and strident politicization of art by the disenfranchised.[18] The idea that the former kind of art has no politics, whereas the latter is nothing but, is to position art and politics on two distinctly different playing fields, as Greenberg did. Doing so implies that art's highest function is to provide viewers with a disengaged and heightened sense of pleasure, rather than to participate actively in the social and political constructions of the real world. Many people both inside and outside the art world continue to believe that the content of a work of art has no relationship to its artistic merit, that aesthetic quality alone is important. In this view, art has nothing to do with our lives and, therefore, has no potential for affecting them.[19] It is safe, defused, ineffective. The determination of integrity and aesthetic purity was then, and is now, the purview of the few, acting on behalf of the many.

"IT'S BEEN A HARD DAY'S NIGHT . . . "

How, then, to fight the growing insistence on separation, encapsulation, categorization, and hierarchies? Certainly not by throwing the baby out with the bathwater; knowledge of the past is necessary if we are to have a future at all. For many, if not most, of the artists in *A Labor of Love*, the answer lies in the deliberate recuperation of the past in order to understand the present. The kinds of work in the exhibition were at one time historically associated with popular forms of art making and culture, forms that were progressive rather than revolutionary, but that

nonetheless affected the micropolitics of quotidian life.[20] Art that uses
the everyday as a source of resistance and inspiration, that constantly re-
turns to viewers a sense of their own ability, creativity, and imaginative
potential, may be forced to operate at the boundaries of artistic dis-
course, but remains central to the discourses of lived reality. Its
predilections are supported by the increasingly visible work of analysts
of the everyday, who explore the ways in which resistance in popular
culture harnesses the power of the quotidian, whose manifestations in-
clude "the adaptation of the body, time, space, desire: environment and
the home . . . work and works of art; the ability to create the terms of
everyday life from its solids and spaces."[21]

Such forms of resistance can be found across the entire spectrum of
American culture and artistic practice; some are the result of very spe-
cific cultural traditions. Cherokee cultural critic and spokeswoman
Rayna Green has observed that for Native Americans "making art that
crosses boundaries constitutes one way of fighting back and reclaiming
culture, redefining it for ourselves. It is the voice of survival, persis-
tence, and cultural self-definition."[22] Similarly, critic and historian
Tomas Ybarra-Frausto points out that because Chicano art is seen as
"going against mainstream cultural traditions of art as escape and com-
modity, [the art object] should provide aesthetic pleasure while also
serving to educate and edify. Chicano art is envisioned as a model for
freedom."[23]

Still other forms of resistance are gender specific. Naomi Schor's
Reading in Detail is a (detailed) analysis of the ways in which detail has
been configured and criticized as decadent, superfluous, contingent,
negative, and above all feminine. Associated with such mid-nineteenth-
century phenomena as secularization, democratization, and the "inven-
tion of the quotidian," the detail was configured in opposition to the
Ideal, the Sublime, the Classical.[24] Schor underscores that what is most
threatening about the detail is "its tendency to subvert an internal hier-
archic ordering of the work of art which clearly subordinates the pe-
riphery to the center, the accessory to the principal, the foreground to
the background."[25] (Any similarity to events and situations outside the
art world is purely coincidental.) Surely, there is no *real* relationship be-
tween art and politics.

Trying to unravel the Gordian knot that confounds the terms "high"
and "low," "mass" and "popular," "folk" and "fine" is a formidable task.
Those who might like to try their hand at it are stopped by multiple and

overlapping definitions that sound as though they'd been formulated by kids playing a particularly rowdy game of "Mother May I Cross Over?" And classifications are tricky things in and of themselves, especially since they're usually used to rank people and practices considered inferior for being most unlike those of the classifier.[26] Perhaps this explains why so much time and effort are spent by the majority of the art audience—largely composed of upper-middle-class, educated whites—mulling over what belongs where in the lexicon of art forms and formulating endless categorical imperatives for different types of work.[27] While artists also can participate in categorical and systemic formulations, they tend to be less rigidly bound by them, understanding that the meaning of any body of work will always change with the context the work is seen in. Viewers who aren't part of the professional art world probably won't care which pieces fit into which categories either, especially if they're having a good time just looking at it.

"LOVELY TO LOOK AT, DELIGHTFUL TO HOLD . . . "

At the turn of the previous century, the simplicity, honesty, integrity, and functionality that were considered integral to the craft idiom linked it to work and the practicality of everyday life, making the fin de siècle practice of crafts seem both aesthetically desirable and socially ethical. Promoted as antitechnological, as the process and product of the hand alone, the craft ethic accorded well with the new turn-of-the-century emphasis on clean, functional design as a moral characteristic. Writing in 1968, David Pye cogently defined the differences between kinds of workmanship,[28] suggesting:

> [O]ur traditional ideas of workmanship originated along with our ideas of law in a time when people were few and the things they made were few also. For age after age the evidence of man's work showed insignificantly on the huge background of unmodified nature. There was then no thought of distinguishing between works of art and other works, for works and art were synonymous.[29]

Surely today's crafts practitioners must feel a sense of loss that this is no longer so. In protest, many see themselves at the opposite end of the spectrum from the fine arts, whose acolytes seem permanently wedded to avant-garde strategies and concepts of innovation. It falls to the

crafts to plug the dike, saving tradition from the threatening forces of change with a single finger. But the possibility that traditions themselves are subject to change unsettles the tradition/innovation dichotomy and, consequently, has been an issue at the heart of many of the crafts debates.[30]

Pye, unlike most of his counterparts in the previous century (and many in this one as well), saw crafts as a complement to industry, rather than in opposition to it.[31] Furthermore, he argued, fine arts and craft are not in the same league, because craft competes with the market for inexpensively manufactured objects of the same kind, which is not true of the fine arts. Pye claimed that people tend to think of crafts as "hairy cloth and gritty pots," but crafts are actually closer to the manufacturing industry than to the fine arts; they can compete, therefore, only on the grounds of exceedingly high quality.[32]

Because such craft work takes a considerable amount of time to achieve, Pye concluded that it needs to be motivated by love and not money, and he urged craftspeople, like poets and painters, to earn their living by doing other work. Pye's support for the "true" amateur, whom he described as a part-time professional, expanded the definition of the crafts practitioner, and by extension, of the artist. In his view, "'amateur' after all, means by derivation a man who does a job for the love of it rather than for money, and that happens also to be the definition, or at least the prerequisite, of a good workman."[33] That this is hardly the generally accepted use of the term seems obvious, since it's often employed disparagingly to describe artists whose work doesn't accord with still prevalent romantic notions of what an artist is and does. But "amateur" is never the word used to describe those untrained or "self-taught" artists who produce the very collectable commodity called folk art.

"SOMEONE TO WATCH OVER ME . . . "

Coming from a fine arts background, I had a monolithic idea of "folk art." But the field is far more complex and diverse than the term suggests. Briefly stated, it divides into several main camps. One is the work first "discovered" by modern American artists, and then collectors, in the early decades of the twentieth century and appreciated largely because of its similarity to the contemporary art they themselves were making or buying.[34] Its makers, while untrained, were mostly white and

not necessarily poor and included "primitive" painters and sculptors, quilters, decoy and weathervane makers, and artisans working in metal, wood, and ceramic. The simplicity, straightforwardness, and stylistic innovation of folk art forms connected them to a modernist high art aesthetic.

As modernism developed and claimed its own adherents, folk art became valued not so much for its innovation as for its connection to tradition. In this model, championed by collectors like Holger Cahill and Jean Lipman, folk art was seen as historical artifact, consisting of pure forms that were no longer practiced once the old traditions succumbed to the lures and demands of mechanization. Like craft, folk art was seen in relation to notions of "the common man," promising freshness, simplicity, honesty, and unselfconsciousness, qualities threatened by urbanization and industrialization.

Another group consists of those folklorists who believe that folk art and objects are traditional, passed down from generation to generation by practitioners living in closed communities. In this ethnographic model, communal, rather than individual, ideas predominate, creating a particular, distinctive style such as those found in Shaker, Mennonite, or Amish religious communities or in the "ethnic" art of immigrant cultures. This work is made by people from many races and backgrounds, most of whom did time on the lower rungs of the economic ladder when they first arrived in the United States. While viewed suspiciously by those descendants of English immigrants who considered themselves to be the only *real* Americans, ultimately this work became part and parcel of what constitutes American culture today.

In the 1970s, ideological battles broke out between the folklorist/communal/traditional people on one side, and the art historical/individualist/fine art people on the other. In the 1980s, the field splintered further when Herbert Hemphill and Michael and Julie Hall began to collect oddball, quirky pieces by living untrained artists, work that traditionalists were unwilling to consider folk art at all. Today, folklorists like Michael Owen Jones, who studies housing tracts and corporate organizational behavior as folklore, have split the folk art world in unpredictable ways once again.[35]

In Europe, the idea of a "folk" tradition was a late eighteenth-century romantic notion. It was popularized through the work of Johann Gottfried Herder, a Prussian doctor and theologian who made folklore and folksong the basis of national character, encapsulating his theories in

Outlines of a Philosophy of the History of Humankind (1784–1791).
He developed a democratic, anti-Enlightenment rationale based on
the creative accomplishments of common people, which was in-
tended to provide a foundation for national culture by proceeding
from the local to the national to the global.[36] His views would later
be appropriated by Nazi ideologists, who turned them into a support
structure for the racism, anti-Semitism, and fervid nationalism that
ultimately resulted in the Holocaust. That Herder himself was an
anti-Semite doesn't help today's reader to separate out his views from
those of his appropriators.

But Herder's original concept of the relationship between folk art and
national identity is the operable one in America, where folk art was and
still is considered "the representative art of the American nation [and is]
thought to embody the vision and accomplishment of the common
American. Folk art is believed to be an everyday art form, made by or-
dinary people from the materials of everyday life [and] said to evidence
the positive attitudes and values of an individualistic, unpretentious, and
democratic nation."[37]

Folk and outsider arts have paradoxically also been defined in terms
of their difference from mainstream fine arts, indicating the extent to
which their presence as "other" functions to reaffirm and maintain the
premise of high art. As Eugene Metcalf suggests, the establishment of
a separate folk category is a way of preserving the status and power of
the leisure class by creating a "dumping ground" for all maverick
forms of expression by artists who don't share the high art values of
that portion of society and might therefore pose a potential threat to
it.[38]

"ARE YOU WARM, ARE YOU REAL, MONA LISA? . . . "

Nevertheless, here as in the high-art discourse, authenticity plays a cen-
tral role. For the folk and outsider art community, authenticity is not a
matter of whether a particular artist actually executed the work in ques-
tion, but whether the artist is personally "authentic," that is, visionary,
honest, pure—untainted by the values of the high art community or by
any cultural or material concerns whatsoever.

For many curators and collectors of folk and outsider art today, au-
thenticity is seen as indigenous to non-Western art.[39] For others, au-

thenticity, while not necessarily confined to "outside" cultures or to the sanitarium, has become a rare commodity because it is seen as being in jeopardy. There's been some discussion, for example, about the dilemma of using drugs to treat schizophrenia, because it might alter, if not eliminate altogether, the production of outsider art.[40] Jane Livingston, in a recent essay on folk art, warns that there is "a possibility that we are dealing with a truly dying cultural form," that "the sense remains that the end of a precious tradition is drawing near."[41] For others, though, there's no sense in bemoaning the loss of an authentic folk culture because in capitalist societies, unlike tribal or folk societies, people don't produce their own commodities, so there's no authentic folk culture to lose.[42]

The concept of authenticity in contemporary folk art literature—the formulation of an innocent, pure, "primitive" other—is a metaphor of colonization strikingly parallel to what ethnographer James Clifford calls "the salvage paradigm." Saving the artifacts of a dying culture for posterity is a means through which the exoticized "other" can be appropriated, collected, and preserved.[43] Like the increasing popularity and frequency of railroad travel to the "wild" West and passenger steamship travel abroad in the late nineteenth century, this overwhelming fascination with the exotic was motivated by escapism. Metropolitan Museum of Art curator Lowry Sims, discussing the celebration of manual work in the African American tradition, has argued that the search for authenticity may be an attempt to "counteract the perception of widespread social, political, and economic excesses" of the 1980s.[44] And Susan Larsen, in an impassioned analysis of how and why self-taught artists have been isolated from the mainstream, maintains that "this art sings a siren's song of freedom and as such is a seductive influence to an art world grown overripe, increasingly uncertain of its direction and hungry for an infusion of energy from some source at once alien and yet accessible."[45] My own feeling is that the search for "authenticity," like the insistence on "quality," camouflages issues of power; whoever gets to define it (and gets others to believe the definition), controls it.

"SHE'S AN ARTIST, SHE DON'T LOOK BACK . . . "

In the establishment and application of definitions, women have been on the receiving end; they were no more players in the romantic scenario

than they were in the late 1950s Greenbergian one. Nineteenth-century women were excluded from formal art schools and training, and the art they made—quilting, embroidery, knitting, sewing, crocheting, and the like—was relegated to the domestic, the useful, and the everyday, rather than elevated to the exalted or sublime spheres of high art.[46] These same distinctions and hierarchies of value are still at work today in the museums and art markets of the world.[47]

Many of the skills employed to make handcrafted, or highly detailed, or labor-intensive and time-consuming pieces have traditionally been considered women's work. Because they were made within the domestic, rather than the public, sphere, were done for love rather than money,[48] or were simply done by women (deemed incapable of creating great art), these handicrafts were ipso facto inferior to fine art, made in the public sphere for money by men.[49] It followed that in the world of crafts, embroidery had a lower status because of its unique identification with the feminine. William Morris's daughter May, reviewing a major exhibition of medieval embroidery that opened in London in 1905, commented on how surprised people were to see such fine work in this medium, considering their unquestioning assumption of quality in the other arts of the same period.[50]

Roszika Parker, in her 1984 study *The Subversive Stitch*, argues that beginning with the Renaissance, the construction of the concept of femininity and the separation of fine art from crafts coincided; they were reflected later, in the eighteenth century, by changes in art education, particularly from craft-based workshops to academies, each consigned to the "appropriate" gender.[51] In antebellum America the separation of men and women's realms became so extreme that virtually all activities except for travel, writing, and getting oneself published were strictly gendered.[52] A society that "required women to be ornamental" threatened those women who in any way resisted or deviated from the requirement with being mocked as "coarse, ugly, even monstrous."[53] No middle ground there.

The Arts and Crafts Movement approached the female problem laterally with a kind of "mental health through domestic design" attitude. Bolstering artistic claims with a seductive appeal to women's rights, house design based on Arts and Crafts principles purported to relieve the housewife of drudgery and provide increased interaction between family members. A 1905 article in Stickley's magazine, *The Crafts-*

man, announced, "Woman is a slave, and must remain so as long as ever our present domestic system is maintained. . . . [E]very additional object in a house requires additional dusting, cleaning, repairing, and lucky you are if its requirements stop there."[54] While this pronouncement may not have contributed much to the fight for women's suffrage, it was at least a recognition of the difference in gendered roles of the period.

When not occupied with dusting and polishing and sweeping and mopping, women were able to find genuine social pleasure while gathering together to sew, knit, embroider, quilt, crochet, and mend, because they were also able to talk to each other. With the widespread use of the sewing machine by the 1860s, however, a once-shared activity became a solitary one. For women the social body began to dissolve into the clatter of machines originally intended to reduce drudgery.

Tapestry, embroidery, needlepoint, and such were much admired from the Renaissance to the late nineteenth century because they were seen as evidence of upper-class leisure and wealth. With the Industrial Revolution, however, these kinds of "female" activities, requiring fine motor skills, dexterity, patience, and of course, good eyesight, came to be considered just work, rather than art. Women's products, particularly embroidery, were dismissed as decorative, "pretty," or mindless, that is, without content. But according to all accounts and as most personal experience confirms, what actually happens is that the meditative and self-contained quality of this kind of work reclaims and interiorizes the mind and body, returning them to the sole proprietorship of their owner. For women, as for the incarcerated, time and work can, for brief or long periods, become one's own.

In the early days of the Women's Movement, circa 1969, "feminist" work was winning out (publicly, at least) over such forms of "feminine" activity as knitting, sewing, needlework, and the like. That these same forms could today be the object of such intense theoretical scrutiny and debate, as well as the locus of political engagement and resistance, is a tribute to the dynamic and self-critical nature of feminism. *A Labor of Love* includes both male and female artists who quilt, embroider, knit, crochet, sew, bead, appliqué, and needlepoint. That so many contemporary artists have recouped these traditional skills and materials and used them to newly trenchant and generative ends indicates just how saturated with meaning they remain.[55]

"FAR-AWAY PLACES WITH
STRANGE-SOUNDING NAMES . . ."

The historian Kenneth Ames, talking about how and why people classify others, identifies two primary and undoubtedly universal categories: men and women, us and them.[56] Both groupings played a major part in gender, class, and racial divisions at the end of the nineteenth century. In the frantic avoidance of these problems, a cult of Americanism emerged, bolstering hostility to things foreign by an essentialist and ethnocentric sense of unity.[57] Paradoxically, the exotic or "primitive" qualities that Americans both sought and at the same time dismissed were not to be found among their own kind—the white, urban, male, sane "us"—but in things foreign—the not-white, rural, female, insane "them."[58] This love-hate relationship with difference caused white, well-to-do Americans to label all art made outside their own cultural traditions as folk art,[59] while at the same time they hungrily bought it up as quickly as possible, and at a good price, too.

M. H. Dunlop's extraordinary account of nineteenth-century travels to the American interior recounts, for instance, the ways in which Native American art and artifacts were acquired.

> Travelers cast the sharp eye of the international shopper on the products of Indian hands, drove sharp bargains for those goods despite the sellers' obvious poverty, and on occasion bought what they wanted directly from the bodies of the sellers . . . rejecting what an Indian offered for sale and instead demanding an object or a garment that was obviously too significant or essential to be up for sale. When travelers came upon an Indian settlement whose occupants were temporarily absent, they ransacked it, stole from it, and destroyed anything they did not carry away. Travelers seemed to operate on the theory that the fewer the possessions the less was a person's right to keep them; only non-Indian possessors of many objects could insist upon ownership and value.[60]

The attitude of travelers toward the objects they acquired was highly ambivalent: Dunlop cites the account of one woman who "found Indian needlework excellent—and bought plenty of it—while simultaneously judging it 'deficient in taste and knowledge of design,'" as well as overly colorful.[61]

But what was this art to its makers? Then as now, Indian objects were statements of collective and communal values as much as they

were individual statements. "To put your name forth via a material object," says Rayna Green, "is to engage in the survival of your people."[62] The process of making was at once the embodiment and confirmation of tradition, a distinct way of seeing the world. Ironically, it was also an attitude once shared by Europeans, at least until the advent of the Renaissance, when individualism, uniqueness, and universality came to be asserted as Western and inherently superior paradigms.[63] Cultural misunderstandings and slippages of this kind can be found everywhere and are certainly not confined to a single culture, much less an Anglo-American one. Virtually all contemporary cultures are hybrid or "impure," but the legacy of the Enlightenment is particularly prevalent in the West, where expressive modes deriving from other traditions are downplayed or ignored.

In Chicano culture, as with Native Americans, art objects and social contexts, artistic practice and everyday life, are inseparable. Both folk and fine art are hybrid, transformational, living forms, "a visual narration of cultural negotiation" among multiple class-based and regional and national traditions.[64] Vernacular art forms deriving from religious icons and images, calendars, posters and advertisements and the artifacts of youth culture continue to influence contemporary Chicano art. But like "Hispanic" art in general, it's often seen by mainstream critics as colorful, folkloric, decorative, and lacking in content.[65]

Take for example *rasquachismo*, an attitude, taste, or stance that Tomas Ybarra-Frausto describes as "rooted in Chicano structures of thinking, feeling and aesthetic choice [and] a visceral response to lived reality."[66] A prevalent form of vernacular, it is likely to be unfamiliar to the viewer from another culture or to be misunderstood.

> In the realm of taste, to be rasquache is to be unfettered and unrestrained, to favor the elaborate over the simple, the flamboyant over the severe. Bright colors (chillantes) are preferred to sombre, high intensity to low, the shimmering and sparkling to the muted and subdued. The rasquache inclination piles pattern on pattern, filling all available space with bold display. Ornamentation and elaboration prevail, joined to a delight for texture and sensuous surface.[67]

Overstatement, alien to an Anglo-modernist sensibility, is also rejected by the Chicano middle class, in much the same way my own second-generation Russian-Polish Jewish parents recoiled in horror from the spectacle of Borscht-belt comedians or scoffed at the *nouvelle* Yiddish

harmonizations of the Andrews Sisters. *Rasquache* is a sensibility that, in the hands of the contemporary Chicano and Chicana artists, is a double-edged sword, collapsing visual seduction and formal subversion into each other to drive critical commentary home.

Equally misunderstood, Asian art was highly valued in the West as exotic artifact (still a giant step down from fine art), an idea reinforced by collectors returning from late nineteenth-century forays to the far-off, exotic lands of the Orient with new acquisitions. Asian art traditions, of course, vary greatly, and one can scarcely lump together the many cultures, languages, and traditions of the entire continent. But that didn't stop nineteenth-century Americans from trying. At the end of the century (and well into the present one), they voraciously acquired the art of the Asian peoples to whom they at the same time attributed an inferior physiognomy, unclean social practices, strange manners and dress, use of pidgin English, "barbaric" eating habits, and dubious ethical practices.[68] I remember clearly how, when I was a child, second-generation Jewish families like mine religiously "ate Chinese" on Sunday nights with a pleasure that contrasted starkly with an embarrassingly voluble, pointed criticism of the restaurant's hygiene, the waiter's temperament, the outspoken mistrust of dishes never tried, and so forth.

Throughout most of Asia there is a deep interweaving of art and everyday activities. Precisely because a wide variety of Asian art forms and practices were inseparable from each other, they were particularly apt to be subsumed by the West under the heading of "curio." (Hence the "cabinet of curiosities," that peculiar display form in which, up until the twentieth century, "strange" and rare objects from disparate places, customs, and practices were apt to be jumbled together.[69]) In India, for example, "ritual practice, education, commerce and pleasure are interwoven and arguably more completely and appropriately understood than when considered in isolation."[70] In Japan, craftspeople and performers can be designated as living treasures, and the culinary arts are on a par with other "fine" arts whose remarkable range includes gardening and package, automobile, and fashion design, not to mention archery, woodcarving, pottery, architecture, and flower arranging.

Contemporary Asian American artists, unwilling to have their work crammed willy-nilly into a single category or style or confined within any kind of artistic boundaries, are deliberately exploring "multiple, layered, and even contradictory identities"[71] in the process

of self-definition. And this means using and adapting the artistic skills of their individual, specific cultural traditions in order to speak to critical issues outside those traditions.

"THAT OLD BLACK MAGIC HAS ME IN ITS SPELL . . ."

The adaptation of past to present can be seen clearly in the melding of various African folk traditions with those of the countries to which Africans were originally transported and exiled as slaves. Among the many artisanal skills brought with those who survived the Middle Passage were blacksmithing, goldsmithing, pottery, beading and macramé, woodcarving, weaving, dying and appliqué; these skills were widely used by slaves on plantations, although credit for them and ownership of their products were more often than not claimed by whites. Nonetheless, they were handed down over generations by African American descendants of slaves; today, the most neglected kinds of black folk art are those utilitarian objects, because, as Metcalf says, they "represent useful work that has not been performed at the behest and for the benefit of the leisure class."[72] More than the skills themselves, Africans brought with them an ethos in which material culture and everyday life were inextricable and which runs counter to the modernist ideology that divides the creative and the quotidian into separate spheres of activity and thought.

In effect, the extensive contributions of African American painters and sculptors from the 1850s on have been invisible until recently, so that the fine arts world, for the most part, equated art by African Americans with popular art and folk art, an attitude that carries over to the present. This exemplifies the class distinctions that are called into service to keep their work controlled and out of the marketplace. Such marginalization, of course, isn't limited to artists from non-Western backgrounds. Artists of Western and Anglo-European descent as well have been able to draw on their own cultural histories to locate and carry forward artistic practices in which the quotidian and the artistic are inextricably interwoven. But because their work is not marketed to the high art audience, it also is effectively kept off the playing field.

The melding of the two spheres is most obvious in music, where it is scarcely contested; even classical music, seemingly so removed from the everyday because of its association with the upper classes, was

common fare during its own period. Like art critics, ethnomusicologists seem to be divided between those who feel that tradition itself is constantly growing and changing (and that therefore "folk" music continues to be written and performed today), and those who consider it immutable. Folk musicians, like folk artists, are seen by the latter camp as either living within the tradition (i.e., untrained, rural, impoverished, and thus "authentic") or as of necessity attempting an end-run "return" to the past, struggling to recapture it—second best, but almost as good as the real thing.

American folk music is (or was, depending on the musicologist's persuasion) ultimately the result of the blending of many cultural traditions, including Anglo-Celtic, Hispanic and Latino, and African and African American. Common to all the cultural traditions in American folk music is a deep and abiding connection to lived reality, from the slave songs of the antebellum South to the tragic love ballads of the Mexican *vaqueros* in the early decades of the twentieth century. Folk music set moral and ethical standards; it mitigated the loneliness of cowboys, sailors, and miners; it established rhythms for stowing cotton, hauling line, cutting lumber, taming broncos, laying track, weaving, spinning, dyeing, stamping, digging; it gave people a sense of unity and shared experience. As a tool for cultural as well as personal survival, folk music was, and continues to be, a means of transmission for crucial values, memories, and practices that can't be taken away from its makers.

"AS TIME GOES BY . . . "

Time passes quickly when you're singing; hard work seems less painful, repetition less boring; feelings of loneliness and isolation melt away in the melding of voices. The sense of community created through shared song is well known and exploited by virtually everyone from kindergarten teachers to dictators. Is it any wonder that U.S. appropriations for military bands hold firm while the National Endowment for the Arts is being gutted? Music is used right and left to support and inspire revolutions, as well as to prevent them.

To say time flies means that it ceases to have any specificity or urgency. Westerners tend to think of this as meditative—what happens when you've gone exploring in the computer, or you're deep into a re-

ally good book, or falling madly in love. It's unusual, something other than the ordinary temporal sensibility that gets us to work, the kids to school, the assignments done, the dinner on the table. How paradoxical, then, that the most rewarding and satisfying activities are those in which it seems as if time ceases to exist.[73]

The way people in any given culture think about time seems natural to them, but the experience of time is a highly variable process. In America, people living in the same household can have entirely different concepts of time because of differences in internal proprioceptors or processing mechanisms. Thus, older people experience time as moving faster than young ones do. People from different cultures have altogether mutually incomprehensible attitudes toward time. For example, if you believe that the past must be kept alive in order to experience the present, as is common in the Near East, time will appear to slow down.[74] Arriving "on time" in São Paolo may mean a two- to three-hour leeway; in Cologne, you'd be perceived as incredibly rude if you were twenty minutes late.

Since labor-intensive and handmade works of art take a long time to make—sometimes a *very* long time—they seem to be at odds with the evolutionary, progressive, monochronic sense of time that informs the high art tradition. (Liza Lou was asked by someone, clearly overcome at seeing her beaded kitchen, "When do you find the time to do all this?") It's quite different from polychronic time, which is interactive, multitasked, social, and in flux, rather than linear or goal-oriented. It's the kind of time experienced in the long and complex processes of embroidering, lace-making, knitting, and quilting. Polychronic time is inherently nonhierarchic and doesn't lend itself to scheduling or prioritizing in the way that monochronic time does. The "outsider" artist, for whom time is not likely to be experienced monochronically, is therefore said to be disconnected from a sense of temporality altogether.[75]

Polychronic time weaves the past and present together, connecting the spiritual with the material dimensions of life. In the West, this sense of temporality is found most clearly in the religious communities of the Amish, Shakers, and Mennonites, who pursue a simple, harmonious way of life and make beautiful objects for everyday use. For them, as for Native Americans, the products of the hand and mind are inseparable. Work is creation, creation work. Through objects, spiritual traditions and communal values and practices are brought forward into the present.

"I'M ALL SHOOK UP . . . "

Just as Arts and Crafts reformist ideology was bound up in racial and class anxieties of the nineteenth-century bourgeoisie who felt threatened by the proliferation of socialists, anarchists, and immigrants,[76] today's attacks on contemporary art reflect similar anxieties, barely cloaking a deep fear of art's ability to upset the apple cart. Lynne Cheney, former chairman of the National Endowment for the Humanities, complained in hearings that the arts "have become highly politicized. Many academics and artists now see their purpose not as revealing truth or beauty, but as achieving social and political transformation."[77] But whose idea of truth or beauty does this mean? Does the fact that American culture consists of people from widely varied cultural and intellectual backgrounds mean that the art they produce is inherently "political"? Under any circumstances, the artists that Cheney disparages have a number of characteristics in common that put them at odds with the romantic ideals of individualism, uniqueness, and originality, particularly as these are represented by the firm of Cheney, Greenberg, Bennett, and Kramer,[78] specialists in intrinsically valuable, disengaged, high art products in the Western tradition.

My point is that the maintenance of rigid categories and hierarchies of art making is today, as it was at the turn of the century, a conservative project. Through the fixing of certain artistic practices and products in time, according them universal characteristics, and perpetuating them as *the* cultural paradigm, these selected forms of art making are kept in a separate and isolated sphere, away from the great majority of people for whom, not surprisingly, they seem to have little or no relevance. Art that raises disturbing questions about society—about race, gender relations, economic issues, moral or religious beliefs—is dismissed as propaganda because it threatens existing power relations. Abstract or nonobjective work ("pure" painting), being free of representational subject matter altogether, seems much safer, much farther away from the exigencies of everyday life, but still runs the risk of being incomprehensible to everyone except the experts. And craft and decorative arts, folk art, "outsider" art, and popular culture are separated out and marginalized as "other" by virtue of class; they're named and controlled not from within, but from without, in order to safeguard the artistic "us" from the unenlightened "them."

The issue, then, is not that one kind of artwork is better than another, since all work operates in multiple ways, in a variety of contexts. But

it's a fundamental tenet of those working in the interdisciplinary area of cultural studies that nothing—no object, artistic practice, or type of work—has an intrinsic or fixed value, function, or meaning; all are subject to the vagaries of variable and changing social relations and ways of making meaning known.[79] It's art and culture that simply don't have the appearance of neutrality that threaten the status quo. What is considered by neoconservatives to be controversial work cuts across the cultural and class spectrum, so that it doesn't matter whether the work is "high" or "low," accessible or not, nonobjective or image-based.

Underlying the desire to separate out certain kinds of art making is a deeply antidemocratic impulse, an ironic accompaniment to the "my kid could do this" attitude. Because the limited arena of "fine art" is largely foreign to the nonprofessional viewer or ignores the idea of there being such a viewer entirely, it gives art a bad rep outside the art world. And this limits and constrains the public's experience of all kinds of art. Granted, there are no new categories for work which falls into the interstices, but I'd be the last to sponsor a "Name That Category" contest to see if it could, like "Pattern and Decoration," or "Op-Art," have its fifteen minutes of (dubious) fame.

"SO LONG, IT'S BEEN GOOD TO KNOW YOU . . . "

I'm not trying to say that there is *no* difference at all between art and life, aesthetics and politics. Nor do I believe that folk and fine, high and popular, art are the same; there are differences in the relation of making to community; differences in intent and value; in function and in form, purpose, training, context, opportunity, reception, and the like, that are neither simple nor singular. But when works of art elude and thus destabilize accepted categories, they encourage us to think about how, when, and for what purpose the categories were created.

As Howard Becker points out, "distinctions between . . . kinds of art are not distinctions of quality; work of every degree of interest can be and has been made in every category."[80]

The difficulties mavericks and naïve artists have making their works and getting them distributed, their difficulties with audiences and authorities, indicate the troubles integrated professionals are spared by participating in art worlds recognized as legitimate parts of society. The dif-

ference between the work of integrated professionals, mavericks, folk
artists, and naïve artists does not lie in its surface appearance . . . but in
the relation between that work and work done by others more or less in-
volved in some art world.[81]

What's at stake? Why keep the doors closed? There are no inherent
boundaries in art making, at least none that aren't created by our social
concerns, interests, needs, and values.[82] Boundaries are created because
some people need them to be there, somewhat like temporary drawer di-
viders. Some of us prefer to keep our socks separate from our under-
wear, but it's not one of life's necessities; you can still get dressed in the
morning. No more do works of art have to look a certain way to help
change the way people see and experience the world.

But because different types of art have come to be differently valued
as a result of distinctions based on race, class, and gender, the one has
an effect on the other. Aesthetic border crossings and social destratifi-
cation have more than a passing acquaintance. Is it any wonder that the
NEA has been brought to its knees by people both outside and inside the
art world promoting a specific "family," "Christian," or "Western" hier-
archy of values? On the one hand, *real* politicos like Cheney and Ben-
nett accuse publicly funded art of being "political," when nothing could
be *more* political than their own attacks on art. Along with a number of
congressmen, senators, religious leaders, pundits, and opportunists who
don't know or care about art, they use it solely for career advancement
or to promote racist, misogynous, and homophobic agendas, not to en-
courage informed debates. On the other hand, professional critics who
attack contemporary art from within, like Hilton Kramer of *The New
Criterion* or Arlene Croce of the *New Yorker*, are upset by its democra-
tizing potential. They long for the good old days when museums were
elite, audiences small, galleries few, artists selectively supported and
white, and the words of the high priests of the field went unchallenged
and underconstructed. The concept of talent and virtue being distributed
among ordinary people rather than being the province of the gifted few
is anathema to those who dread democratization, who see in the death
of "quality"—that absolute monarch of Ultimate Value—the death of a
social order which has been highly beneficial to them. That the latter
bunch is in bed with the former is testimony to just how cold the
weather out there has become.[83]

Labor intensive or handcrafted work, folk and outsider art aren't locked into an ideologically pure, outmoded time zone somewhere in the past, inert and neutralized. They're not necessarily nostalgic, nor are they ipso facto regressive. For me, and perhaps for many of you as well, this work is an invitation to engage in those larger dialogues that are important not only to the arts today, but to the health and well-being—dare I say the continued existence?—of American cultural life at large.

NOTES

1. Eugene W. Metcalf Jr., "The Politics of the Past in American Folk Art History," in *Folk Art and Art Worlds*, John Michael Vlach and Simon J. Bronner, eds. (Ann Arbor: UMI Research Press, 1986), 39. I have drawn heavily on Metcalf's writings on the history of folk art, the collecting and exhibition practices that engage with it, and his approach to material culture at large. My own views are informed by his critical—and still controversial—work in the field, to which I am greatly indebted.

2. T. J. Jackson Lears, *No Place of Grace: Anti-Modernism and the Transformation of American Culture, 1880–1920* (Chicago: The University of Chicago Press, 1994), 74. The period produced what Lears calls "a vast literature of complaint."

3. William Bennett, "The Case for Abolishing the National Endowment for the Arts and the National Endowment for the Humanities," written testimony delivered before the House Appropriations Subcommittee on the Interior, January 24, 1995, 3.

4. Quoted in Michael Bérubé, *Public Access: Literary Theory and American Cultural Politics* (London: Verso, 1994), epigram.

5. Lears, *No Place of Grace*, 307.

6. That this is so seems self-evident, but perhaps it will suffice to point to the existence, in separate buildings and parts of the city in New York alone, of The American Crafts Museum, The Museum of American Folk Art, The Cooper-Hewitt National Design Museum—not to mention The New Museum of Contemporary Art. The fact that there are also separate museums for work by Native Americans, Hispanic and Latino artists, African-American artists, and Asian artists, past and present, is another, not unrelated, matter.

7. For a discussion of the democratic, egalitarian, even revolutionary aspects of the Rococo style, see William Park, *The Idea of Rococo* (Newark: University of Delaware Press, 1992).

8. George Lipsitz, *Time Passages: Collective Memory and American Popular Culture* (Minneapolis: University of Minnesota Press, 1990), 13.

9. Lawrence Levine, *Highbrow/Lowbrow: The Emergence of Cultural Hierarchy in America* (Cambridge, Mass: Harvard University Press, 1988), 164.

10. Levine, *Highbrow/Lowbrow,* 163.

11. David Novitz, *The Boundaries of Art* (Philadelphia: Temple University Press, 1992), 22.

12. Joanne Cubbs, "The Artist as Outsider," in *The Artist Outsider: Creativity and the Boundaries of Culture,* Michael Hall and Eugene W. Metcalf Jr., with Roger Cardinal, eds. (Washington, D.C.: Smithsonian Institution Press, 1994), 79.

13. Quoted in John Fiske, *Understanding Popular Culture* (Boston: Unwin, 1989), 53.

14. Fiske, *Understanding Popular Culture,* 52.

15. Robert Storr, "No Joy in Mudville: Greenberg's Modernism Then and Now," in *Modern Art and Popular Culture: Readings in High & Low,* Kirk Varnedoe and Adam Gopnik, eds. (New York: Harry N. Abrams, 1990), 165. Storr's essay is a brilliant analysis and critique of Greenberg's ideas, influence, and politics.

16. Clement Greenberg, *Art and Culture* (Boston: Beacon Press, 1961), 3–21.

17. Greenberg, *Art and Culture,* 16.

18. The 1993 Whitney Biennial, organized by curator Elizabeth Sussman, was strongly criticized by many. See, for example, Hilton Kramer, "The Biennialized Whitney: Closed for Deconstruction," *The New York Observer* (March 29, 1993): 1, 19. The 1995 exhibition, organized by Klaus Kertess, was widely hailed as a refreshing antidote. See Paul Goldberger, "The Art of His Choosing," *The New York Times Magazine* (February, 26, 1995): 30–62.

19. Novitz, *The Boundaries of Art,* 182.

20. Fiske, *Understanding Popular Culture,* 161.

21. Henri Lefebvre, quoted in Fiske, *Understanding Popular Culture,* 35.

22. Rayna Green, lecture at The American Crafts Museum symposium, May 17, 1991.

23. Tomas Ybarra-Frausto, "The Chicano Movement/The Movement of Chicano Art," in *Exhibiting Cultures,* Ivan Karp and Stephen D. Lavine, eds. (Washington, D.C.: Smithsonian Institution Press, 1991), 128.

24. Naomi Schor, *Reading in Detail: Aesthetics and the Feminine* (New York: Routledge, 1989), 4, 15.

25. Schor, *Reading in Detail,* 20.

26. Kenneth Ames, "Outside Outsider Art," in *The Artist Outsider,* 261.

27. For example: "Through our research we identified a certain restricted range of expression among the outsiders that has intrigued five successive gen-

erations of artists in the twentieth century. That range of expression includes the following: a distinct compulsiveness, a visionary tone, a fusion of edgy uncertainty and anxiety with a firm certitude, a sense of exorcism, and the need and intent to get it out and place it down and to grasp and anchor the ephemeral. Such expressiveness verges on the hallucinogenic; it grapples with the unknowable; it does not—as is often the case with folk art—affirm the status quo." In "Introduction," Maurice Tuchman and Carol S. Eliel, *Parallel Visions: Modern Artists and Outsider Art* (Los Angeles and Princeton: Los Angeles County Museum of Art and Princeton University Press, 1992), 10.

28. David Pye, *The Nature and Art of Workmanship* (1968; Cambridge, Mass.: Cambridge University Press, 1988), 17. He distinguishes, for instance, between the "workmanship of risk," the "workmanship of certainty," and "regulated workmanship," the first being where the quality of the finished product is at issue throughout its making, the second where any "operative" applying its rules is unable to spoil the job, and the last whereby "the naked eye can detect no disparity between achievement and idea."

29. Pye, *Nature and Art,* 30.

30. Sylvia Kleinert, "Do We Have a Healthy Crafts 'Critical Culture'?" in *Craft 2000: The National Craft Conference* (Perth, Australia: Crafts Council of Australia, 1992), 31. The proceedings are also relevant to crafts issues in the United States, particularly as the discussions are both lively and complex.

31. However, as Joanne Cubbs pointed out to me, an interesting reversal occurs just after the turn of the century when artists like those working in the Bauhaus looked to the machine not only to democratize their ideals, but as a means of achieving a more austere and absolute (i.e., moral) aesthetic form. Thus, the ideal of the handmade evolved into that of the machine-made, while keeping the ideology of the former intact.

32. Pye, *Nature and Art,* 76–79.

33. Pye, *Nature and Art,* 78.

34. Eugene W. Metcalf Jr., "Artifacts and Cultural Meaning: The Ritual of Collecting American Folk Art," in *Living in a Material World*. Metcalf clearly elucidated the history of folk art that follows in "Confronting Contemporary Folk Art," in *Ties That Bind: Folk Art in Contemporary Culture* (Cincinnati, Ohio: The Contemporary Arts Center, 1987).

35. Michael Owen Jones, *Exploring Folk Art: Twenty Years of Thought on Craft, Work, and Aesthetics* (Ann Arbor: UMI Research Press, 1987) and Michael Owen Jones, Michael Morre, and Richard Snyder, eds., *Inside Organizations: Understanding the Human Dimension* (Newbury Park, Calif.: Sage Publications, 1988).

36. Gene Bluestein, *Poplore: Folk and Pop in American Culture* (Amherst, Mass.: University of Massachusetts Press, 1994), 30–56.

37. Metcalf, "Artifacts and Cultural Meaning," 221–222.

38. Eugene W. Metcalf Jr., "Black Art, Folk Art, and Social Control," *Winterthur Portfolio* 18 (1984): 287.

39. Maurice Tuchman and Carol Eliel, *Parallel Visions; Modern Artists and Outsider Art* (Los Angeles and Princeton: Los Angeles County Museum of Art and Princeton University Press, 1992), 10.

40. Eugene W. Metcalf Jr., "From Domination to Desire," in *The Artist Outsider*, 218–219.

41. Jane Livingston, "The Art of the Self-Taught/The Art of Our Time," in *Self-Taught Artists from 1940 to the Present* (New Orleans: New Orleans Museum of Art, 1993), 27.

42. Fiske, *Understanding Popular Culture*, 27.

43. James Clifford, "On Collecting Art and Culture," in *Out There: Marginalization and Contemporary Cultures,* Russell Ferguson et al., eds. (New York and Cambridge, Mass.: The New Museum of Contemporary Art and MIT Press, 1990), 141–169.

44. Lowery Stokes Sims, "Artists, Folk and Trained: An African-American Perspective," in *Self-Taught Artists,* 31.

45. Susan Larsen, "Art of the Self-Taught," 42.

46. Paul Lauter, "Working Class Women's Literature," in *Feminisms: An Anthology of Literary Theory and Criticism,* Robyn R. Warhol and Diane Price Herndl, eds. (New Brunswick, N.J.: Rutgers University Press, 1991), 845.

47. An interesting example can be found in a review of Ann Hamilton's exhibition at the Ruth Bloom Gallery in Los Angeles. David Greene writes: "Hamilton's work . . . calls to mind Faith Ringgold's quilts, a slew of nineteen-seventies feminist video and performance, and the whole history of installation art . . . but without the risk-taking that made much of that work interesting, if briefly. Instead, Hamilton signals the end of installation art as we know it: by making it decorative, she ushers installation into the realm of popular folk art." In *Art Issues* (September–October 1994): 42. Here's a fascinating conflation of categories placed under a single judgment call.

48. Parker, *The Subversive Stitch,* 5.

49. Linda Nochlin, *Women, Art, and Power* (New York: Harper & Row, 1988); Carol Duncan, "Virility and Domination in Early 20th Century Vanguard Painting," *Artforum* (December 1973): 30–39; Janet Wolff, *The Social Production of Art* (New York: Macmillan, 1981).

50. Parker, *The Subversive Stitch,* 39.

51. Parker, *The Subversive Stitch,* 5.

52. M. H. Dunlop, *Sixty Miles from Contentment: Traveling the Nineteenth-Century American Interior* (New York: Basic Books, 1995), 144. "Men and women had different work, had different access to money and amusement, spoke in groups about different subjects, wore different clothes, ate different food at different rates, were subject to different judgments on their looks, were

required to manage their bodies differently, had different manners and different addictions, had different access to both space and information, worked within different limits imposed on looking at and speaking of the other gender, and were subject to different degrees of definability. Among the few gender-neutral activities available, however, were traveling, writing, and getting oneself published. Anyone, regardless of age or gender, could be a travel writer and, sitting in gender-divided space, perform the gender-neutral activity of writing about gendered space."

53. Dunlop, *Sixty Miles,* 164.

54. Edward Carpenter, quoted in Coy L. Ludwig, *The Arts and Crafts Movement in New York State*, 27.

55. A 1994 exhibition entitled "Guys Who Sew," organized by Elizabeth Brown and Fran Seegall for the University of Santa Barbara Art Museum, clearly made this point.

56. Ames, "Outside Outsider Art," 261.

57. Eugene W. Metcalf Jr., lecture at the American Crafts Museum symposium, May 17, 1991.

58. Cubbs, "The Artist as Outsider," 89. Cubbs refers to "the relentless fetishizing of difference" in the construction of outsider art as a category.

59. Metcalf, lecture at the American Crafts Museum symposium.

60. Dunlop, *Sixty Miles*, 105.

61. Dunlop, *Sixty Miles,* 109–110.

62. Rayna Green, lecture at the American Crafts Museum symposium, May 17, 1991.

63. Rick West, director of the Museum of the American Indian, Washington, D.C., speaking at a panel organized by the Association of Art Museum Directors. "Why Do Art Museums Matter?" Friday, June 16, 1995.

64. Tomas Ybarra-Frausto, "Rasquachismo: A Chicano Sensibility," in *CARA/Chicano Art: Resistance and Affirmation* (Los Angeles: Wight Art Gallery, University of California, 1991), 147.

65. Ybarra-Frausto, "Rasquachismo," 146.

66. Ybarra-Frausto, "Rasquachismo," 155, 156.

67. Ybarra-Frausto, "Rasquachismo," 157.

68. John Kuo Wei Tchen, "Believing Is Seeing," in Margo MacHida, Vishakha Desai, and John K. Tchen, *Asian/America: Identities in Contemporary Asian American Art* (New York: The New Press and Asia Society Galleries, 1994), 17–18.

69. Clifford, "On Collecting," in *Out There*, 149.

70. Richard Kurin, "Cultural Conservation," in *Exhibiting Cultures: The Poetics and Politics of Museum Display*, Ivan Karp and Steven D. Lavine, eds. (Washington, D.C.: Smithsonian Institution Press, 1991), 319.

71. Tchen, "Believing," 22.

72. Metcalf, "Black Art," 288.

73. E. T. Hall, *The Dance of Life: The Other Dimension of Time* (New York: Doubleday, 1983), 148. A more critical and theoretical discussion of time is found in Johannes Fabian, *Time and the Other: How Anthropology Makes Its Object* (New York: Columbia University Press, 1983).

74. E. T. Hall, *Dance of Life*, 141.

75. Metcalf, "From Domination," 219. Metcalf describes how the modern concept of time is "viewed as a story of the progressive, evolutionary development of the social stages leading from savagery to civilization, a development which was now thought to be 'natural,' the outcome of the operation of scientific laws."

76. Lears, *No Place of Grace*, 70.

77. Lynne V. Cheney, chairman, National Endowment for the Humanities, 1986–1993, written testimony delivered before the House Appropriations Subcommittee on the Interior, January 24, 1995, 1.

78. Hilton Kramer, former *New York Times* art critic, editor of *The New Criterion*, and art writer for *The New York Observer*, has picked up where Clement Greenberg left off, taking romantic notions to a place where no man has ever gone before—at least not since Royal Cortissoz graced the field of art history with his particular brand of shortsightedness in the 1920s. Kramer's attacks on any and all art that purports to have a relationship with the larger world are by now legendary and make for lively, if not terribly informative, reading. These days, Kramer devotes much of his writing to separating art from "non-art," a Herculean task, but one that he feels singularly qualified to tackle. All nontraditional art making, all work that addresses social or political concerns (despite the precedents of Dürer, Goya, Picasso, etc.) or appropriates images or techniques from popular culture is suspect.

79. John Frow, *Cultural Studies and Cultural Value* (Oxford: Clarendon Press, 1995), 145.

80. Howard Becker, *Art Worlds* (Berkeley: University of California Press, 1984), 270.

81. Becker, *Art Worlds*, 269–270.

82. Novitz, *The Boundaries of Art,* 85.

83. Bluestein, *Poplore*, 22. Thanks also to Tim Yohn for additional background and analysis.

Elizabeth McGrath, Pose. Monofilament line and recycled batting, 32½ × 17¾ × 8 inches, 1996. Copyright Elizabeth McGrath. Photo by Eugene Binder Gallery.

8

Affectivity and Entropy: Production Aesthetics in Contemporary Sculpture

Johanna Drucker

A tension exists in contemporary sculpture between work that possesses seductive production values (looks good, is obviously well made, and has the degree of fine finish worthy of a showroom floor) and work that aggressively disregards these values (so that it looks like cast-off debris beneath the level of roadside junk). In both cases, I would argue, sculptors are struggling to make their attitudes towards production so conspicuous that they differentiate their work from other consumable objects of mainstream material culture in formal as well as conceptual terms. Whether contemporary sculptors make a show of attending not at all to formal, material values or attending too much to these values, they seem united in their efforts to use this self-consciousness to make clear that theirs is an art product. This suggests that no matter what a sculptor's work is about thematically, it is always trying to balance the values of production and the production of value(s). Paraphrased, this suggests a struggle to keep standards of making (fabrication, finish, the intrinsic worth of the stuff, and the finished quality of the reworked object) from becoming values that simply reinforce and reiterate the prevalent standards of the standard market for consumables in mainstream culture. At the same time, the object has to demonstrate enough value not to be dismissed from all aesthetic or critical notice.

Overall, this work pushes aside the shadow of negation that has been so central to contemporary art and its critical reception as a legacy of the classic avant-garde. The aesthetic differentiation this work embod-

This essay grew out of a talk at the University of Chicago in conjunction with the exhibition *Blunt Object* and the article "Thingness & Objecthood," published in *Sculpture*, April 1997.

ies presents an alternative to the values of mainstream consumer culture. A feature that distinguished work in the last decade of the 20th century from now-classic postmodern work—with its allegiances to a cool, critical, differentiation from the mass-culture objects it was at pains to critique—is an attitude that can only be described as affirmative.

The idea that affirmation is a viable premise on which to continue the romantic project of art as that which allows us to imagine otherwise is so unfamiliar that there is almost no critical scaffolding on which to begin its discussion. Much of the work I will discuss here enacts its transformations of the materials and objects used for its production through an enthusiastic engagement with studio practice, the flirtatious appreciation of artists for mass-culture artifacts and iconography, and a very positive playfulness. All are elements of an attitude that can't be adequately contained within the critical parameters of negativity. Nor can it be subsumed under a claim to be "political" in the old-fashioned sense that still floats through much of the rhetoric of contemporary art and critical practice. That rather simpleminded elision constrains the concept of political to a notion of instrumental transformation of institutions, sites, and relations of power and as an intervention in the symbolic order (with its considerably more distant, muted efficacy). Almost all contemporary art practice that claims to be political falls into the latter category, though the category struggles to pass itself off as "instrumental" in a way that falls apart at the first serious scrutiny. Clearly, an alternative theoretical foundation is needed that construes transformations and alternatives within the symbolic order as significant without requiring that they conform to a negative criticality.

This introduction is meant to frame the discussion of production values and to show that they embody a shift in attitude within artistic practice that calls for a radically different critical premise. This is an attempt to imagine otherwise, to think ourselves out of the cul-de-sac of received tradition and its adherence to a set of critical principles that simply don't apply (and haven't for a long time) to current work. Recent sculpture is no longer framed within the critical precepts of modernism and its supposed negativities.[1] The challenge is to think about recent work in a way that moves beyond this moribund critical legacy premised on refusals and rejections towards another, equally insightful but differently premised, critical point of view.

Writing about the late-1990s exhibition of sculpture she titled *Blunt Object*, curator Courtenay Smith used the phrase "latent entropy" to

describe the condition presented by several of the pieces. She was referring to an evident material contradiction in the works between their appearance of solidity and the fact that in many cases they were highly fragile. Alternatively, they gave the appearance of being tremendously ephemeral and delicate objects—though in fact many were virtually indestructible pieces made by new technological production processes whose longevity can be measured against the half-life of current landfills. Smith's emphasis was not on temporality or the physical life expectancy of these works, but on the interrelation between production values and the production of values in new sculpture. The challenge she identified is the one most fundamental to contemporary artists: how to make an image or object that has any clear identity as a work of art in the context of a culture of maxed-out consumption in its material and visual domains. How do you call attention to production as something that matters? In particular, how can production claim attention for itself as a defining element of a work of art when the high end of the spectrum of production values is populated by mass-produced objects? The idea of "latent entropy" suggests that though it may not be easy to maintain this stance of differentiation, a crucial aspect of making the attempt is to enact a strategy of displacement and transformation at the level of material production of the object. This strategy allows the aesthetic domain of art activity to effectively exercise a measure of critical transformation with respect to the broader cultural field of the production of objects.

Such strategies of differentiation, I suggest, gravitate towards two poles—that of "entropy," invoked by Smith, and the counterpole of "affectivity" invoked in my title. To understand the way these are defined, it is useful to invoke the classical Aristotelian distinction between form (as organization and structure) and matter (as that which is possessed of qualities, even without having form). In my discussion of sculpture, form is meant to carry the resonance of that philosophical legacy, particularly in the role it plays in making matter into something meaningful.[2] Transposed into contemporary parlance, these traditional concepts have become enriched with other critical attributes: the definition and understanding of matter is also imbued with the characteristics of materiality, with all the social and cultural implications the latter term invokes. Like form, matter can be read through semiotic and cultural codes in which its specific attributes are given some kind of value. Therefore, matter is never outside a cultural (economic and historical)

system of production, but always inscribed within it, as well as providing the substantive foundation of that system. That is, the value of any material comes through its place in a structural system, but the system has no means of articulating such values without the presence of material through which to do so. Form is the signifying configuration in my discussion, and matter the inherently valuable stuff. Form configures and thus pulls material into a system of meaning, but material provides a basis with intrinsic properties that can be worked upon. By linking this discussion back to the investigation of contemporary art and Smith's curatorial project, the dualism of form and matter as two variables that are always, in every work, in some specific (but distinct) relation to each other becomes apparent.

The distinction between affectivity and entropy embodies a contrast in approaches to production. In the first, affectivity, form is pushed to the fore to add extra value through organization, while in an entropic approach, matter insists upon itself in an attempt to undermine normative ideas of meaning. In current sculpture, this production aesthetic plays a crucial part in putting fine art on a viable footing with contemporary material culture. This is, of course, a longstanding issue. Far from cropping up as a symptom of late-1990s work, it has its roots within the foundation of modern art—itself always in dialogue with industrial production and commercial and popular culture. As I've written elsewhere, by the 1960s, with pop, minimalist, and, more importantly, conceptual art, a serious gesture of capitulation was made by fine art to the overwhelming superiority of the production values of material culture. At that historical moment, fine art retreated to the high ground of conceptual premises to distinguish fine art objects from material culture objects. What is interesting in this recent work is the shift back to an engagement with production as a viable means for articulating artistic identity for a sculptural object. This move builds on the solutions arrived at in postmodern sculpture, pushing them into new territory in an explicit enthusiasm for material culture.

I should also point out that I've deliberately identified the two poles of affectivity and entropy to echo the title of Wilhelm Worringer's famous essay of 1907, *Abstraction and Empathy*.[3] This is more than mere parody since the structural underpinnings of Worringer's approach were organized around the interpretation of form as a specific cultural response to a natural environment. I argue that the works in *Blunt Object* are specific responses to a cultural environment, each

working symbolically to describe a relationship to its natural-seeming systems of consumption and production.

Worringer sketched out two opposing poles of form, the geometric and the organic, and suggested that the first is created out of a response of fear of the natural world, the second as an expression of harmony with it. The geometric enacts an aesthetic of distance and control, the organic a synchronous ease of relations. Worringer had elicited his analysis from the study of motifs and patterns of decoration and device. His insights, reductive though they may be, belong to the phase of art historical scholarship intent upon finding meaning in style. In defining affectivity and entropy, my interest is not in providing a key to the meaning of forms, but rather, a way to understand how it is that a use of material can effectively show up—that is, register as significant—within the overwhelming field of other things. At base my argument is simply an attempt to understand how objects can answer the challenge to art posed by material culture. Art cannot possibly compete on its own terms, so it must arrive at some mode that belongs entirely to it. Affectivity and entropy are axes of critical insight along which art gestures slide the habits of thought into a condition of surprise to disturb the epistemological conventions. These are radical gestures, but not too radical, and the affirmative aspect of this new criticality marks its distance from the old-fashioned radicality of resistant avant-gardism, with its shrilly pitched defense of difficulty as the essence of resistant work.

The sculpture of mainstream 1980s postmodernism made clear that the aesthetic austerity that minimalism and conceptualism employed no longer served to provide an engaging formal basis for contemporary artists. The capitulations to consumer culture that came to the fore in the 1980s were overt in their flirtation with the material mainstream, even if they had a repressive quality in relation to the culture's explicit attitude towards pleasure. Modes of appropriation and display (Haim Steinbach) or fabrication (Jeff Koons) differentiated art works from commercial works through a self-consciousness about the framing effect of the gallery and the formal means of restructuring meaning through rearrangement and re-ordering. Other sculptors of the 1980s created a trash aesthetic as a comment on or alternative to the glitzy superficiality of material culture (Cady Noland and Mike Kelly). But to some extent, all of these artists kept a cool distance from the objects and world they commented upon. If Noland loved the aluminum cans in her installations or the rubbish in her pilfered supermarket cart or the cheap American flags that festooned a

work, she didn't show it. A sense of critical objectification pervaded her production, as it did Koons's supercilious self-indulgence in kitsch and Steinbach's designer-perfect eye. Even Kelly's fetishization of worn material wasn't about adoring the material culture origins of store-bought Steiff toys, but about the display of emotional history that had worn the fuzz off the felted eyes of the favorite crochet bear in his collection. Tellingly, none of these artists was involved in any serious tradition of studio practice. None was engaged with the transformation of matter into form, with any artisanal skill base, or with any addition of value through a process of facture in the largest sense of the term.

Thus, for all its apparent engagement with mass material culture, the sculptural mainstream of 1980s postmodernism maintained a degree of distance from it. This isn't surprising. This attitude continues the self-identified intellectual's disdain for television so familiar from the academy or art circle. Such postures of distance don't admit to the seductive intensity of contemporary material forms or objects. I mean, how can an artist make anything as amazing, in sheer production terms, as a pink plastic laundry basket from K-mart? This isn't a historical moment in which artisanal superiority resides within the artistic community so that its products can be readily distinguished from those of "low" culture. Artisanal skill is positioned in a very different spectrum of production values than those that characterized early modernism and the avant-garde. The cool critical stance belies, or at least qualifies, any charge of genuine attraction between the artist and the artifacts of mass culture. I am not suggesting that this is a false stance or that it enacts a critical bad faith—but I do want to suggest that the critical paradigm that emerges from the attitudes can't explain works that proceed from an affirmative or even qualifiedly positive relation to mass culture and its artifacts.

In the late 1990s, the urge to play with mass material culture on its own terms eclipsed the alienated critiques of earlier generations' resistant gestures. This is not to say that contemporary sculpture (or image production) is absolutely one with or indistinguishable from the mass culture with which it flirts so openly. Strategies of displacement and transformation remain crucial features of the art move, the distinguishing feature of a process that creates a space for reflection and criticism between perceived phenomena and the critical act of understanding. Social and cultural networks of production may overwhelm the casual consumer. But the artist's capability, what I am terming the affirmative, positive capability of the art move, is in the still potent capacity to jar

the familiar senses and cognitive channels long enough to produce a moment of dissonant sensation and insight. Not quite the avant-gardist's dream of social revolution or cultural transformation, but the continuing blip on the radar screen of otherwise complacent, complicit, or confused (un)consciousness in the dazed consumer-overload state of current culture.

Art practice is still a significant, institutionalized, cultural space in which such critical positions are articulated and rewarded. These attitudes serve as a major justification for the existence of an entire sphere of cultural production. Here again the terms of an affirmative criticality have not been clearly articulated, so we still suffer from the persistent model of negation within the aesthetic field—suffer because the model is inadequate descriptively and critically. It's easy to assert that artists should do things through materials, forms, and objects that succeed in performing and communicating some kind of displacement from the habitual modes of use in which they are encountered. It is another proposition altogether to construe the means of doing so in ways sufficiently effective to actually achieve such displacements.

The work in the *Blunt Object* exhibition is at once consumable and critical. The dreadful inflexible arbiters of avant-gardism, who dictated that to be important and political art must be difficult, are shown up as cheerless schoolmen of a new academicism by this work, since it has humor, lightness, and beauty and makes use of the qualities that make material culture attractive, rather than eschewing them in favor of dreary esotericism. This work dispenses with making a virtue out of difficulty, for its own sake, as if the reward were in the very resistance it offers, a too-Adorno-esque extreme that has come to be the hallmark of academic writing and academically acclaimed artistic practice.

But, if sculpture were to become too consumable, would it run the risk of simply passing for any other object, being absorbed and consumed without causing the least ripple in the surface of consciousness? How can art status and art identity be embodied in a piece, not merely by its place in the gallery setting or museum hall, that indicates the distinction between the art object and the thing of the world? This was the challenge originally answered by minimalism in the embrace of the least-gesture of distinction and difference (arrangement, configuration, displacement). With the upped ante of high-stakes materialism, a mere stack of bricks can't compete with a rack of barrettes or new running shoes for our attention.

Affectivity and entropy are intensified gestures of differentiation. Each defines a relation to the contemporary world of production and consumption that allows visual art to distinguish itself from mainstream consumer and material culture while still engaging with its very means. Rather than defining art as an entirely separate domain, affectivity and entropy suggest that fine art is a use, a way of working, a gesture of distinction, within the realm of material culture and of its objects, things, and stuff. Each describes a distinctly different mode of transformation.

The affective gesture puts material objects (or stuff, that is, cloth, string, things that are often shaped by use after they are purchased in bulk) into an organized construction. In so doing, the affective gesture brings the inert to life, it rehumanizes material, not in the romantic sense, but in a production sense. Affectivity gives material a sense of intention and form, of sentience and action; it shifts it out of the mere material while engaging with it, tweaking the stuff, making it active. Affectivity takes what looked like matter already formed and uses it as simple matter to give rise to another level of organization and structure. Thus, a laundry basket or a soap dish becomes the marble of the new sculpture and becomes organized into another level of form. Meanwhile, the associations invoked by the functional identity of these objects-as-material are also part of the final communicative whole of the piece.

Entropy, on the other hand, is a deconstruction of normative identity through material means. It demonstrates the effect of removing things from the system of production and consumption in which they normally circulate. By rendering objects nonuseful, the entropic gesture forces attention back onto its "mere" materiality as an object, as a thing, so that it can't be pulled back into the form of the usual "commodified" (and readily consumable) object. The affective gesture is active. It is the positive dynamic of doing; it is action on the processes and materials of consumption. The entropic gesture is passive. It is constituted by the negative dynamic of undoing and the taking apart of the processes and materials of consumption. Many look-alike precedents for this exist within the tradition of the modern readymade, the assemblage mode, the postmodern acts of appropriation and display. But the new modes of affectivity and entropy can be distinguished from these by the imaginative reuse to which they subject the materials and forms of these works. The postmodernism of the 1980s had no place for the massage of form and extraemotional seductive charge that affectivity adds to an object, any

more than it would have permitted the wanton deconstructive negativity of an entropic act. Neither affectivity nor entropy is about pulling materials of real life into art as a transgression of boundaries, as if to shock the fine art world by an act of material bad behavior. Those gestures belong to the classical period of modern art, in which the break with academic tradition was marked so clearly by a slumming-it superficial flirtation with mass culture, not a relation on terms of equality, or one in which the advantage is assumed to lie with the mass rather than the elite term.

This new work continues the exploration of nonorthodox materials that has been part of modern art and, in particular, 20th-century sculpture. Again, the significant point is that the underlying anxiety in the current climate of art production is how to make art count, how to make it show up on the culture screen. How, in fact, can any act of art making compete in a manner that is sufficiently interesting to be distinct from nonart products? In answering this question, the artists of *Blunt Object* have gone straight to the source of their anxiety and pleasure: they shop for their materials at Waldbaums, Stop and Shop, Home Depot, and Toys R Us, selecting the stuff of their production from the aisles of bright, vividly colored plastics, paints, and other already made things. No fine cherry wood, no Carrera marble, no bronze, no gold. The point of departure for production is mass-produced and processed stuff, generally plastic, synthetic, indestructible-seeming artifacts.

By the mid-1990s, sculptor Jessica Stockholder was using plastic laundry baskets, vivid latex paint, hardware, and general merchandise as the basis of a formal approach to installation-scale sculpture. A recognizable and distinctive feature of this work was its distance from the merely appropriative and display-oriented sculptures of the late 1980s, of which Haim Steinbach is exemplary. Steinbach's arrangements eschew the presence of hand or the transformative gestures of making or remaking. In short, Steinbach's work is separated from Stockholder's by his refusal to engage with studio practice or to let any of its trademarks show through in the final form of the work. No trace of hand or of artistic facture is present. They are systematically and conspicuously absent.

All the work in *Blunt Object* manifests some trace of studio practice as a part of its production, though often through materials or processes that would have been taboo as elements of studio work the last time production values were considered important to artistic objects. This would correspond to the handpainted phase of pop art, of late abstract expres-

sionist canvases and sculptures, and of assemblage and funk work. Feminist aesthetics and work invoking ethnic traditions also tended towards the evident display of studio practice, which usually meant handwork (though it would be a mistake to characterize all feminist or ethnically rooted art in this way). A stark division exists between work that foregrounds studio practice and work that aggressively represses or denies it. The latter category belongs to the definitive phase of New York postmodernism, from about 1979 through the early 1980s, in which "the photographic impulse" and implications of mechanical and distancing production held sway. Such work displays a conspicuous absence of affectivity, a deliberate absence of feeling, emotion, and even individual subjectivity.

A veritable catalogue of possibilities for reinventing traditions of art making and of shifting the relation of critical opposition to mass media into a different key can be enunciated, one in which the pleasures of consumption are an acknowledged part of aesthetic production rather than a repressed one. Both affectivity and entropy are part of a taking out of service of material, a displacement from the use and activity in which the material or object originally was found or for which it was intended within the cultural context of its production. As Wilhelm Worringer indicated in his description of the empathic and abstract modes, these ways of working were both means of making a significant relation to the natural world through artistic form. Form had meaning in its specific qualities as well as in the mere fact of being made as art at the intersection of individual and collective expression. In the current phase of contemporary life, when all of nature is culture, when the line between these two once-conceived-to-be-separate domains is all but erased, then affectivity and entropy act out the fundamental gestures that produce aesthetic value and render aesthetics significant through transformations and alternatives to mainstream value and production.

NOTES

1. There is an enormous problem of exclusion from critical consideration within mainstream art history of works produced within the historical period of modern art—particularly the early 20th century—because they do not conform to these supposed negativities. See my article "Who's Afraid of Visual Cul-

ture?" *Art Journal* Vol. 58, No. 4 (Winter 1999): 36–47.

 2. Bertrand Russell's summary of Aristotle's positions is succinctly cited: "We may start with a marble statue; here marble is the matter, while the shape conferred by the sculptor is the form." He goes on to emphasize, however, that " 'form' does not mean 'shape' " in a reductive or literal sense, but in the sense of defining border and delimited identity. Bertrand Russell, *A History of Western Philosophy* (New York: Simon and Schuster, 1945), 165–66, where Russell summarizes Aristotle thusly: "Form is 'more real than matter'—and a form can exist, as per Plato's notion of idea, outside of matter" (p. 166).

 3. Wilhelm Worringer, *Abstraction and Empathy* (New York: International Universities Press, 1953).

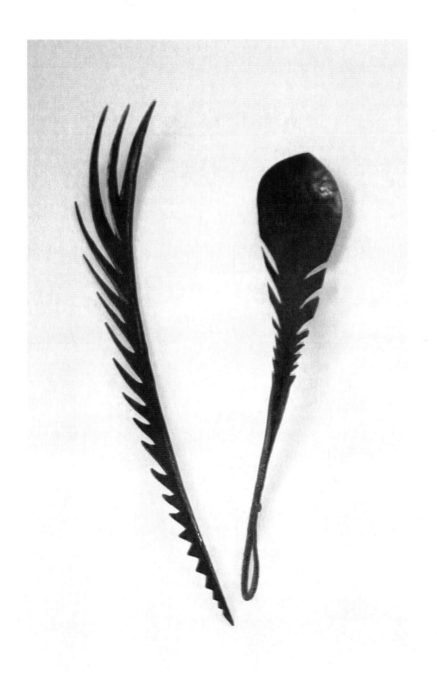

William S. Rogers, Feather Serving Set. *Forged steel, each 10½ × 2½ inches, 2002. Photo courtesy of the artist.*

9

"Reading" the Language of Objects

M. Anna Fariello

Today we can only begin to imagine the emotion that must have accompanied the initial discovery of nature's material properties, the paradoxical twin characteristics of malleability and permanence of clay, for example. Surely, this dichotomy appeared as one of life's first mysteries. How could a material so plastic and soft become durable and substantive, or how could metal, at first indistinguishable from rock, under heat and hammer come to bend and be forged into a thing made? This power of transformation must have captivated the imagination of the first craftsmen. That artists have continued to build on tradition—and still make pottery and metal sculpture today—is nothing short of miraculous. Other human endeavors have come and gone, while craftsmanship has remained part of a phenomenal continuum, a genealogy of sorts, extending back more than 8,000 years. A creative triad is reenacted time and again: maker meets material on the stage of process and through the application of technology—old or new— an object is created.

One of the marvelous things about aesthetic objects is that, through them, a transference of meaning can take place over vast periods of time. The meaning invested in an object by a maker in one epoch lies dormant until discovered by someone from another century. Because of the object's long half-life, its meaning can reappear at any time, like a genie in a bottle.

This essay is expanded from "Material + Technology: Reconsidering the Object," originally published in the catalog *ReFORMations: New Forms from Ancient Techniques* (2000) and draws from "Material Meaning," an earlier essay published in *Studio Potter* (1996).

A PURPOSEFUL LANGUAGE

This essay proposes that the language of objects is discernible and, although subtle, can be *read* to discover meaning inherent in creative objects. More specifically, I propose that the meaning of an object may be interpolated by reading it as a document, a metaphor, or as an object of ritual. As a document, the object is a physical record of the process that produced it. From the object as document, we may learn about inspiration, human creativity, and technological experimentation. As a metaphor, the object yields insight into the human condition. The best works capture the motivations of an individual life and, extending specific circumstances and situations, translate these into a more universal language to reveal a collective human story. As ritual, a work operates within the realm of day-to-day experience, enriching perception by diverse experiential means: visual, haptic, intellectual, sensual, emotional, and kinesthetic. As part of daily life, the ritual object invites the viewer or holder to participate in a second creative act, thereby elevating ordinary experience to the extraordinary.

The above argument is predicated upon the assumption that creative objects made by humans play a significant role in culture, a role interwoven with complex relationships of meaning and value. An object's meaning is manifest in its physical form and in markings on its surface, while its value is culturally ascribed. The latter part of this paper represents a shift in focus from the object itself to the value of the action of its making. The focus of this secondary concern is not the value of a work, but the value of its working. In considering the effect that creative process may have on its maker, its holder, and, collectively, on the culture in which it exists, I propose that the value inherent in an object is also the value inherent in its making. Throughout, the argument for a *readable* object relies on the notion that aesthetic meaning can be discovered through the application of imagination. The genie's magic is released by vicarious experience carried forward from the past into the present, via maker to user.

In an attempt to level the field of inquiry, I have adopted language in a purposeful manner throughout this essay. I use the word "maker" interchangeably with "artisan," "craftsman," or "artist." I have consciously avoided the usual categorical descriptions of aesthetic objects, such as "craft," "fine art," or "decorative arts," because these terms carry the weight of values and assumptions honed by their traditional usage.

Instead, I use more generic terms, "object" and "work," to refer to any form of human-made artifact with an aesthetic or creative component. All creative works, regardless of scale, material, or style, are considered "objects" under this discussion. Thus, paintings and sculpture come under our lens of inquiry, as do jewelry and pottery, although our primary focus will remain on the three-dimensional object. I ask the reader to temporarily set aside the usual methods of classifying objects—using form, geography, or chronology—and instead apply a methodology based upon inclusion and continuity. Likewise, the proposed methods of reading an object may be applied equally to historical and contemporary works.

Although the aesthetic objects under discussion do not resemble one another in form or style, they share a bottom line: they are all things made with a conscious purpose by the application of the human mind and the skill of a human hand. I prefer the broad definition put forth by Jules Prown and Thomas Schlereth as a contextual base for considering works of art.

> Material culture properly connotes physical manifestations of culture and therefore embraces those segments of human learning and behavior which provide a person with plans, methods and reasons for producing and using things that can be seen and touched. . . . [The individual object] is concrete evidence of presence of a human mind operating at the time of fabrication.[1]

In applying a more complex interdisciplinary methodology, I needed (and used) a terminology capable of describing meaning in a more objective way. In our first usage of gender-free language, we struggled with cumbersome sentence constructions and new terms, like "s/he." Throughout this paper I attempt to use the word "holder" as a parallel to the word "viewer," a term common to art writing. While I personally like the word viewer, objects are more often held, rather than viewed and I would like to underscore this notion. One of the main points of this essay is to emphasize the interactive experience provided by three-dimensional objects as opposed to the more passive experience of viewing a two-dimensional work from a distance. Thus, holder seems more appropriate to describe this participation. I have tried to avoid the word "user" for reasons expressed in the section on use and cost, "use" having the implication of being "used up,"

that is, consumed. While such nontraditional language can create somewhat clumsy-sounding sentences, my use is purposeful. I wish to shift the point of emphasis. I ask the reader to bear with me as we traverse new terrain in developing ways to reveal the subtext of meaning found in material objects in order to better understand our material culture and our creative selves through reading the language of objects.

THE OBJECT AS DOCUMENT

Contemporary culture bombards us with extreme sensations and frantic actions devoid of transcendence, longevity, or the binding qualities of community. Thus, we continually long for the unknowable, never realizing that satisfaction and meaning are rooted in the physicality that exists below the radar of a highly technological world. Through material, we remain connected to nature, which helps us cope with a society increasingly removed from nature. The materiality of objects conveys its own history, what Jules Prown so eloquently calls "the mute heritage of things."[2] What we make, beautiful or not, is a record of what went on in the studio between maker and material. Every mark left on an object is a record of a decision made and an action taken by the hands that formed it. Each mark—in clay, wood, stone, fiber, glass, pigment, or metal—is the archeological evidence of a creative action taken by an object maker. Indeed, the object represents a subtle reenactment of maker with material, although much escapes the viewer's sensibility. Accustomed to a continual blast of sensation on the margins of our perception, it is difficult, indeed, to absorb the nuances of creative experience.

Like much new work on the cusp of the art-craft continuum, Albert Paley's steel sculpture can be read as document, work that is the physical evidence of its own making. Paley creates vertical sculptures executed in forged and fabricated steel in a recognizable linear and lyrical style. Over the course of his long career, color has played an increasing role in his work, which, for some years, relied on the inclusion of nonferrous metals to add a naturalistic coloration. Other work, including his hallmark ribbon forms, are airbrushed with acrylic pigments. But among the most interesting of his pieces are those that

utilize colors within the metallic spectrum that are revealed during fabrication. Exaggerated by the heat-forming process and often seen only by the metalsmith, the iridescent peacocks and fire reds that mark the temperature of the steel are deposited onto the metal's surface to yield a subtly beautiful finish.

But in a culture where extreme has become the way in which we pursue experience, the subtleties of the object are difficult to perceive. Twenty-first century culture (American culture, anyway) seems incapable of perception unless a thing hits one squarely on the head. Popular music, movies, sports, and weapons are created with maximum shock value, some with lethal consequence. Parents no longer advise their children to act in moderation; extreme is valued for its own sake. So why bother with the subtle nuances and multivalence of the object? Because such subtlety can provide enrichment on a personal and day-to-day level, an enrichment that appears to be missing from these times. As water and wine satisfy thirst in different ways, a dime store glass offers an experience different from that offered by one that is hand blown. The latter has a potential for meaning beyond its physicality and material worth. While it certainly remains material, a handcrafted object has the capacity to contain an essence of meaning that simultaneously exists in spirit.

Throughout the ancient world, the primary elements of scientifically isolated principles—earth, air, fire, and water—were recognized for their role in nature's balanced and mysterious environment. During the earliest of human experience, things not of the natural world were rare; consequently, their making was accompanied by ceremony, ritual, and magic. The artisan had the ability to control and transmute the elements, interacting with the stuff of life to perform the earliest alchemical experiments. The results of these experiments are recorded in the object as document, tangible evidence of success or failure on the part of the maker. Taking earth, adding water, applying fire and air, a maker would transform the intangible and fluid into something physical, solid, and lasting. These first craftsmen developed a capacity to transmute base elements—while not into gold—into useful implements, which in many cases were more critical to the survival of their nascent cultures than gold would have been. How far would human culture have progressed without baskets, without cloth, without tools, or without the many other things made from materials taken from the earth?

AN EVOLVING TECHNOLOGY

Transmutation—the transformation of material via process—has long been celebrated in myth and song for its capacity to harness natural elements for human use. Some creative acts were marked with explosive fanfare; the god Vulcan captured bolts of lightning to fuel his forge. While weavers did not wield such apparent superhuman power, they possessed the capacity to calculate the warping of a loom, which required an understanding of complex mathematical reasoning. Obviously, this process was not commonly understood; otherwise, Odysseus's wife Penelope could not have so long deterred her fate by clever manipulation: weaving by day and unraveling her work by night. In the Judeo-Christian tradition, the craft of woodworking was honored with special status in Bible stories that described Jesus as a carpenter. Working at a trade involving hand skill implied attributes both human and divine. In the Pueblo creation story, the protagonist was both spinner and potter. Spider Woman used earth to create the people in a rich array of colors: red, brown, white, and black from various clays. She spun her web and, in the process, wove the fate of her human creations. This fusion of mortality with the divine, with matter and mind, is apparent in an ancient epic poem that credits the goddess Athena with the creation of pottery and weaving:

> Ancient Weaver, I am but a novice at the craft you taught, a mere mortal attempting to disentangle the threads of your unsurpassed divinity. . . . Yet still I cannot weave the pattern before I add the colors of your inventiveness to my armful of scattered threads, for they tell me that it was you who first invented the wheel for the potter . . . and, of course, Ancient Weaver, it was you who designed the first weaving loom.[3]

This anonymous writer acknowledged not only creativity of craft makers, but also their inventiveness.

Twentieth-century scholars, like the eminent physicist Cyril Smith, acknowledged the artist's role as innovator. Smith proposed that, throughout history, technological experimentation took place in the artisan's studio, rather than in the scientific laboratory. Influenced as we are by today's science-driven standards and values, it seems unlikely that the artist would have played a primary role in technological discovery. But in his essay "Matter vs. Materials: An Historical View,"

Smith concluded that technological modification of materials appeared "first in decorative objects, rather than in tools or weapons necessary for survival."[4] Of course, until modern history, with little distinction between the fields of art and science, there was little difference between technique and what we now call technology. From a contemporary standpoint, it may be difficult to appreciate the fact that craftsmen played a role in developing the technologies that evolved into our modern academic disciplines. Yet, the earliest forms of mathematics, pyrotechnics, metallurgy, and physics were, indeed, part of craft process. While science has evolved into a profession that now appears quite different from the arts, the two once shared a common foundation of using empirical observation as a way to explore natural phenomenan. Indeed, fire-controlling smiths, potters, and glass makers were part artist, part scientist (and part wizard) by virtue of their power over the elements and their ability to turn raw matter into completed object.

Methodologically, Copernicus and Michelangelo were not so far apart in their day. Had they lived in the twenty-first century, their respective disciplines would isolate one from the other, probably at the far corners of a university campus. Today, art making remains an empirically based, open-ended exploration, while science has come to insist upon predictability and repeatable performance. Scientific process is systematic, leading one along an ever-narrower path toward a specific conclusion. In contrast, in the craft studio, the exploratory process fans outward, toward an infinity of multiple solutions and a network of connections. While the scientist is in search of one particular, determinant solution, the artist is in search of many. The system of interconnectedness and nested structures that characterizes the World Wide Web is similar to the approach used in art making and may provide a new way to think about the creative process. In working a material into a finished object, the maker's next mark has the potential to lead in an infinite number of directions. Thus, each mark implies a host of new possibilities. It is this expansive quality that is intoxicating to the maker—and threatening to those who become paralyzed by an infinity of opportunity.

A DEEPER SEEING

Psychologist Carl Jung observed that creative insight was not usually the result of a planned path to discovery; rather, solutions more often

emerge from a dream-like state of reverie. Today, we would frame this observation in physiological terms, concluding that creativity defies the quantification of left-brained logic. It is holistic thinking, occurring within the right hemisphere of the brain, which creates a potential for metaphor. Contemporary craftsmen tacitly propose that metaphor serve as a new function for craft objects. Regardless of scale, form, or function, an object's meaning is couched in a nonverbal language to be received and perceived tactually and visually.

Our understanding of the meaning inherent in objects is hampered by the fact that the English language so poorly serves the sensual and visual. While the brain can process visual information simultaneously in unfolding waves of seeing, perceiving, feeling, and reacting, verbal language is limited by virtue of its linear placement—word by word—and a subsequent sequential processing by the brain over time. Visual artwork speaks a holistic language that is immediate and creates a synthesis of understanding. Such language appeals to our minds in a way that verbal language may in poetry and metaphor, but seldom does in other forms of writing. The object's native tongue resists the quantification and codification common to verbal communication.

While verbal language can provide clues to understanding and can stimulate reflection, it cannot replace knowing the work through experiential methods. We lack a specific word for the action that wholly engages a deeper seeing on behalf of the viewer, seeing in a full aesthetic and experiential sense. This method of seeing engages the viewer's tactile and kinesthetic sensibilities, as well as the visual. It is a synthetic experience, rather than an analytic one. This expanded definition of seeing implies full participation on the part of the viewer; such seeing is not a passive experience. This deeper seeing implies an immediate and profound impact felt by the viewer, more difficult today because of what has come to be called visual overload. Take color as an example of a visual element that could potentially contain a larger capacity for meaning, but seldom resounds with a strong message in our contemporary world. For most twenty-first-century Americans, color contains little, but residual, categorical information. Yes, red, white, and blue tell us that Independence Day is near, or orange and black remind us that Halloween is soon to be celebrated. But is this the extent of the emotive power inherent in color today? How have we arrived at such superficiality? Red was not common to the human eye prior to the advent of commercial pigments in the nineteenth century and was still not common until well into the

twentieth. In preindustrial times, red would have had an impact beyond our understanding, a meaning beyond a categorical measure rooted in the brain's left hemisphere. Where would red be found in a preindustrial world? A particularly dramatic sunset might display an intense vibrancy or we may encounter a field of poppies in bloom. Or, reluctantly, we may have witnessed profuse bleeding in the death or injury of a companion. In either case, red would trigger a meaning full of emotion and consequence, one not likely to be forgotten for a long while.

Are we better off having red as part of our everyday lives? Surely such accessibility is a straightforward advancement of human culture: that we can buy red clothing, shiny red cars, watch movies in color, and purchase our food in cardboard boxes drenched in color. Have we gained from the wide availability of red as part of our everyday? While our lives are enlivened superficially by such display, the meaning and effect upon our sensibilities of such extreme manifestation of color is diminished by its commonness. Through its proliferation, we have lost a measure of our visual acuity. Ask most anyone, what does red mean?[5] and you will be met with a perplexed look. Today, there appears to be little "meaning" to color. Although today's object makers are articulate storytellers, the subtleties of language—stories told in elements of color, form, proportion, and balance—are difficult to read by a society with dulled visual and tactile capacities.

THE OBJECT AS METAPHOR

As metaphor, the object is a vehicle that carries its viewer into an expanded universe. The more intangible properties of the object—materiality, tactility, intimacy, domesticity, containment, ornament, utility—are difficult to perceive, though they bind us to an ever-evolving human tradition. Containment is one of those subtle attributes of craft objects that may be explored in a metaphoric sense. The abilities to hold, to save, and to possess are basic human desires that satisfied the earliest human needs. At one time, a container may have been the most valuable possession a family could own. A broken water pot could be a tragedy, a life-threatening crisis to a family group. A basket or carved wood bowl may have functioned as a bank, the sole repository of all that was personally owned and cherished. Neolithic pottery served as coffins for infant children. Thus, containers

separated the precious from the ordinary, the valued from the value-less. Water, food, and medicinal plants were not always readily at hand and a group's very survival may have depended upon the ability of a vessel to store provisions for a later time of greater need. Indeed, the prosperity of our species depended upon the ability to contain. We can assume from these circumstances that containers were so significant to survival that they were imbued with a protective magic to ensure their capacity to perform a valued function. If we place ourselves in the context of these ancestral objects, we can better understand the reverence played out in the Japanese tea ceremony. We can begin to appreciate how simple objects could have been intentionally invested with a spiritual quality, a ceremonial capacity, a protective magic, and an awesome reverence.

In twenty-first-century America, the container as metaphor is revealed in the story of a simple bowl. In "Blue Bowl of History," Martha McPhee compares a bowl inherited from her grandmother to others that, at first, appear quite similar.

> Examining the bowls . . . I noticed subtle differences in the designs. Leaves painted more thickly, a lighter blue, a chip. Each one was individual. Mine was a deeper cobalt. A faint crack webbed the base. A chip scarred the scalloped edge. Like birthmarks, they identified the bowl. But it was larger than the details. My bowl, and mine alone, held Nancy and thus my grandmother. It was the stories that I wanted when she was dead and gone, and she'd done a good job of pasting them to the objects—objects that, like books, could be read. My bowl had life. My bowl had history. . . . My grandmother mythologized her past, and in these myths she lives. In my bowl, I see my grandmother . . . telling me about Nancy. I see Nancy with her seven children, the Cantonese bowl in her hands, hiking over the Alleghenies. I see a line of ancestors marching over time, whispering to each other stories that, like stories told in the children's game of telephone—like history itself—are utterly transformed along the way.[6]

McPhee's tale about a young girl and her relationship with her aging grandmother is centered on an antique ceramic bowl, passed from one generation to the next. The author never refers to the bowl as an actual container. Its purpose was not to hold food or drink, paper clips, or Post-It notes. "It was the stories that I wanted," the author insists, stories held, that is, contained, within the form of a bowl.

In our throwaway, disposable society, containers, implements, cover-

ings, and the like are no longer necessary to our survival in the sense of their indispensability to community. They do continue, however, to operate on the level of metaphor and can contribute to the well-being of our spirit. For this reason many of today's craftsmen are loyal to the vessel as a basic form of expression; indeed, vessel forms predominate in contemporary ceramics, glass, and turned wood. Even when the finished form is not intended to be put to a traditional use, contemporary craftsmen seem willing to work within the parameters of prescribed form, limiting though they may appear to be. Perhaps it is the metaphoric concept of containment, in and of itself, that is a fascinating point of focus. As such, containment can be explored as a metaphor apart from the physical reality of utility. Humans save, we store, we sometimes hoard, and, certainly, we isolate certain possessions apart from others; containment separates us from our more primal relatives. We are self-conscious about our actions and purposefully ascribe specific meaning to certain things. Today's craftsmen have the opportunity to work within a material tradition, either embracing or ignoring traditional forms expressed in object making. Many have abandoned traditional form, but just as many find comfort within it. In serving as metaphor, the object needn't necessarily abandon its useful role.

Sometimes the form itself is a commentary on the object's content. This type of expression can be seen in a salad serving set made by metalsmith William S. Rogers, who fashioned a long-handled fork and spoon with which to toss a salad. The set takes the form of a miniature pitchfork and shovel, duplicating the exact construction techniques used to manufacture the full-sized garden tools. When asked about the form, the artist first mentions the visual pun. Digging in a salad bowl with replicas of garden tools links the user to the source of nourishment. But the set is more than a visual pun and functions on a deeper level. The work refers as well to the artist's rural perspective, his love of old tools and metal objects whose sturdy construction is giving way to composite plastic forms found at Home Depot. The salad set will serve salad, but in so doing, it is at once a commentary on the contemporary society's diminished respect for values.

Likewise, techniques can be used above and beyond their fabrication purpose to serve as a metaphorical component in a work of art. In creating the *Dinner Party*, a work for and about women, artist Judy Chicago purposefully used needlework and china painting to underscore her feminist message. The artist's incorporation of traditional

women's work resulted in a connective network, forming a community of makers over time. Likewise, by virtue of her selected materials, an implied metaphorical meaning anchors her work to historical circumstance. Inherent in traditional form and its evolutionary changes in style is an object's historiography and a kernel of its meaning. As metaphor, the object finds meaning in traditional function—as container, implement, covering, amusement, ornament, furnishing, talisman, or image—or in the social connotations of technique.

With painting at the apex of the aesthetic pyramid, and sculpture and architecture as supporting buttresses, needlework—one of the world's oldest crafts—lies along the base. Only recently has contemporary feminist art and woman-centered scholarship opened new avenues of understanding into an acknowledgment and serious consideration of textile-based art forms. From Mildred Constantine's seminal catalog *Beyond Craft*, to the stitched runners of Chicago's *Dinner Party*, to Rozika Parker's *The Subversive Stitch* and Elizabeth Barber's analytical *Women's Work*, viewers and readers have come to appreciate the complex web of socially defined roles that women—and fabric—have played throughout history. We have come to realize that the assumptions upon which this hierarchy is based are socially constructed and that, unless we are willing to unravel the densest construct, we will repeatedly arrive at clichéd answers to questions that appear unresolvable.

The function of an object as metaphor need not be private or subtle and can enter the political arena as well, as was demonstrated during the late 1990s, when Russian leader Boris Yeltsin held a summit with two world leaders. To symbolize the importance of the event and the new, cooperative relationship among the three leaders, Yeltsin commissioned a silver tray with three goblets firmly attached. The goblets could only be taken apart from the tray with a key, which was to be saved for the next summit. Although the maker of this elaborate silver service remained anonymous, and the story broke only as a bit of journalistic trivia, nevertheless, the object in this instance served as a powerful metaphor, adding meaning and value to the political encounter and elevating its significance by virtue of a phenomenological understanding.

Rose Slivka prophetically recognized the metaphoric quality inherent in craft and proposed an alternative function for the object. Her watershed essay "The Object As Poet" was written for an exhibition catalog for the Renwick Gallery in Washington, D.C., in 1977. Slivka introduced ideas that remain relevant today, concluding that an object made from "craft"

materials could function beyond the obvious purpose of its utility.

> Craftmakers and artists . . . [are] reaching inside and beyond the physical
> nature of the object. At peak, at that moment of rightness, there is trans-
> figuration, an exchange of presence between maker and object. The object
> becomes itself the poet. The object is seen and touched in the language of
> materials. . . . The object is the visual metaphor. . . . The object provides
> thereness, a physical place: it holds the space, marks the terrain, the ge-
> ography of the metaphor. . . . The artist-shaman invokes invisible forces
> through the interaction . . . of the spirit of the material object. They be-
> come our vehicles of workshop, of fantasy, of remembering, of foresee-
> ing, of power, of making.[7]

Slivka argued that the importance of an artwork, in any form, is its ca-
pacity to induce wonder through the invocation of "invisible forces."
She called upon the artist as shaman to perform a transformative cere-
mony in which "an exchange of presence [takes place] between maker
and object."[8] The contemporary artist—as shaman—continues to oper-
ate within an ancient and primitive paradigm in which the unknowable
is valued and respected. Our reliance on scientific rationalism has
eroded our trust in mystery, the irrational, and our need for elaborately
creative myths. The unexplainable is pushed to the periphery of experi-
ence or fancifully rewritten into stories for children. Mystery and the ir-
rational remain the stuff of popular entertainment, children's' stories,
pulp fiction, pseudoscience, and cult worship, while serious pursuits are
purposefully limited to more concrete avenues of exploration.

The essence of the object as metaphor is its capacity to share the
spirit of creativity with its ultimate audience, the user or holder. For the
perceptive holder, there is an elevated experience in perceiving the ob-
ject as both document and metaphor. While the object as document con-
tains a record of its making, the object as metaphor contains the spirit
of creative process. Held in the hand, the handmade object delivers
more than a thirst-quenching drink. I am reminded of René Magritte's
painting of a pipe, on which was written the caption, "Ceci n'est pas une
pipe" (This is not a pipe), a confusing message to many art history stu-
dents. Magritte was concerned with the multiple levels of reality and
our perception of them. Of course, his was not a pipe, but a painting af-
ter all. Likewise, craft makers who work wholly within traditional form
can claim this is not a goblet, a blanket, or a knife, but all of these things
and more. These objects do more than address needs of survival. Not a

meal to ward off famine, they are a feast of gourmet delights and, thus, sustain a spirit of creativity.

THE OBJECT AS RITUAL

Ritual is a way of moving through an activity to bring a heightened awareness of the actions that form it. In many preliterate societies, ritual is prescribed and carries within it a collective memory of some important aspect of culture. Thus, cultural meaning can be carried from one generation to the next through a series of specific activities performed by members of a group. In the Western world, we have substituted the cult of the individual for the hegemony of community. Mere vestiges of ritual remain in our lives, such as shaking hands in greeting. To preserve a sense of binding tradition, ritual has remained strong on annual holidays. We find common experience in blowing out birthday candles, serving turkey on Thanksgiving, or lighting fireworks on Independence Day. Except for holiday celebrations, religious traditions, and ethnic customs that perpetuate age-old ceremonies such as baptism and bris, there are few opportunities to experience meaning through ritual in our busy lives. This is not necessarily true for craftsmen, for the daily act of making is a ritualized process and the resultant object allows its holder to participate in ritual through use.

The repetitious activity of making and a self-conscious awareness of the object through use characterize ritual in craft process. The glide of a wood plane along a ridge of oak is a mesmerizing movement with ritualistic overtones. The smith's hammer plays metal like a drum, the measured sound recorded in repeated marks upon material. We recognize the skill of a smith by the pattern impressed upon metal in an even-textured surface or an evenly spaced twist. The entire process of making pottery exemplifies ritual. Hand meets clay, turn, turn, hand meets clay, turn. Throwing, trimming, curing are followed by the same trinity of operations until there are enough pieces to fill the kiln. Bisquing, glazing, and firing correspond to a symmetry. Temperature rises—building, heating, maturing—then cooling to the touch, returning the clay to the potter's hand. Unloading a kiln begins a new cycle of sharing, showing, and selling, extending the ritual to an appreciative audience. From the potter's hand to the user's hand, the object flows from a rhythm of making to a daily ritual of holding. When wrapping one's

hand around a cup that has been (hand)made by a potter, the day begins with a symbolic exchange of touch. The morning cup is full of coffee and, too, of intangible meaning available through the ubiquitous American ritual of morning coffee. Superficially, the object continues to function in a "traditional" manner, but imperceptibly, through ritualized use, it has elevated experience above the routine.

The ceramic sculpture of Masako Miyata reverberates with layers of meaning and a rich cultural complexity. *Green Tea* is a tableau alluding to the traditional Japanese tea ceremony, but one that takes on a distinctly American flavor. In her trompe l'oeil study, tea is served in an American-style coffee cup and stirred with a bamboo whisk. The simple still life sits atop a morning paper, read through the filtered lens of two cultures. *Green Tea* allows the viewer to vicariously partake in two traditional rituals, the Japanese tea ceremony and the American routine of morning coffee. Miyata's tableau is meditative, allowing the viewer to partake in a ritual of the everyday. In *Green Tea* differences converge—the artist's Japanese ancestry, her American career, and her Appalachian environment become a point of intersection for maker, viewer, and culture.

Again and again, the maker invests an object with self-conscious and thoughtful process, each act resulting in a deliberate mark. Human-made artifacts are distinguished by such an ordering principle.[9] When we enter a natural forest, we expect to see a diverse population, a mixture of trees, not conforming to any pattern. But when we enter upon a neighborhood, we recognize it immediately as a human community by the systematic placement of structures lining the road like beads threaded along a string. Likewise, our backyards may be filled with an abundance of natural plant life, but to be sure, our flower bulbs are lined up like platoons of well-trained soldiers. A systematic principle of order allows an archeologist to distinguish an ancient burial from a random deposit of bones. Well illustrated in works created with thread, the ordering principle is evident in a well-crafted object composed of row upon row of neatly placed stitches. In textiles the very definition of craftsmanship is determined by order: measured stitches, even tension, and regular placement constitute a well-made work. In contrast, we recognize the work of a beginner by the absence of order; a beginner's work is marked by a random unevenness that interrupts the overall pattern.

The concept of the object as ritual came to me through personal ex-

perience. Having questioned the wisdom of using carefully made textiles on a Thanksgiving table, I pondered their meaning and value. What is the meaning invested in handmade objects? The use of such elaborately constructed textiles is surely not the obvious; they are much too precious to keep spilled gravy off the table. With precaution the most precious textile inheritance is laid out for special occasions. White wine is served instead of red, no matter what the main course. Because of their beauty and fragility, such textiles cause concern. Every spill is mentally categorized, the proper antidote recalled. Surely this is not the gift bequeathed by one's ancestral maker, to worry over a legacy of stains and spills? I had long since given up my search for meaning, going about postholiday laundry with a lack of mental awareness. On this particular day, my routine was interrupted by the unexpected appearance of my grandmother's embroidered signature. This signature diverted my attention, brought an automatic routine to an abrupt standstill, and sharpened my awareness. Here was a signed work of art, however economically valued or devalued. Here was a mark made in another time, in another place, by another generation. This mark was made by someone as much a part of my past as the DNA that ran through every cell in my body. The legacy passed to a new generation by an ancestral maker is not the object itself, as I had long assumed, but the effect that holding that object would have on its user. From that moment onward, every aspect of my daily routine became a conscious act felt to be an act of heightened aesthetic awareness. Encountering the handmade object elevated a mundane experience to the level of ritual.

The object serves as a marker, setting ritual action apart from the ordinary. The lighting of a hand-wrought candelabra marks the initiation of ritual, reminding us that a meal is more than mere sustenance. Lifting us out of the ordinary, the object possesses an uncanny ability to transform daily experience, as the maker originally transformed material. Could an elated feeling of creativity, similar to that experienced by a craftsman in the studio, be transferred to the object's future holder? If so, then life has the potential for a day-to-day enrichment through a self-conscious awareness and appreciation of objects.[10] Rather than seeking heightened experience in a self-constructed manner, be it vacation or intoxication, one need only participate in ritual by using valued objects. Perhaps craftsmen are driven, not by the occasional sublime experience, but by ritual constructed from the repetition of daily life after all.

A MULTIPLICITY OF FUNCTIONS

In the previous sections I introduced three alternative views of the object: as document, metaphor, and ritual. These are not new; art has long since functioned as document, depicting historic and political events and the likenesses of important personages on canvas, fresco, and vase painting, and in ivory, metal, and tapestry. Art has long illustrated lessons and told stories. In every epoch, art objects have been used to indicate or elevate status. Only later would art be stripped of its multiple functions to arrive at the singular position of art for art's sake. Modernism would "free" the object from its social, political, religious, and sensual functions, while isolating aesthetics as its primary sole purpose. Likewise, the hierarchy—which posited the mental/cerebral/intellectual over the manual/sensory/haptic—created a caste system of aesthetic production and perception. We find ourselves emerging from this fractured state to articulate a new paradigm in which mind may be reunited with matter and culture with nature. Although many of these efforts are more focused in the fields of ecology and psychology, under a new arts paradigm, aesthetic works can be considered from a fresh perspective.

In order to construct such a new framework, value must have meaning beyond the superficial, beyond the physical and measurable properties of use and cost. If the value of the made object were limited to its quantifiable values, then creative production could only yield more things to be bought and sold, contributing to the increasing commodification of our culture. Even in use, however, the object can offer something apart from mainstream consumer culture in which production and consumption ride a merry-go-round of exploited resources, fashionable obsolescence, and unsatisfied desire. The object offers an alternative in that it is not wholly consumed in its utility. In contrast, a craft object is meant to be used again and again in a ritual of engagement and metaphor that intensifies its capacity for interaction and meaning with each encounter, rather than diminishes it.

To achieve full understanding of an object, the meaning of its function must not be limited to its use. Function exists in the realm of the metaphysical, while use can be understood in physical terms. Does this teapot pour? Does it drip? How much liquid can it hold? Does it become too hot to hold? The use of a quilt may be as a bed cover, but its func-

tion is greater than the sum of its component pieces and encompasses the autobiographical story of its making, its maker, and the entire quilt tradition. Aside from its use as a bed cover, its function embraces the quilt as document (of a family's cast-off clothing), as metaphor (the double meaning of providing warmth), and as ritual (in its use on special occasions). Thus, the multiple functions of an object exist apart from its use and are made up of layered intangible meanings, rather than its physical properties alone.

Early in the twentieth century, an ironic turnabout reintroduced the object into the fine arts arena, while concurrently maintaining, even strengthening, aesthetic differentiation, which placed craft in a peripheral position. Marcel Duchamp, hero of the avant-garde, introduced the idea that the creation and perception of the object are located in the mind and eye of the artist, rather than in the hand. Duchamp isolated specific found objects and deemed them art by declaration. By this radical action, Duchamp elevated common objects to the status of *objets d'art*, transcending their original functions. Exhibiting a snow shovel, a bicycle wheel mounted on a wooden stool, and, outrageously, a urinal, Duchamp proposed that these objects were works of art, however "ready-made." In the wake of his actions, artists began to intentionally produce objects that inherently implied conflict, like Meret Oppenheim's fur-covered cup and saucer, Joseph Cornell's collaged boxes, and Man Ray's altered objects. These pieces shared characteristics with craft objects of their day; they were similar in scale, in tactile sensuality, and sometimes in form. The surrealist object, however, differed from the craft object in intention. Its maker sought conflict, rather than resolution, and all but ignored craftsmanship in favor of a conveyable message. Surrealist philosopher André Breton acknowledged that the supposedly passive actions of intention and contemplation could propel an object into the artistic arena, but in the modern world, the artistic arena was becoming an arena of the mind. The surrealist critique created a paradox and layered meaning. On the one hand, there appeared a glimmer of hope that the value of the object was dependent upon the maker's intention, and thus, there was an implicit suggestion that upward mobility was possible. On the other, the traditionally held belief that art was a product of hand labor and hand skill was permanently shattered, leaving the craft object hopelessly adrift and its maker with little but time on his hands.

A MATERIAL MEANING

Clement Greenberg, whose aesthetic criticism shaped much of the aesthetic thinking in the latter half of the twentieth century, published his classic essay "Modernist Painting" in 1965. In this seminal work, Greenberg carefully deconstructed the aesthetic object and concluded:

> Each art had to determine, through the operations peculiar to itself, the effects peculiar and exclusive to itself. . . . The unique and proper area of competence of each art coincided with all that was unique to the nature of its medium.[11]

Although Greenberg intended that his ideas be applied to painting, alone at the apex of a well-defined aesthetic pyramid, his essay may be reread and applied to other media as well. Greenberg asked his readers to consider, "What is the nature of a medium that is exclusive to itself . . . [its] unique and proper area of competence?"[12] The application of this question to the discussion at hand provides a valuable point of departure. While Greenberg's concern evolved from a critical perspective, nevertheless, his words addressed issues that emerge from the relationship of the artist maker to material. It would follow Greenberg's argument that the artist—painter or craftsman—would consider the inherent structural qualities of each material. To create, one must know the basic physical properties of each material, to understand, for example, that the strength of wood is in compression, but that the strength of thread lies in tension. Put visually, an artist recognizes that wood is mass, while thread is line. Could it be that certain forms spring naturally from the physical act of making them, influenced by the material of which they are made? While Greenberg didn't state the obvious, he could have said that paint is pigment, pigment is color and, therefore, flat. What Greenberg did conclude was that "flatness" was the essence of painting. Likewise, one could argue that *dimensionality* is essential to the object. The "nature of a medium" begins to take shape from its material characteristics, regardless of the intentions of its maker.

Marshall McLuhan, another great twentieth-century thinker, analyzed media apart from content. However, when McLuhan wrote that "the medium is the message," craft media was not on his mind. His concern was the hot, new electronics of the day. However, his idea—that the material of a thing influences our appreciation and understanding of

it—has been true since the beginning of making. In every medium, there is an underlying assumption that influences how we think about the thing made, colored by the value we place upon the material. Consider our culture's stubborn refusal to accept clay as an art medium. This issue has been debated and discussed from every point of view: function, scale, economics, and history, and, still, clay work is marginalized aesthetically and economically. Since mid-century, ceramists who wanted to increase appreciation of their work abandoned pots, first for vessels, then for sculpture. Ironically, their work remained undervalued. Are some materials inherently humble? Contemporary craft has evolved from a heritage of "truth to materials" in which work is made with respect for the natural qualities of each medium. Craft objects celebrate the material of their making. In craft, the medium is truly the message, or, as this essay proposes to illustrate, the medium can be significant to content. Its subject aside, the craft object is often about the nature of wood, clay, metal, glass, or cloth. And herein lies the dilemma. Our aesthetic value system is inextricably linked to our understanding and appreciation of ecology and nature. If the medium is truly the message, then work made from the Earth's most basic natural resources will never transcend our cultural prejudice while dirt is considered dirty. If the Earth is useless unless plowed, plundered, or paved, then craft will never attain high social value. This is the state we find ourselves in today, with most of the Earth's inhabitants disdainful of—or at best ignorant of—the clay beneath their feet.

A SUSTAINABLE PROCESS

The word "craft" became popular in the context of the Arts and Crafts Movement in response to problems associated with industrialization. The movement sought to reinject the hand back into the workplace. That craftsmanship was considered integral to production, well into the Industrial Revolution, is reflected in the etymology of the word "manufacture," from *manus* meaning "hand" and *facere* meaning "to make." Implicit in manufacturing was the handmade. While "manufacture" came from "handmade," consider that the new workplace—the factory—specifically removed the hand from the making, a distinction that speaks volumes about the meaning of work in the nascent industrialized society. Arts and Crafts—with capital letters—was an international counterrevolution that

attempted to reinstate a holistic approach to process through a variety of studio-centered activities in Europe and America. This precise point in time is the vortex of craft scholarship.

The ideological underpinning of the Arts and Crafts Movement in England was based on the premise that art making could be of value to the maker. Both John Ruskin and William Morris sought to restore dignity to labor through a reconstruction of the industrial workplace along the lines of studio production. Ruskin used the medieval guild system as a model because he believed it allowed for more individual creativity. Morris attempted to put Ruskin's ideas into practice and established a number of production workshops, including his well-known Kelmscott Press. In the United States, Kelmscott was copied many times over, most notably in East Aurora, New York, by Elbert Hubbard in establishing Roycroft Press. More than an operation to make hand-tooled leather-bound books, Hubbard attempted to create a community of workers.

The transplanted English ideology—which I have dubbed the *craftsman ideal*—also put the "art" into "art pottery." Understand that this term refers to the production process rather than to the product. At the time of its introduction, artistic pieces of pottery were already being made in abundance, coming from famous pottery centers at Staffordshire, Limoges, Sèvres, and Meissen. What set *art* pottery apart from mainstream production ware was that each piece was made from start to finish by a single creator. Process, fractured by a system of divided labor early in the Industrial Revolution, was made whole once again. Eventually, the American Studio Craft Movement lost track of these social underpinnings to favor the production of well-made pieces, but the initial impetus of the movement was to inspire a more creative workplace and, eventually, a more creative workforce.

While the Studio Craft Movement gained ground in America and frequently paid homage to its English parent, in practice it all but abandoned its social objectives. In name, there were numerous Morris Societies established, but, except for its initial flowering—in settlements like Hull House in Chicago, at various "producing centers" in Appalachia, and in intentional communities such as Roycroft in New York—the movement evolved into one focused on well-made objects, rather than on the process used to produce them. For a brief while and supported at the highest levels of society through the popularity of revivalist forms, the craftsman ideal appeared to be moving into the main-

stream of American cultural and aesthetic thought.[13] The once confined canal of modern art theory appeared to widen to become a delta of meandering waterways in which craft objects might find a rightful place. A few twentieth-century thinkers attempted to formulate theories regarding the social benefits of art making, but they were not well received in aesthetic circles. Working for the American Federation of Arts, curator Allen Eaton organized craft exhibitions that circulated throughout the country. When Eaton's *Art and Crafts of the Homelands* opened in Buffalo in 1919 at the Albright Gallery, 43,000 people came to view the show, breaking all attendance records.[14] But the paradigm of popular arts, under which Eaton worked, was eventually subsumed by the objectification of artistic process and the corollary of art for art's sake, which came to dominate the mainstream. In contrast, Eaton focused on the intangible values of the object and its function—the effect of the work on producer and consumer—rather than on the object as product. His value system remained in opposition to the mainstream paradigm. "Every kind of work will be judged by two measurements," Eaton wrote again and again, "one by the product itself . . . the other by the effect of the work on the producer."[15] Eaton, as the ideological offspring of Ruskin and Morris, hoped to imbue the work process with value in and of itself in an attempt to return dignity to labor. Eaton's view of craft—diametrically opposed to the idea that the object has a singular aesthetic purpose—was adopted as a model in occupational and art therapy. It is here that craft took another surprising downturn, for as emphasis was placed on the value of therapeutic process, many sad pieces were produced under the banner of Arts and Crafts.

What use are objects? As long as worth was tied to necessity, then to scarcity, communities placed a high value on the physical object. But today, conditions have made the object functionally unnecessary. We hope to regain insight into an object's meaning via an understanding of its expanded functions as document, metaphor, or ritual, as well as considerations of its use, value, and material. Our ability to *read* the language of objects, as well as knowledge gained through a deeper seeing, can result in a reverberation of transferred meaning. This transference occurs on levels of materiality, physicality, and touch and sight from maker to viewer, using the object as a vehicle of transference. Each of these factors, however, continues to depend upon an analysis of the end product, the object as object, so to speak. A reconsideration of process, of why or how a thing is made, rather than what is made, may yield new in-

sights into the human condition as it relates to work. If we were to con-
sider the content of process—that the value inherent in the object is also
the value inherent in its making—we may arrive at a more broadly ap-
plicable conclusion about creative experience. Creative process can be
cultivated as a means of resisting the increasing commodification of
production and the devaluation of work of the hand.

THE INTEGRATED OBJECT

How have we arrived at this juncture when, as noted early in this essay,
object making began its journey amid fanfare and ceremony? The ubiq-
uitous nature of making as an activity, traversing geographic, cultural,
socioeconomic, and temporal boundaries, lends credence to the argu-
ment that art making is essential to the human condition.[16] With an en-
thusiasm that follows them daily into the studio, today's professional
makers are expressing a resurgence of interest and experimentation in
material technologies, process, and form. On the other hand, many
Americans continue to feel that their work is "just a job." For this
broader public, the creative interface of maker with material can con-
tribute to a dialog with far-reaching social implications. The implication
of introducing such dialog into contemporary culture is that we may
achieve greater fulfillment from our work and foster a more positive
work ethic in market-stricken America.

John Ruskin prophesied that society was erroneously focusing on la-
bor as a means to a sound economic future, rather than as an end in it-
self. He wrote, "It is not that men are ill fed, but that they have no plea-
sure in the work by which they make their bread and therefore look to
wealth as the only means of pleasure."[17] Further, Ruskin recognized that
a mechanistic approach to labor would be detrimental to the individual
as a creative being. His warned that we "were not intended to work with
the accuracy of tools, to be precise and perfect in all actions . . . [with]
fingers to measure degrees like cogwheels and arms [to] strike curves
like compasses."[18] Ruskin's nineteenth-century analogy and his conclu-
sion that society must refocus on the inherent dignity in human creativ-
ity and labor may sound dated, but they remain applicable to today's
workplace. His writing proposed that intention, thoughtful action, and
creativity play important roles in the workplace. The concern of both
Ruskin and Morris for the effect of the work on the worker is a notion

abandoned by the business-centered American workplace, but these principles can still be found in studio process. As many craftsmen can testify, the satisfaction of studio process is found in an ever-evolving practice and in the experience of losing one's self in the act of making. Today's object is critically positioned as a fulcrum between maker and viewer and between making and perceiving. Indeed, process may be the sustainable aspect of our aesthetic future. Divisions that separate and classify objects focus our consideration on differences in form— what is fine art and what is not—and ignore the common bond of making found in studio process. Such categorical distinctions contribute to the intellectual and economic devaluation of handwork and the hand-made object. In contrast to an object existing apart from its social milieu for purely aesthetic purposes is the notion of the socially integrated object.[19] Such a holistic and multivalent character has been a part of the aesthetic object for most of its history. As we move through the twenty-first century, can the object be rescued from its place in the domestic kitchen of the art world to reclaim a more central place in our world?

James Gilmore and Joseph Pine in *The Experience Economy* identify experience as a distinct, fourth economic offering along with the tradi-tional three—commodity, goods, and services—defined by the eco-nomic sector. The authors cite Disney as a pioneer in the experience arena, which has evolved to include theme restaurants and "shopper-tainment" stores. These, the authors claim, are "heralds of the emerging experience economy." They write:

> Experiences are inherently personal. They actually occur within any in-dividual who has been engaged on an emotional, physical, intellectual or even spiritual level. . . . While the work of the experience stager per-ishes upon its performance . . . the value of the experience lingers in the memory. . . . People greatly value the offering because its value lies within them, where it remains long afterward.[20]

For the creative individual, process sustains. Whole process—an inte-gration of creative making, a reading of the object's meaning, and a deeper seeing[21]—makes us want to reenter the studio again tomorrow. This aspect of craft as experience will become more significant as we seek to counterbalance the desensitivity of contemporary life. Com-pressed inside its small material self, the genie of meaning, captured by the artist, is released by a viewer who willingly participates in the mys-teries of making.

172 *M. Anna Fariello*

NOTES

1. Thomas Schlereth, *Material Culture Studies in America* (Walnut Creek: Altamira, 1999), 3; Jules David Prown, "Style As Evidence," *Winterthur Portfolio* vol. 15, no. 3 (Autumn 1980): 198.
2. Prown, "Style," 198.
3. Merlin Stone, *Ancient Mirrors of Womanhood*, vol. 2 (New York: Sibylline Books, 1979), 92–93, 193–202.
4. Cyril Stanley Smith, "Matter vs. Materials: An Historical View," *Search for Structure* (Cambridge: MIT Press, 1981), 113.
5. This same question can be extended to other colors. In *Painting and Experience in Italy*, Michael Baxandall explains that blue from lapus lazuli was so costly that it was reserved for the robe of the Madonna in Italian painting both before and after the Renaissance. Such limited use would associate blue with the holiest of holies. Later, purple, made from thousands of minute sea creatures, would be reserved for royalty, to eventually become known as Royal Purple. My point here is that color had strong associations, which deepened its meaning.
6. Martha McPhee, "Blue Bowl of History," excerpted in the *Utne Reader*.
7. Rose Slivka, "The Object As Poet," in the Renwick Gallery, *The Object As Poet* (Washington, D.C.: Smithsonian Institution Press, 1977), 8–10.
8. Slivka, "The Object," 10.
9. Schlereth, *Material Culture*, 2.
10. The idea that domestic objects could transform daily experience and the home environment was promoted by the Aesthetic Movement in England and later, albeit in a more limited manner, by the Arts and Crafts Movement. See the introductory essay, "Regarding the History of Objects," in this volume.
11. Clement Greenberg, "Modernist Painting," *Clement Greenberg: The Collected Essays and Criticism*, vol. 4 (Chicago: University of Chicago, 1993), 86.
12. Greenberg, "Modernist Painting," 86.
13. Support came from a number of presidential first ladies. Ellen Axson Wilson redecorated the White House bedroom using handmade Appalachian craft and Eleanor Roosevelt's name appeared on a number of craft exhibition catalogs.
14. Eugene Metcalf, "Politics of the Past in American Folk Art History," *Folk Art and Art Worlds*, J. M. Vlach and Simon Bronner, eds. (Ann Arbor: University of Michigan, 1986), 44.
15. Allen Eaton, *Handicrafts of the Southern Highlands* (New York: Russell Sage, 1937), 21.
16. A main proponent of the theory that art making is a universal experience is Ellen Dissanayake, whose two texts *What Is Art For?* and *Homo Aestheticus* argue the case from a biological point of view.

17. John Ruskin, *The Stones of Venice*, numbered artists edition (New York: Merrill & Baker, n.d.), 164.

18. Ruskin, *Stones*, 164.

19. See Suzi Gablik, *Modernism and the Re-enchantment of Art*.

20. James Gilmore and Joseph Pine, *The Experience Economy* (Boston: Harvard University Press, 1999).

21. Beginning in the 1980s I argued for a language that would not disadvantage an entire class of objects in "In Defense of the Object," *Clay USA* (Radford, Va.: Radford University, 1989), and again in "Market Forces As Moral Value: A Questionable Aesthetic," *Ceramics Monthly* February 1996.

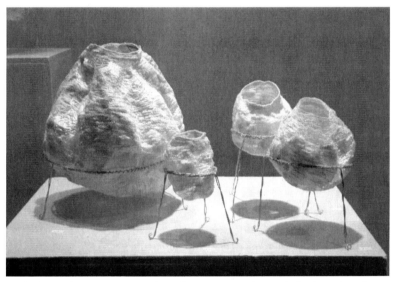

Michele Hardy, Victorian Vessels. *Silk, cotton, synthetic cloth, thread, and wire paint, 1990.*

10

Feminism, Crafts, and Knowledge

Michele Hardy

When I sit down to my sewing machine and prepare to work, everything must be right before I can proceed. Of course, my materials must be at hand and my tools available and in working order. A pot of tea is usually handy. There are subjective factors involved as well. My ideas must be ripe or, rather, animated—they may yet be uninformed, but they are ready to focus and create. I cannot begin a new project until my ideas, materials, and tools fit together—not like a jigsaw puzzle, flat or static, but as something generative and unbounded.

There are many parallels between the way of working and the intent of this paper. It is a meditation on the real value of craft—value in a contemporary and holistic sense. This is new ground that I can only begin to glimpse, but the materials are assembled, connections tentatively formed, and my perspective as a craftsperson conscious and clear. At the heart of this paper is the premise that the nature of one's engagement with the world shapes one's perspective, or rather, *what* we know is contingent on *how* we know. The first step to reaching this new ground is to recognize the specificity of our engagement as craftspeople. A story within a story within a story—this paper explores the continuing development of my awareness of craft as a way of knowing the world, as a body of knowledge, and the implications of this.

This essay has been reprinted with the kind permission of the Canadian Museum of Civilization. It was originally published as "Crafts and Knowledge" in *Making and Metaphor: A Discussion of Meaning in Contemporary Craft*, edited by Gloria Hickey, 1994.

This story begins, then, not with my training in textile crafts or my experience as a craftsperson and instructor, but with my return to university. Plunged into an environment that privileges received knowledge, I craved the direct experiences I was used to. I longed to touch the artifacts I was studying, not with gloves, but directly with my skin. I pondered and probed those artifacts, not so much as illustrations, but as facts in themselves. I sensed in them not just representations of distant cultures, but something of the logic of their materials and manufacture.

Since I entered graduate school, my knowledge of textiles repeatedly has been challenged. Because it has developed through intensive and extensive experience with cloth, there are few course numbers and no marks to qualify as tangible. Stultified by a mindset I could not yet name, I similarly could not question its validity or authority. It was not until I became familiar with feminist theory and with feminist critiques of science and philosophy that I began to recognize my experience and name my frustrations. These are that, as a woman and a craftsperson, I have felt insignificant, devalued, and guilty of self-indulgence, both generally and specifically within the university. My experience with textiles was excluded and discounted as knowledge by a system for which science and objectivity are preeminent in the discovery of knowledge. My frustration was latent and unnamed because I could not see credible alternatives to this established value system. Feminism has thus helped me to recognize the value of my experience with textiles and, furthermore, to realize that alternatives are possible.

Experience has played a crucial role in the development of feminist thought. The first wave of feminism introduced women as worthy objects of study, encouraging reflection on the nature of women's experience and the sources of oppression they experience. With the recognition that women's voices were seldom heard and their interests not always protected, feminists began to challenge the hegemony of the dominant discourses (Harding 1990). The second wave of feminism began to expose the insidious implications of patriarchy and to question whether these established modes of thought could accommodate women. Feminists' recent critiques of philosophy and science have encouraged a reevaluation of experience per se and its relationship with the construction of knowledge (Hawkesworth 1989; Haraway 1988; Code 1991). Together with postmodernism, feminist critiques have turned to deconstructions aimed at dismantling the mechanisms

of exclusion and have insisted on women as the subjective possessors of knowledge (Harding 1987; Gross 1986; Code 1991).

Feminists have thus critiqued both the form and content of science and philosophy. Objectivity, "pure" reason, and empiricism are the means of understanding privileged by the scientific method. Vision is the primary tool of the scientist in his search for truth. Supposedly unclouded by emotion or bias, this vision is unidirectional and noninteractive; it assumes a passive, objective, and, therefore, observable reality. Severing the subject from the object, science heightens the distance between humanity and nature, contributing to a dichotomous conception of reality. Objectivity is pitted against subjectivity, intellect against feeling. The scientist is thus autonomous, but alienated, privileging theory over experience, the quantitative over the qualitative, detachment over responsibility.

Feminists have disputed the assumptions upon which scientific knowledge rests. They question the possibility of objectivity and point out that the exclusion of women from the ranks of science betrays a subjectivity it will not admit. In her book *What Can She Know?* feminist philosopher Loraine Code discusses the exclusion of women and their "traditional" skills from who counts as knowers and what counts as known:

> The withholding of authoritative epistemic status from the knowledge women have traditionally constructed out of their designated areas of experience affords a peculiarly salient illustration of gender politics at work. "Gossip," "old wives tales," "women's lore," "witchcraft" are just some of the labels patriarchal societies attach to women's accumulated knowledge and wisdom. Its subjugation and trivialization can be explained only in terms of the structure of power and differential authority encoded in the purity demanded by ideal objectivity. This knowledge cannot attain that standard, the supposition is, because it grows out of experiences, out of continued contact with particularities of material, sensory objects—and it is strongly shaped by the subjectivity of its knowers: women. (Code 1991, 68, 69)

With the recognition, first, of a woman's perspective, then, of women's perspectives, the authority of science to name universal truths has been eroded. Early feminists sought to determine the essence of a woman's point of view, an idea gradually replaced by the recognition of multiple views. "Woman," for example, has been shown to be a category constructed within a particular context. Women of color and women of the

third world and the fourth are claiming their right to determine their identities, their agendas, and their feminisms (Mohanty 1988; Amos and Parmer 1984). (Fourth world refers to indigenous and minority women of the Western industrialized countries.) The struggles of native people for self-determination in this country poignantly illustrate the clash of two very different ways of knowing and therefore of "proving" land ownership—contractual agreements as opposed to the demonstration of extensive and intimate knowledge of land use. These examples suggest that there are many ways of knowing and many points of view and that there are many knowers unrecognized and devalued by science and the philosophies modeled on science. Value, including moral value, has been restricted to a very narrow and problematic way of knowing.

The pitting of subject against object forces a dualist conception of the world, one in which only half of the pair is credible. Black or white, sink or swim—these are the poles of late capitalist society. Female/ male, nature/culture, subjective/objective—these are the axes upon which intellectual thought has turned. The feminism I embrace and believe should influence any consideration of craft is not one intent on sacrificing a patriarchal scapegoat or creating a cult of essential victimhood. Rather, it is a feminism that acknowledges and explores the potent gray areas between the poles. It is a feminism that is critically aware of the hierarchies and biases resulting from science's monopoly on knowledge. It is one that fosters a "discursive space" (Gross 1986, 204) for exploring multiple possibilities and for reevaluating the importance of personal experience and the subjective in the construction of knowledge. Code suggests, for example, that both "emotion and intellect are mutually constitutive and sustaining, rather than oppositional forces in the construction of knowledge" (1991, 47). She concludes her discussion of the possibility of a feminist epistemology by opting for a well-mapped middle ground, one that "offers a place to take up positions of strength and the maximum productivity from which exclusionary theories can be tapped critically and creatively for criticism and reconstruction" (p. 318). This middle ground between the dichotomies that have dominated Western thinking offers a place to share ideas and tap new potential. Craft, though traditionally relegated to the hinterland, rather than to a middle ground, can legitimately take a place in this creative milieu.

Earlier I expressed some of the frustration I have felt as a craftsperson and a woman. Through feminism I have begun to recognize the

specificity and value of my perspective and understand the mechanisms that had prevented me from doing so. This has been enormously empowering. Through this paper I am hoping to shed some light on the situation of craft. Mirroring my own experiences, craft is a marginalized, trivialized enterprise, more often connected with an extinct preindustrial past than the present. Craftspeople are like relics from another age— part technicians, part magicians. Crafts are discussed according to their tangible techniques, their products, or the subjective experience of the craftsperson. The maker's hand supposedly manipulates materials in a prescribed way according to the nature of the medium.

The difference between art and craft has traditionally involved the cognitive transcendence of material and function. Craft remains tied to necessity and to the maker's hand, as opposed to the maker's intellect. The artist is credible by transcending the particularities of materiality. The craftsperson cannot claim the same transcendence and is therefore denied the same status. Feminism has demonstrated, however, that the means of assigning epistemic, moral, and economic value have been predicated by an objective, scientific model; therefore, we should reject this characterization of the unknowing craftsperson. Feminism has furthermore opened up the potential to consider multiple possibilities and a range of ways of knowing. Code has suggested, for example, intuitive, experiential, and aesthetic ways of knowing (1991).

From my experience as a craftsperson, I am claiming that craft is a particular engagement with the world, a particular way of knowing the world, and that it has a particular, though possibly nonverbal, known. I am also claiming that there are many benefits to exploring crafts as knowledge and as a way of knowing—benefits that are not easily quantifiable, but that do have implications for life on this planet. Let me draw on some of my experience for you. As a child I could not wait to sew. The attraction was not so much about being able to use a sewing machine as it was about creative possibilities and autonomy. It was not until sometime later, after I had become competent and comfortable technically, that the textiles themselves grabbed me and I became intensely aware of their tactile qualities. Later the relationship of physical structure and drape sparked my imagination. Most recently color, light, transparency, and opacity have intrigued me. Each new discovery overwhelms me with possibilities—it is like seeing cloth anew each time. My technical skills pace, and keep pace with, this evolving awareness of cloth. They are a means of manipulating and thinking with textiles.

My knowledge of cloth is of both the head and the fingertips, of the intellect and the whole body. It is derived not only from academic study, but also from intensive and extensive experience. I can identify different fibers by touch. I can tell how a certain fabric will drape or wear—how it will look made up. I can imagine vividly how a fabric will fall on my body, whether it is a cool breezy wisp of silk pongee or the crisp dryness of cotton percale. I can describe how my scissors slice finely into silk or clump their way through a bulky woolen tweed. I can also describe the squeal of moiré or taffeta as I run a fingernail over it and the wave-like rumble and crash of a heavy rug being shaken. Similarly, I can describe the faint, sweet acrid smell of indigo or the briny earthiness of new wool. There is a certain empathy among the senses—I can feel a fabric, know how it will drape and sound, *visually*. Furthermore, I can remember colors and textures and create with them in my mind.

The particularity of my experience with textiles predicates a particular engagement with the world. The known of craft and the skills and qualities it engenders shape our awareness and interactions. A craft knowledge includes the whole body sensitivity I have described above. It is not just an awareness, like some supersensitive sixth sense, and is certainly more than just technique. If we have been unable to articulate this knowledge, it is as much a limitation of language (Miller 1987) as it is the failure of established epistemology to recognize both subjectivity and objectivity as components of the construction of knowledge.

The mindset that privileges scientific objectivism similarly privileges the mastery of the media that art engenders—the medium is harnessed, manipulated, or perfected by the artist's vision. Craft encourages sensitivity and empathy for one's medium. This burl of wood, lump of clay, or skein of yarn is not simply the object upon which skills are worked. It is the medium and thus active in the sense that it determines, develops, and changes throughout a process, requiring minute, subtle reactions and decisions by the craftsperson. The division of subject and object engendered by science and art is not the case between craftsperson and medium. Craftsperson, medium, tools, they are of one unified gesture of creativity; their boundedness is less metaphysical than physical. Ursula Franklin reminds us that when we uncritically accept objective rationalism, "the logic of technology begins to overpower and displace other types of social logic, such as the logic of compassion or the logic of obligation, the logic of ecological survival or the logic of linkages into nature" (1990, 95).

Whereas a scientific perspective views the world passively and disinterestedly, a craft way of seeing admits its subjectivity and is comprehensive in its awareness. Code notes, "brought to bear on observations of the natural world, this kind of seeing could signal a more respectful relation with nature, [and] a greater care for its peculiarities, than objective observation admits" (1991, 145). A craft perspective is therefore potentially more responsible to the medium and its source because of the nature of its engagement.

Craft engenders another responsibility—the responsibility of the object. I recently read an account of Navaho aesthetics that moved me very deeply. Beauty to the Navaho is tied to the effectiveness or benefit of the object—a conceptual experience as opposed to a strictly perceptual one (Anderson 1990, 106). This goes beyond the idea of beauty received by the eye of the beholder to a more holistic experience uniting the mind, the eye, and the body, individuals and the community. If beauty has been trivialized by Western society, it is because it is restricted to the physical. The beauty of craft is not restricted to its isolated formal characteristics, but includes consideration of production, materials, time, and place. I argue that craft is beautiful furthermore because it is beneficial—not just for the individual craftsperson, but through the creation of objects that engender a responsible relationship with nature and that celebrate the potential of human makers.

In this paper I have tried to illustrate with my own experience the lessons we as craftspeople can learn from feminist critiques of science and philosophy. Feminism has opened the door to the consideration of many possibilities for knowing the world—craft represents a particular perspective. Questioning the values and aims implicit to science, feminism has furthermore demonstrated that these other points of view have value. The value of craft involves technical expertise, sensitivity, creativity, and a comprehensive awareness that acknowledges responsibility for process, materials, and product. By recognizing the particulars of this perspective, the value of our knowledge, and its challenge to objectivity—in other words, by becoming empowered to see and understand who we are as craftspeople—we can begin to break the shackles of romanticism and nostalgia and begin to weave, throw, forge, or carve a vital, more central and current role for craft.

BIBLIOGRAPHY

Amos, V., and P. Parmer. "Challenging Imperial Feminism." *Feminist Review* vol. 17 (Autumn 1984): 3–19.

Anderson, R. L. *Calliope's Sisters: A Comparative Study of the Philosophies of Art.* Englewood Cliffs, N.J.: Prentice Hall, 1990.

Code, L. *What Can She Know?* Ithaca: Cornell University Press, 1990.

Franklin, U. M. "Let's Put Science under a Microscope." *Globe and Mail* (29 August 1990): A14.

Gross, E. "Conclusion: What Is Feminist Theory?" pp. 190–203 in *Feminist Challenges: Social and Political Theory*, edited by C. Pateman and E. Gross. Boston: Allen and Unwin, 1986.

Haraway, D. "Situated Knowledges: The Science Question in Feminism and the Privilege of Partial Perspective." *Feminist Studies* vol. 14, no. 3 (Fall 1988): 575–599.

Harding, S. "Introduction: Is There a Feminist Method?" pp. 1–14 in *Feminism and Methodology*, edited by S. Harding. Bloomington: Indiana University Press, 1987.

———. "Feminism, Science, and the Anti-Enlightenment Critiques," pp. 83–106 in *Feminism/Postmodernism*, edited by L. J. Nicholson. New York: Routledge, 1990.

Hawkesworth, M. E. "Knowers Knowing Known: Feminist Theory and Claims of Truth." *Signs* vol. 14, no. 3 (Spring 1989): 533–557.

Miller, D. *Material Culture and Mass Consumption.* Oxford: Blackwell, 1987.

Mohanty, C. "Under Western Eyes: Feminist Scholarship and Colonial Discourses." *Feminist Review* vol. 30 (Autumn 1988): 61–88.

Alyssa Dee Krauss, Braille Series: L'essentiel est invisible. *18k gold, ¼ × 1 inch, 1998.*

11

Intimate Matters: Objects and Subjectivity

Suzanne Ramljak

All the spaces of intimacy are designated by an attraction. Their being is well-being.

—Gaston Bachelard, *The Poetics of Space*

Intimacy is a universal human desire. We are destined to pursue close personal and physical relationships with other people and things. While the means for achieving such intimacy vary from culture to culture, this basic need finds fulfillment in every society. Within our own high-tech culture the opportunities for intimate, personal encounters are becoming rarer as mediated experience supplants direct contact and public and private realms increasingly converge. The function of objects at the turn of the millennium should be assessed against the backdrop of this growing depersonalization and blur of modern life.

Of the various roles that objects can perform—as agents of utility, communication, status, and wealth—it is their ability to foster intimate experiences that will be addressed in this essay. As will be shown, the efficacy of intimate objects results from a unique union of psychological, physiological, and social factors. The traits that characterize the intimate object will be examined, including diminutive scale, secret elements, and strong tactility. The effect of such objects on the beholder will also be explored, foremost the heightened sense of privacy and self-awareness generated in an intimate encounter.

This essay was derived from two previous publications: "The Power of the Intimate" in *One of a Kind: American Art Jewelry Today* and "Keeping Vigil: Jewelry, Touch, and Physical Engagement" in *American Craft*.

Etymology proves useful in conveying the key qualities of an intimate exchange. The word is rooted in the Latin *intimus*, meaning "inmost." Intimacy is, above all, an experience that engages our internal domain. The centrality of interiority for intimate states is further borne out by dictionary definitions of the term. Connotations of the word "intimacy" include intrinsic; deep; pertaining to the inmost or essential nature; and existing in the inmost mind.[1] All of these meanings reiterate the inwardly directed quality of an intimate experience; its concentration on subjective space.

Over the last century, due largely to psychoanalytic practice, we have come to recognize the vital importance of interior life. An entire therapeutic industry has emerged to engage our inmost selves. Art has also been enlisted as a means of activating our inner dimension. For Donald Kuspit, a critic trained in psychoanalysis, art objects have the capacity to function as restorative "toys" for adults. According to Kuspit, children use toys to make the transition from subjectivity to objectivity, whereas adults use "the toy of the work of art to make the transition back to the interior reality he or she tends to forget in his or her dealings with exterior reality."[2] He further observes that there is very little in modern society, apart from art, that encourages us to become subjective.[3] Among the various forms of art, intimate objects have a distinct advantage in cultivating our subjectivity and in aiding the transition back to ourselves.

Kuspit's comments also underline a key aspect of intimate experience, namely the inherent tension between private and public life. Intimacy is a state achieved apart from, and often in spite of, the social sphere. Sigmund Freud, a champion of the rights of inner man and woman, probed this dynamic in *Civilization and Its Discontents*.[4] Freud sought to reveal how social order is built on an individual's renunciation of personal satisfaction, asserting that the "replacement of the power of the individual by the power of a community constitutes the decisive step of civilization."[5] Freud also questioned the inflated significance of social life and the widely held belief that civilization is the primary means through which we can achieve the happiness and progress we all desire.[6] This view reverses the common notion that public events are more potent in shaping our lives than personal ones. On the contrary, it could be argued that the private domain is primary, not secondary, in the life of an individual. What happens in secret, behind closed doors, has much greater force than the pull of a throng. It is through the small and subtle exchanges that our selfhood can emerge.

A related case for the primacy of individual and intimate experience is made by Janna Malamud Smith in her book *Private Matters: In Defense of the Personal Life*. Malamud Smith argues for the benefits of privacy on several fronts, claiming that it "encourages self expression and elaborate aspects of intimacy" and "offers a space in which a person might become more fully himself."[7] She goes on to describe how privacy helps us to drop our guard physically and emotionally and become open to nuanced expressions. Her ultimate concern, in keeping with Freud, regards the fact that privacy and intimacy are conditions that must be wrested from social life. She writes, "The human attributes that privacy sanctions and encourages are on one edge of what instinct allows culture to elaborate. When we use privacy to make temporary space for the individual . . . we make possible a place for various exquisite aspects of humanness."[8]

Certain people and things need to be enveloped in privacy, in the comfort of seclusion, in order to unfold to their fullest. It is like the children's story of a toy shop where the toys become animated only when the store is locked up at night, remaining lifeless during the day. Similar qualities characterize our intimate experiences with both objects and people. Ideally, we would satisfy our longings for intimacy within healthy human relationships, but when this satisfaction is unavailable, it is comforting to turn to other sources like animals or substitute things. There are distinct advantages to having intimacy with an object; it provides many of the same psychological and physical rewards, but without the uncertainty and potential pain of interpersonal contact.

One of the primary ways that objects can engage us on an intimate level is through hidden or secret components. An element of secrecy or discretion adds to our personal involvement with an object, requiring extra investment and attention. As a verb, "intimate" means to make known indirectly, to hint or suggest, rather than fully reveal. Intimate objects with private parts speak to us in an insinuating, come-hither tone, instead of declaring themselves outright. Coyly introverted forms, they are seductive in their discretion. Several contemporary artists have explored the dynamic of secrecy in their work, cultivating an intimate "for your eyes only" aesthetic. A complex approach to this thematic is found in Otto Künzli's iconic 1980 arm piece *Gold Makes Blind*. Consisting of a gold ball sheathed in a black rubber tube, the work plays with notions of secrecy, preciousness, and private versus public value. Viewers are asked to accept the worth of the treasure encased within the

rubber, sight unseen. The opposite of conspicuous consumption, this object hides its wealth, teasing the onlooker while secretly appeasing the owner.

Another cogent work in this regard is Nikki Theopahanous's ring *Secret Comfort,* which features a gently contoured pod for wearers to grasp in the hand. Such an object again turns its back on the viewer's social space and demonstrates that what is hidden can be more compelling than what is seen. Yet another variation on the secret object is Sondra Sherman's *Cupid's Folly* pendant of 1993. A chain, designed to encircle the waist, culminates in a dangling ornament that can be hung inside the wearer's clothing to provide hidden pubic stimuli.

Alyssa Dee Krauss creates wearable works that are not only hidden from sight, but also integrate secret messages through the use of Braille and Morse code. Krauss's original inspiration for jewelry making was her grandmother's wedding ring, an object invested with immeasurable worth and sentiment, virtues endowed by the wearer's own experience. Krauss tries to recreate that emotional attachment in her work, stating "What inspires me is . . . the potential of jewelry as metaphor, and the relationship that can exist between a piece and its wearer, an object and its holder; the idea that people develop personal, sentimental, or intellectual affinities with objects."[9] The artist encourages such relationships in work like her 1998 *Braille Series,* which explores the value of the invisible and ineffable. In the gold pin *L'essential est invisible,* the title (from St. Exupéry's *Le Petite Prince*) is spelled out in Braille and is designed to be worn under the clothes, with raised text facing the wearer's skin. A ring from the series incorporates a Shakespeare quote: "Love sees with the heart but not with the mind therefore is winged cupid painted blind," coiled up like a Braille scroll to form the ring's circumference. And a bracelet in this same set includes the coded phrase, "None so blind as those who will not see," spelled out in beads of rock crystal Braille.

A highly conceptual approach to secretive object relations is jeweler Karl Fritsch's aluminum *Suppository,* which ironically features a diamond ring engraved on its surface. Whether or not this work is actually inserted into an orifice, as its title implies, it is still in keeping with common cultural practices like the piercing of hidden body parts. The increase in piercing, tattooing, and other forms of private body art speaks to a similar desire to cultivate intimacy and subjectivity within one's life. In their book, *Modern Primitives,* Andrea Juno and V. Vale discuss

the motives behind various forms of body alteration. As they explain, "Increasingly, the necessity to prove to the self the authenticity of unique, thoroughly private sensation becomes a threshold more difficult to surmount. . . . But one thing remains fairly certain: *pain* is a uniquely personal experience."[10]

Hidden body alterations and secretive objects both provide opportunities for intimate sensation, an alternative realm for self-realization. Such covert exploration represents an extreme form of privacy and, as such, can engender a powerful sense of knowingness and self-sufficiency. In fact, private space is so essential for our identity formation that when you set out to destroy someone psychologically, one of the best and most common tactics is to undermine his or her privacy.[11] Numerous factors in our culture conspire to inhibit our cultivation of secretive space in favor of more easily surveyed behavior. Objects or experiences that strengthen our bond with ourselves can therefore play a part in fortifying us against outside influence and offense.

Another key feature of an intimate object is size, specifically small scale. The significance of scale in our experience of objects is especially crucial and should not be overlooked. Recent protests notwithstanding, size does really matter in both life and in art. Contrary to the old adage "bigger is better," however, there is a case to be made for the power of diminutive things. Just as less can be more, smallness can have immense implications. This inversion of scale values parallels the overturning of values regarding the public and private sphere. There is a long-standing bias in our culture towards largeness over smaller, more intimate things. In simplified terms the cultural equation goes as follows: big/male/public versus small/female/private. Feminist theorist Naomi Schor examines this bias in her book *Reading in Detail*, where she discusses the "alleged femininity of the detail," which has "until very recently been viewed in the West with suspicion if not downright hostility."[12] By upholding the virtues of smallness and intricacy, intimate objects can serve to challenge the entrenched hierarchy of scale in our culture.

The potency of little things is evidenced in the mania for miniatures throughout human history. Today, entire subcultures, replete with newsletters, chat rooms, and collector's circles, have emerged to quell the obsession with tiny objects, from miniature teddy bears to locomotives. For many of these miniaturists the love of the diminutive is tied to the control one feels in relation to little things. The ability to manipu-

late small items lends them an undeniable appeal, as does their sheer cuteness, which endears them to us even further.

Miniatures and detailed objects can also engage us because of the amount of attentiveness and devotion they require to be fully appreciated. Extremely intricate things, such as the minutely carved ivory and wood sculptures of the Middle Ages, have the ability to immerse us in their complexity, leading to a slowing of time and thickening of experience. Many have noted how, through intense concentration, the minuscule can seem monumental, how we can come to see the world in a grain of sand. This intense involvement on the part of both maker and observer is harder to achieve in the rush of modern life. As Gaston Bachelard has observed, "we haven't time, in this world of ours, to love things and see them at close range, in the plenitude of their smallness."[13]

In addition to taking more time and concentration, diminished scale also demands an adjustment of the viewer's stance vis-à-vis an object. To be seen properly, small objects require us to get close, and this closeness is central to the intimate experience. Just as a whisper makes us draw nearer to decipher the words, so too intimate objects demand close proximity before divulging themselves. Unlike our encounters with larger objects, intimately scaled works need a greater degree of privacy and heightened awareness to be fully appreciated. Like peering into a peephole, we must gather ourselves around a point and focus with intent; we must become fixated. Most diminutive things have the power to captivate us in this way, whether the object in question be an insect or a finely detailed brooch.

An example of potent tininess within contemporary art is Charles Simonds's miniature clay dwellings. Purportedly built by a nomadic race of little people, these Lilliputian edifices were created by the artist in urban settings during the 1970s and early 1980s. Simonds's minute constructs provide a welcome occasion for intimate discovery. We are invited to step out of the urban bustle and commune with his microcosms in the midst of an impersonal city.

Another operative element in the intimate experience is bodily touch. Indeed, to become intimate with someone is commonly understood to mean touching or fondling them, usually in a sexual manner. Touch has rightfully been called the "mother of the senses," and much has been written about the importance of tactility for human development and self-awareness.[14] Touching activates our skin, an all-encompassing organ, which forms the outermost portion of our nervous system. While

we need certain amounts of tactile stimuli to develop as healthy human beings, the decline of touch experience in everyday life has transformed this basic sense into a rare and even radical element. The cardinal rule within the institutionalized art world is still "thou shall not touch," and so this craving must seek satisfaction through other means.

An array of objects from diverse cultural traditions has been devised to address our tactile needs. Such hand-based objects or fingering devices include amulets, worry stones, worry beads, rosaries, prayer beads, and Chinese balls. In each instance, regardless of symbolic import, the implicit function of these objects is to provide relief for the body through focused tactile motion: rubbing, twiddling, fingering. If, as some theorists hold, our impulse towards objects is directed at the reduction of tension, psychological and physical, then we should remain alert to the properties of soothing objects from various other cultures.[15]

Several contemporary artists are also keen to satisfy our tactile sense and need for bodily ease. Through virtuoso craftsmanship, Daniel Brush has created a stunning range of *objets de virtue* incorporating goldsmithing techniques from earlier cultures. With titles such as *Hand Piece* or *Palm Piece,* Brush's objects make an explicit appeal to the hand. Usually less than four inches wide, his objects merge steel and gold into compact geographies. *Maze* (1992) encourages the fingertips to literally get lost in textured nuance, while *Companion I* and *II* (1990–1993) offer richly textured escorts for the hand.

Ruudt Peters's untraditional objects are rings without the ring; they lack a hole in which to insert our finger. Instead of wearing these hand-based objects, one must carry them between one's fingers or in one's palm. Wearers are transformed into bearers of little things. They are rewarded for their efforts by the finely textured nuggets on the objects' undersides, which protrude below the fingers for hidden delight. Texture is a highly enticing means of arousing our tactility, and artist Daniel Jocz uses the technique of flocking to great effect in his wearable objects, producing peach-fuzzy surfaces that beg to be touched.

Not surprisingly, many of the examples given of intimate objects fall under the category of jewelry. Jewelers, or metalsmiths, dwell in the minute realm and must master the craft of intricacy in order to excel in their art. As seen in the figure at the beginning of this chapter, jewelry is a three-dimensional format that provides a direct and sustained form

of bodily contact. Not just a bauble or visual diversion, jewelry of this sort can serve as a means of engaging the flesh, an instrument for self-awareness, and as a source of tactile delight.

An extension of the sense of touch pertains to what can be called "oral objects," things we stick into our mouths or put to our lips, such as cups and glasses, spoons and forks. These commonplace objects that we employ every day are greatly undervalued in terms of their power to affect our physical happiness. Indeed, with the possible exception of the fingertips, our lips are endowed with more sensory receptors than any other part of our body.[16] It has also been calculated that the cerebral area that processes input from the lips exceeds that devoted to sensory data from the entire torso.[17] Lips are our very first means of contact with the world, even before our hands become active. We are, to turn a phrase, born suckers, instinctually programmed for oral ingestion.

The mouth is not only a primal organ, it is fertile ground for the cultivation of exquisite private sensation. Consciously or not, our tongues ceaselessly navigate the teeth and tissue of our mouths, like sharks in dark waters. In this respect, the dentist's art, which involves shaping the oral terrain, is not fully appreciated for its contribution to our well-being. Our mouths could even be called the ultimate intimate object: hidden from sight, relatively small, and excruciatingly sensitive. When we engage our mouths with other things—implements, or food, or a lover's lips—we experience a consummate form of sensual intimacy.

Returning again to the cultural role of intimate objects, we can see that their effectiveness derives from a number of converging features. In general, we need objects for our physical development and to keep us focused and anchored in the world. Etymology stresses this stabilizing function of objects. The word "object" stems from *obicere,* meaning "to throw in the way of or hinder"; as a verb the word "object" means "to oppose or resist." Without the grounding force of objects, we would be adrift in a void without measure or weight. Objects provide us with a tangible source of comfort, something to hold on to in a shifting world.

The overall importance of objects in our lives, coupled with the rewards of personal involvement, lends the intimate object an increased value. Our interactions with such objects become even more precious in light of the digital revolution now under way. In many respects, digital technology is the antithesis of intimacy; it removes us from direct contact with experience, with each other, and even with ourselves. The

price we pay for such technological advance was captured in 1928 by E. M. Forster's disquieting story "The Machine Stops." In this futuristic, but not improbable, tale of life ruled by machines, people have become horrified by direct contact and have entirely ceased to touch one another. An epiphany at the story's end leads the characters to realize that the machine "has robbed us of the sense of space and of the sense of touch, it has blurred every human relation and narrowed down love to a carnal act, it has paralyzed our bodies and our wills."[18] Although Forster's story is fictional, this impoverishment of our relations due to computers and other machines cannot be overstated. In spite of current efforts to make computer technology more human, it will always lack the "imponderable bloom" that is the essence of personal intercourse.[19]

It is widely agreed that time spent with computers can leave one feeling enervated and isolated, rather than enlivened and fulfilled. The current boom in computer ownership, which will eventually include every household as the television came to do, is undermining our basic need for intimacy and sensory solace. A recent study on the widespread impact of Internet use found that "the more hours people use the Internet, the less time they spend with real human beings," leading to growing social isolation and "the specter of an atomized world without human contact or emotion."[20] To counter the spreading addiction to time online and other forms of virtual experience, powerful antidotes are required, something more effective than the squeeze balls sold at stores to relieve mounting stress.

For a deeper sense of psychological and physical satisfaction, the best solution remains old-fashioned tangible art. Anthropologist Ellen Dissanayake has extolled this function of the arts, noting that "until quite recently, the arts have been a way of treating the inner life and its concerns seriously, requiring development, cultivation, and maturation, a lifelong acquisition of insight."[21] Although such sustaining art is becoming scarcer, we should continue to turn to art objects to assist us in repersonalizing our lives and setting us back on the path to ourselves. Real intimacy with objects and with other people is not only necessary for individual growth, it is also the source of our greatest pleasures. For if God is in the details, as is oft stated, then heaven must reside within intimate encounters.

NOTES

1. *American College Dictionary* (New York: Random House, 1970).
2. Interview with the author, *Sculpture* (November/December 1992): 30.
3. Interview with the author, *Sculpture*.
4. Sigmund Freud, *Civilization and Its Discontents*, James Strachey, trans. (New York: W. W. Norton, 1961).
5. Freud, *Civilization and Its Discontents*, 42.
6. Freud, *Civilization and Its Discontents*, 91.
7. Janna Malamud Smith, *Private Matters: In Defense of Personal Life* (Reading, Mass.: Addison-Wesley, 1997), 8, 11.
8. Malamud Smith, *Private Matters,* 236.
9. Alyssa Dee Krauss, unpublished artist's statement, 1999.
10. V. Vale and Andrea Juno, *Modern Primitives: Tattoo-Piercing-Scarification* (San Francisco: Re/Search, 1989), 5.
11. Malamud Smith, *Private Matters*, 28.
12. Naomi Schor, *Reading in Detail: Aesthetics and the Feminine* (New York: Routledge, 1989), 3.
13. Gaston Bachelard, *The Poetics of Space,* Maria Jolas, trans. (Boston: Beacon Press, 1969), 163.
14. Ashley Montagu, *Touching: The Human Significance of the Skin* (New York: Harper & Row, 1971), 3.
15. Jay R. Greenberg and Stephen A. Mitchell, *Object Relations in Psychoanalytic Theory* (Cambridge, Mass.: Harvard University Press, 1983). "Within classical drive theory the object facilitates the attainment of the ultimate aim of the impulse; the reduction of tension" (p. 158).
16. Montagu, *Touching*, 116.
17. Montagu, *Touching*.
18. E. M. Forster, "The Machine Stops," *The Eternal Moment and Other Stories* (New York: Harcourt Brace & Company, 1928), 23.
19. Forster, "The Machine Stops," 5.
20. John Markoff, "A Newer, Lonelier Crowd Emerges in Internet Study," *New York Times* (16 February 2000): 1A, 18A.
21. Ellen Dissanayake, *Art and Intimacy, How the Arts Began* (Seattle: Washington University Press, 2000), 223.

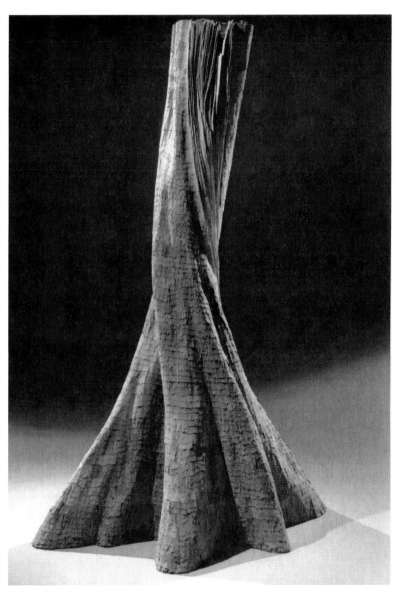

Barbara Cooper, Mast. Wood and glue, 84 × 55 × 32 inches, 2003. Photo by James Prinz.

12

Workmanship: The Hand and Body As Perceptual Tools

Polly Ullrich

Craftsmanship is "a word to start an argument with."

—David Pye[1]

\mathbf{A} generation after the advent of conceptual and electronic art, handcraft in art making—once associated with the most traditional of earth-bound art practices—has reappeared at the nexus of aesthetic and philosophical issues. Disembodied avant-garde conceptual art, which garnered its "radical" status in the second half of the 20th century because it emphasized the primacy of the idea over the physical reality of an artwork, is no longer the sole standard bearer of innovation. The fluid, dematerialized qualities of technology and digitalization, because of their association with the dominance of the mass media, are now ordinary, daily events, even as they continue to redefine core human experiences. Thus, it is perhaps not surprising that the arrival of conceptualism and digitalization in the 1960s was paralleled by another influential trend in contemporary art—the repositioning of the visceral human body as an important aesthetic subject. However, the issues surrounding handcrafts, with their relation to the body and physical senses, also allow contemporary artists, working in a wide variety of fields, to investigate what has become a new paradigm at the turn of the 21st century—the juxtaposition of our embodied selves and our corporeal world within a technological and scientific worldview that relies on decoherence and cybernization to explain and depict the material environment and human relationships.

This essay was revised from ideas introduced in "The Workmanship of Risk: The Re-Emergence of Handcraft in Postmodern Art," *The New Art Examiner*, April 1998.

How can handcrafts in the 21st century be "radical" when the history of aesthetics in the West has generally ranked handwork far below brain work in status? In an age of mechanical duplication, the hand should never be seen as a replacement for technological or industrial processes. Rather, its power comes from its symbolic state, as a sign of the individual, of idiosyncrasy, of personal identity and spiritual power. In an age dominated by linear, cerebral, and linguistic analysis, the hand also stands for human understanding based on experiential qualities and sensation, a kind of rich ecology of feeling. The hand stands for an existential, being-centered quality in art of perception filtered through multidimensional sites in the body as well as the mind. "Beyond all question of old or new, the human hand is the ever-present tool of human feeling, whereas the machine, however new, is soon out of date," writes Soetsu Yanagi, the Japanese craft theorist in his classic book *The Unknown Craftsman*. Yanagi also adds, "No machine can compare with a (hu)man's hands. Machinery gives speed, power, complete uniformity and precision, but it cannot give creativity, adaptability, freedom, heterogeneity. These the machine is incapable of."[2]

The issues surrounding handwork are radical, too, because, since they have traditionally been associated with women and minorities, these processes can reveal alternative voices. Critic Barry Schwabsky, for example, has observed that the African American artist Robert Colescott's paintings in the United States pavilion at a recent Venice Biennale were "a reminder that what seems most traditional can be most subversive."[3] Colescott's traditionally handled paint and narrative figurations nevertheless convey stinging social satire about racial inequality in the United States. In addition to alternative messages, some contemporary artists are increasingly employing the process of handcraft itself as a subject matter for investigation in order to synthesize handwork with brain work. Now, embracing the hand does not necessarily mean abandoning art that purveys intellectual themes. One of the original pioneers of conceptual art, Mel Bochner, for example, has moved into heavily handworked abstract painting. And other artists who once worked in the older conceptual deconstructive mode have followed suit. Bochner uses his paintings to address philosophical issues as dense as any he worked on in the 1960s, primarily by recording—via brushstrokes made by hand—the mental processes that go into making art. Bochner has called the original "rebellious" impulse behind conceptualism now "academic," adding that painting,

even though steeped in tradition, now seems "a lot less predictable" than other kinds of art making.[4] Others in the art world, such as Paul Schimmel, the North American curator for a recent São Paolo Biennale, have identified "a concentration of decoration and craft as the new common ground" for the next generation of young artists.[5]

The synthesis of hand facture and postmodern themes has roots in the 19th century with the invention of photography, when it became clear that mimesis was no longer the primary function of art. The emphasis on artworks as special, handmade, precious objects conveying a peculiar, individual power, rather than as attempts to replicate reality, began to take hold. The handcraftedness of fine art objects, downplayed since the Renaissance in an effort to distance them from the less prestigious handcrafted objects such as pottery or textiles, gained new respect. Now, with the postmodern blending and leveling of art hierarchies, art and craft have edged even closer toward an acknowledged, and not shameful, union. Scholars and artists—even those in media that seem most dematerialized—are now working out a kind of integration of the visceral body and the cerebral mind that centuries of Western thought has attempted to deny. That history and the recent renaissance of handwork can be identified from a wide variety of sources. It is the goal of this essay to draw on some of these sources to clarify the place of the hand in contemporary art.

HAND AND BODY: THE CONCEALED PRESENCE

> There is a history of hands. They actually have their own culture, their particular beauty; one admits their right to enjoy their own development, to have their own desires, feelings, moods, and their own favorite pursuits.
>
> —Rainer Maria Rilke[6]

Symbolically and literally, the hand has appeared in art since the earliest human cultures. Prehistoric cave walls in France, Spain, and New Guinea are covered with hundreds of printed and stenciled images of human hands, possibly as a symbol of spiritual strength and personal singularity. But the hand and its associated meanings (the fleshly body and manual craftsmanship) have suffered from a long-standing prejudice in the West going back to ancient Greece, when Plato defined the

"soul," or mind, as separate from the body, a duality that simply negated sensory experience by subjugating it to the Platonic world of the Ideal. Even though the Greek word *aesthesis* specifically means sense (as in bodily) perception, the denigration of manual labor and the body has permeated Western philosophy and aesthetics. During the Renaissance especially, painters and sculptors struggled to separate themselves from hand-oriented crafts such as glass making or pottery and to ally themselves with poets, architects, and musicians, forming a new, more refined, intellectual and prestigious category called "fine art." Sixteenth-century duels were fought over these issues, such as the altercation between the Renaissance sculptor Baccio Bandinelli and the Vidame of Chartres, who contemptuously declared that Florentine nobles, like Bandinelli, who had taken up painting and sculpture were merely practicing the "manual arts."[7] During the Middle Ages, sculptors had belonged to guilds that included stone masons and bricklayers, while painters belonged to guilds for gilders and saddlers. The guilds became so powerful, however, that they challenged monarchical decisions in many urban areas. It was no accident, then, that the advent of academies for artists in the 17th century, which drew artists away from membership in guilds, was heavily sponsored by monarchs and royal courts, who saw an opportunity to break the power of the guilds. This separation—between painters and sculptors and the other craft workers—definitively separated fine art from what was left to be called "craft." It also stamped in place a false dichotomy between the (superior and dominant) cerebral intellect and the (lowly and inferior) hand or body in human art making and perception, a break that was a result of politics rather than aesthetics.

Perceiving and then organizing the world through the use of such antinomies, or opposing dualities, was developed further by 17th- and 18th-century philosophers, and it still colors the way that many Western people perceive the world to this day. During the Enlightenment, philosophers set up binary systems, by employing dualistic terms such as normal/deviant, well/sick, mental/manual, inner/outer, soul/body in order to analyze and control all kinds of natural phenomena under theoretical models.[8] While we have benefited from many of the breakthroughs made by Enlightenment thinkers—for example, their questioning of authority, their individualism, their faith in progress, their trust in common sense rather than divine will, and their drive to understand and solve problems—contemporary artists are still confronting an

Enlightenment legacy of dualism in art theory that privileges brain work over handwork and language over corporeality. This tension between phenomena that are characterized as transcendent and phenomena that are seen as immanent, noncognitive, or experiential (and therefore inferior) culminated in René Descartes' famous statement, "I think, therefore I am," a bifurcation of the mind and the material world (where the act of thinking, rather than feeling, assures us of our existence). The Cartesian mind/body split is still a dominant focus for philosophical thought today: 250 years of Western philosophizing has tried inconclusively to find a way out of this dilemma posited by Descartes. But the contemporary search to reintegrate the hand, the body, and the physical senses continues to be one way for artists in all media to begin to heal that rift.

During the 19th century, the mark of the hand became a sought-after quality in the decorative arts because of the influence of the Arts and Crafts Movement in Great Britain. The Arts and Crafts Movement, however, had a crusading edge, by equating handcraftsmanship with social structures that improved the quality of human life and contributed to the "moral uplift" of workers. But the Arts and Crafts theoretician William Morris, who founded the Morris and Company design firm, in practice did not argue against the use of all machinery in production, especially when craft workers were not exploited and the quality of the output was good.[9] Morris, who was a socialist, was actually more interested in promoting the processes of handcraft in small, integrated workshops that could stand as alternatives to the hierarchical division of labor between designers and workers in huge and anonymous 19th-century industrial settings. Morris's ideas arguing for equal status in art work—both fine art and craft—were taken up later in the 20th century by another influential designer, Walter Gropius, at the Bauhaus in Germany. "There is no essential difference between the artist and the craftsman," Gropius wrote in the Bauhaus Manifesto in 1919. "The artist is an exalted craftsman. . . . Let us then create a new guild of craftsmen without the class distinctions that raise an arrogant barrier between craftsman and artist!"[10]

Although neither the Arts and Crafts Movement nor the Bauhaus succeeded in breaking down the hierarchy between higher "fine art" and lower "craft work," the early 20th-century avant-garde tacitly carried forward hand-making traditions. Early modernist painters such as Cozen made the sense of touch visible by constructing art with heavily

hand-applied brushwork and materials. The modernists Cliff Bell and Roger Fry (with the Omega Workshop) democratized art categories, as did the artists in the Dutch art group De Stijl and the teachers at Black Mountain College in the United States.[11]

Qualities that seemed especially inherent to "craft" work, such as a heightened sensitivity to materials and a delight in spontaneity from the fusion of design and factor (or handling), were developed further by these modernists. Concurrently, by the middle of the 20th century, craft artists, finding that industrially produced objects had long ago replaced their work, began to define themselves more as artists than as laborers or designers. They demanded qualities in their work that seemed intrinsic to fine art, such as timelessness and authenticity.[12] After World War II, there was an explosion of craft activity in the United States and Great Britain, as consumers demanded functional craft objects that were decorative as well as utilitarian. It is no accident that a clay artist such as Peter Voulkos, who clearly emerged from craft traditions and schooling, could identify his work with abstract expressionism in the 1950s. No longer part of the industrial or economic base, craft objects had edged toward fine art objects.

THE HAND CONVEYS AESTHETIC RISK

This is a sincerity culture. Pluralism is a word that is often used, but I think syncretism more accurately defines the situation, accretions of cultural artifacts brought together in ways that suggest unification rather than dissolution or disjunction. At this moment, there is an effort to heal the artificial rupturing that has occurred over the last 100 years.

—Philip Taaffe[13]

As art categories continue to be dismantled and mixed together under postmodernism, many fine artists and craft artists alike find they stand on common ground, especially as their work revolves around the issues of process, materials, and handcraft. Long relegated to the noncognitive realm of brute matter, craftsmanship has emerged as a subversive stance, as a means of conveying aesthetic risk. Craftsmanship provides an opportunity to critique and redefine the status of materiality or physicality in our media-based postmodern culture. Some contemporary

artists from many backgrounds have decided to thread the line between
the sensual and the conceptual by emphasizing either the metaphorical
or the literal use of hand processes in their work, in the process creating
art that embodies ideas as much as relays them—a synthesis that has a
long history in craft art. The potter Marguerite Wildenhain, for exam-
ple, writes:

> This intimate correlation of the quick perception of the eye with inner
> concepts of the heart and mind, and the sensitive training of the hand, this
> immediate reaction of all the capacities of a human being, will always be
> the aim of a craftsman and artist. It is only the potency of these combined
> abilities that will give the artist the power to convey what he feels in his
> own personal way.[14]

Young painters such as the Americans Elizabeth Peyton and John Cur-
rin or the Belgian Luc Tuymans, for example, cull their images from
fleeting postmodern sources such as video stills, newspapers, snapshots,
and celebrity portraits, but use a concentrated hand facture to pull the
work into the physical world. These artworks, however, are not typical
mass media–based postmodern "representations of representations."
The mark of the hand makes these works obstinately somewhere, of a
place. Laura Hoptman, a curator for the Museum of Modern Art in New
York, who organized an exhibition that included Currin and Peyton, her-
alded this as "a significantly changed attitude among new painters," an
attitude that integrated conceptual themes with a serious, passionate,
and unironic love for the physical act of painting. "This work is about
preparing to stun you with the painting," she has said.[15] Tuymans,
whose wan, tight paintings of painful subjects—such as concentration
camps—that barely restrain violent emotion, has called his work so
"concentrated" that he compares it to "another type of arousal."[16]
 The synthesis of a transient idea-oriented postmodern sensibility with
the flat-out gorgeousness of handworked material is apparent, too, in
the work of some mid-career artists such as Lari Pittman's baroque,
flamboyantly decorated paintings or Sue Williams' political, bitter, ob-
sessively painted images of sexual abuse. Philip Taaffe, whose Islamic
patternings involve numerous hand processes that include constructing
templates, sanding, painting, hand-inking, and collaging, has described
his art making as "a search for the ruthless thing," adding, "what I want
to make is something very physical and very perceptually demanding"
at the same time.[17]

The process of craftsmanship itself, however, can be used as a vehicle for exploration and risk, an idea pioneered by the British designer and woodworker David Pye. Pye's classic book *The Nature and Art of Workmanship* dryly debunked much of the sentimental and moralizing tone of the Arts and Crafts Movement and set out to analyze a core and invaluable component that handcraftsmanship added to art. Pye called this the "workmanship of risk." Pye expressed irritation at the phrases "handmade" or "done by hand," inexact terms that loosely seem to stand for hand techniques of any kind used before the Industrial Revolution. But Pye liked to point out that some power tools, such as the water-driven hammer, are ancient, and he mentioned that just exactly where the hand leaves off in some centuries-old machine processes, such as the 12th-century stamping dies for ornamental grillwork or the potter's wheel or the hand loom, is difficult to determine. In addition, he said, much of the workmanship in contemporary mass production is excellent and in some cases has never been surpassed by handwork.[18]

Pye asked, "What makes handcraftsmanship unique in production processes?" He invented the phrase "the workmanship of risk," defined as:

[W]orkmanship using any kind of technique or apparatus in which the quality of the result is not predetermined, but depends on the judgment, dexterity and care which the maker exercises as he works. . . . The quality of the result is continually at risk during the process of making.[19]

Pye contrasted this with the "workmanship of certainty" found in quantity production and automation, in which "the quality of the result is exactly predetermined" before anything is made. Speed and accuracy are usually the incentives behind the workmanship of certainty. In the workmanship of risk, however, Pye maintained that the "risk" must be real: can the worker spoil the job at any moment?

Why is the workmanship of risk valuable in art objects? The workmanship of certainty can also yield high quality. Only through the workmanship of risk, however, is it possible to reveal the sense of life and the moment-by-moment human decisions that are recorded in the act of making. The workmanship of risk has "diversity," Pye wrote. It produces subtlety, richness, and variety in the art's formal elements that deepen upon closer and closer inspection. Pye wrote, "A thing properly designed and made continually reveals new complexes of newly perceived formal elements the nearer you get to it." Design is not the crucial factor in this aspect of fabrication—only workmanship can provide

the "short-range elements."[20] Although Pye quibbled with the term "handmade," the qualities he found important in art making are almost always associated with the hand: individuality; variety; facility; close, tactile familiarity with a material; and an emphasis on an intimate visual range in experiencing the art. To perceive what Pye calls "diversity" requires that the observer move in close—within hand's reach—and employ much more than a narrow Cartesian mental capacity.

The workmanship of risk, by recording the vivid, personal, and ongoing intuitive decisions in making, conflates time and process in art. The painter Vija Celmins, for example, whose thickly built-up canvases of galaxies, oceans, and deserts sometimes include as many as eighteen layers of paint, has talked about "packing time into a work" with the depth and physical density of handwork. She has aimed for what she called "fatness" or "volume" in her art, attempting to consolidate both intellectual and physical matter in order to record experience. "I like to think that time stops in art," Celmins once told an interviewer. "When you work on a piece for a long period it seems to capture time. . . . When you pack a lot of time into a work, something happens that slows the image down, makes it more physical."[21]

Mel Bochner, the pioneer conceptualist, had been an essential influence in introducing "the priority of the idea" into contemporary art making—that is, the confidence that the work's idea was more important than its physical embodiment. But as early as the 1970s, Bochner, like Celmins, switched focus and began to think about the development and physical recording of time in his work. Bochner's masking tape and text artworks from his earlier conceptual period had never been mere straightforward vehicles for communicating ideas; the works actually were visual investigations into—and critiques of—ideas. Nevertheless, the literalness and declarative character of most conceptual art, in which the work simply stands as a ready-to-digest, preformed linguistic statement from its inception, no longer accommodated Bochner's increasing desire to encode the memory of process inside the art itself. What, for example, about ideas that develop while actually making the art? Bochner's next step was to turn painting into a language, a text that could be continually rewritten. His transition to keenly handworked, sensuous, abstract painting allowed him to continue his investigations into how the mind works by recording "a narrative of revisions" through his brush strokes. "For me, painting, because it is in and of the material world, offers an access to the

processes of the mind, to the indecisions and uncertainties philosophy can't cope with," he has said.[22]

The workmanship of risk, then, is an open-ended undertaking that incorporates experiment, skillfulness, complexity, and intimacy over time. It is an uncertain enterprise, one with unforeseen results. Celmins has called her precarious process of working with physical materials a "phenomenological investigation."[23] Bochner, rejecting a didactic legibility in which the viewer simply reads, interprets, and learns from the art, has moved from linear explication to somatic experience and multidimensional perception as the subject of his painting. Perception, allied with the ambiguity of the physical senses, has been factored back into the art making process in contemporary art— a development that makes the hand and craftsmanship once again of vital importance.

THE HAND AND BODY AS PERCEPTUAL TOOL

The artist "takes his body with him" in making art.

—Paul Valéry[24]

Defining art as experience or perception, engaged with how humans understand and maneuver through the world, threatens to raise, once again, the arid centuries-old Western legacy of dualism (beautiful/ugly, mind/hand, art/life, consciousness/world). But a countertrend that accepts the totality of human perception and sensation as a rich and embodied way of being in the world has been a persistent and ever-expanding theme across a wide range of fields in 20th-century Western philosophy, aesthetics, cognitive science, and psychology.[25] In art, the integration of perceptual dualities is being worked out in diverse kinds of media, including those that at first glance seem most dematerialized. These artists have expanded the project of art and aesthetics into the complete universe of human perception and sensation, including, but also going beyond, the domain of conceptual thought, pure idea, or mere intentional act.

While a small group of contemporary philosophers has been chipping away at the mind-over-body bias emanating from the 17th century, a seminal 20th-century influence has been the French phenomenologist Maurice Merleau-Ponty, who died prematurely in an automobile accident in

1961. Merleau-Ponty sketched the outlines of a philosophy of perception that emphasized the "embodiment" of consciousness in *The Phenomenology of Perception* and developed this theme in later writings. Merleau-Ponty suggested that human consciousness is not an "inner," dematerialized, centralized, cerebral self that processes information to dominate and organize the "outer" world of matter. Rather, consciousness and perception emerge from a complicated blend of interaction between one's body and the world that engages all our sensory, motor, and intellectual capacities. Human perception, rather than being transcendent, is a reciprocally lived experience—we are intertwined in things; our selves are caught up in the fabric of the world; our understanding is inseparable from the body and its senses. "What makes the weight, the thickness, the flesh of each sound, of each tactile texture, of the present, and of the world, is the fact that he who grasps them feels himself emerge from them," he wrote.[26]

Art that employs embodied perception finds meaning not by opposing the materiality of the world, but by working through it. While works of art have semantic qualities, that is, "formal configurations which refer, in some sense, beyond themselves," they are also more than their linguistic structures.[27] Embodied art constructs a sensual reality as we might encounter it in perception itself, through the marks, the erasures, and the physical processes left by the artist's hand in the work. In this regard, art reflects our own insertion in the world. The artist who most represents this insertion is Cézanne, said Merleau-Ponty. Freed from the retinal dominance of Renaissance perspective, Cézanne's skewed, paint-laden, flat images are actually phenomenologically correct; that is, they show the way the world takes form around us when all of one's sensory abilities are more completely unified in perception: Cézanne "makes *visible* how the world *touches* us."[28]

THE HAND IN TECHNOLOGY: "IMMERSIVE" ART

For my part, when I enter most intimately into what I call myself, I always stumble on some particular perception or other, of heat or cold, light or shade, love or hatred, pain or pleasure. I never catch myself at any time without a perception, and never can observe anything but the perception.

—David Hume[29]

Art that symbolically or literally employs the hand engages in a special dialogue with postmodern technology and culture. Contemporary critical theory is laden with references to decentering and dematerialization—much of it blamed on the electronic media's ability to quickly and fluidly reproduce and modify images. Because we are electronically bombarded by multiple and continuously shifting points of view, everyday life appears less than solidly "real," according to this theory. Meaning, found either in oneself or in the world, must be deciphered from this broad and unstable network of viewpoints. And because the network is constantly shifting, meaning is continuously reconfigured; "reality" is continually being remade. Walter Benjamin, whose *The Work of Art in the Age of Mechanical Reproduction* set the tone for much of 20th-century cultural analysis, wryly put it this way: "The sight of immediate reality has become an orchid in the land of technology."[30]

The media-driven construct of reality as a process, rather than a static ground, however, has not been the only front on which the 20th century redefined the perceptual aspects of the physical world. The fields of mathematics and physics reconfigured the very basis of materiality itself, as linear cause-and-effect relationships between phenomena have been replaced with a paradigm that is most like an interactive matrix. The supposition that "objective reality" could be discovered by a passive scientist through logical, reductive, or even common-sense methods has been replaced by theories of indeterminism. Quantum theory and Einstein's theory of the relativity of space and time, which posited a reality that could no longer, as traditionally, be characterized as "solid," have most certainly widely influenced contemporary syntax and ways of viewing postmodern culture in general.[31] In philosophy, debate over the mind/body problem continues, as philosophers speculate about human consciousness and attempt to locate a continually reinvented and abstract "self" somewhere in relation to its organic bodily base. Some of the most interesting of these theories now incorporate the idea of "emergence" for consciousness—that is, shifting from the old-fashioned Cartesian central internal model to one that is external, emerging from a wide network of cerebral, experiential, and perceptual functions.

This recurring prototype of diffusion and multiplicity, of the network, resounds throughout contemporary art as well. The relation of the artist's self to the artwork and to the art audience has decidedly shifted, with the meaning of the art depending as much on audience reception

as on artistic intention. Postmodern audiences, in negotiating the art ex-
perience, are no longer required to look through a central privileged
point of view created by an artist, but find themselves as active partici-
pants in creating meaning.[32] And increasingly, contemporary art does
not seek to represent the world; rather, it operates in the realm of "felt"
experience. The contemporary orientation toward context and tran-
sience emerges particularly in genres such as installation art, which re-
lies on a field of relations between a spatial environment to create mean-
ing, rather than a conventional model of art object and observer. The
matrix model in digital art, too, has spawned interactive webs of simul-
taneous or sequential events for audiences with multiple levels of per-
ceptual space within a virtual environment.[33]

The human hand—and its association with identity, authenticity, sen-
sual experience, perception, and skill—stands in a unique position in a
culture that operates under conditions of diffusion, dematerialization,
simulation, and transience. At its most basic, handwork is subversive, a
stark alternative to technological dominance, even though it may not be
unreasonable to wonder whether we have become a "postmanual" soci-
ety. But "nostalgia is always in wait for us," warned the theorist and de-
signer David Pye, who debunked sentimental art that longingly looked
back to a premodern, premechanical pastoral past.[34] Rather than demon-
izing the qualities that define dematerialized media in order to charac-
terize their position in culture as a place of battle, it might be useful to
acknowledge how the values and the physical reality of the hand and
handwork are still integrated into contemporary art making—because,
whether they are negotiating a visceral or virtual environment, human
beings must still operate with a perceptual system that is organized
through their senses.

In fact, at the beginning of the 21st century, there has been a conflu-
ence of issues between what might be seen as two opposing camps—
artists who work by hand in physical materials (such as clay, fiber, or
paint) and artists who work in so-called dematerialized media (such as
video and computers). Many on both sides are exploring the place of
sensuous perception in their art. Conceptually oriented painters, for ex-
ample, do not deny the complexity and diffusion of postmodern culture
with their handwork, but rather use the hand to provide a powerful em-
bodied reference point—a "real" map—within provisional experience.
Likewise, in functional craft art, the most earth-bound, useful objects
humanize, but never deny, postmodern instability—the user always

maintains a central point of bodily reference within the fluidity of time and action. As they are used, therefore, functional craft objects are bound up with or immersed in an event—body, art, and process are intertwined in the most literal way, and the "meaning" of such objects is only completed by use over time.

Ironically, functional art, with its ancient handcraft traditions, incorporates an aesthetic of immersion—immersion in an event of the body or in life. It is not unlike the paradigms coming out of contemporary science and philosophy, that is, meaning as emerging from a lived process or network. It is not unrelated to Merleau-Ponty's description of reality as "a closely woven fabric."[35] The aesthetic of immersion, indicating a totality of body experience, has also coalesced in what might be considered to be the most dematerialized and newest art forms: video and digital art.

Many artists in electronic media, such as Bill Viola, Pipilloti Rist, Paul Sermon, and Robert Wilson, rather than neglecting the physical aspects of the body, are exploring the sensual aspects of consciousness with these forms.[36] Viola's monumental walls of video images in public spaces, with their vivid depictions of waterfalls, birth, death and roaring fires, heighten sensory experience and position it as a subject for investigation. "Experience is so much richer than light falling on your eyes," Viola has commented. "You *embody* a microcosm of reality when you walk down the street—your memories, your varying degrees of awareness of what's going on around you, everything we could call the contextualizing of information. Representing that information is going to be the main issue (for art) in the years ahead."[37] In his video art, which he called "telepresencing," Paul Sermon developed a method of projecting the image of a human body from one location over an ISDN telephone system to another location hundreds of miles away. "The whole point of telepresencing is to allow changes in the perception of the body," Sermon once told an interviewer. "And that is the central issue: where the body exists, does it exist here in the flesh, or does it exist in its effects? I believe that where a body can [have an effect] is really where it is . . . now, you can interact anywhere."[38]

While none of these electronic artists devises physically handmade objects, the work of each unarguably explores the visceral aspects of human perception and consciousness. For this reason, they are certainly allied with the experiential human-centered qualities associated with handcraftsmanship and the visceral body. As such, the aesthetic values

of the hand have not been lost, but rather have been dispersed into contemporary art forms. It is interesting, however, that as many contemporary artists push their work into even more dematerialized settings, they feel the need to intertwine their ideas more overtly with materiality, with gesture, and with the lived body. This can only enrich and enliven art making—and it positions the hand in the place of prominence it should have had in art history all along.

NOTES

1. David Pye, quoted in Tanya Harrod, "Paradise Postponed," in *William Morris Revisited, Questioning the Legacy* (London: Crafts Council Gallery, 1996), 19.

2. Shoetsu Yanagi, *The Unknown Craftsman* (Tokyo: Kodanska International, 1972), 108, both quotes.

3. Barry Schwabsky, "Loose Ends, Conceptual Knots, Liquid City," *The New Art Examiner* vol. 25, no. 1 (September 1997): 23.

4. James Meyer, "Mel Bochner: The Gallery Is a Theater," *Flash Art* vol. 27, no. 177 (Summer 1994): 142.

5. Edward Leffingwell, "Report from São Paulo," *Art in America* vol. 85, no. 3 (March 1997): 39.

6. Rainer Maria Rilke, quoted in *The Extended Hand: A Portfolio of Experiences for the Hand* (University of Kansas Museum of Art, 1974), unpaginated.

7. Janet C. Mainzer, "The Relation between the Crafts and the Fine Arts in the United States from 1876 to 1980," Ph.D. thesis, New York University, New York, 1988, 186.

8. Barbara Maria Stafford, *Body Criticism: Imaging the Unseen in Enlightenment Art and Medicine* (Cambridge, Mass.: MIT Press, 1991), 29.

9. Harrod, *William Morris Revisited*, 7.

10. Frank Whitford, *Bauhaus* (London: Thames and Hudson, 1984), 12.

11. Ann Gibson, "Avant-Garde," in *Critical Terms for Art History*, Robert S. Nelson and Richard Schiff, eds. (Chicago: University of Chicago Press, 1996), 162.

12. Jennifer Harris, "The Unity of Art," in *William Morris Revisited*, 82.

13. Philip Taaffe, "Talking Abstract, II," *Art in America* vol. 75, no. 12 (December 1987): 122.

14. Marguerite Wildenhain, *The Invisible Core: A Potter's Life and Thoughts* (Palo Alto: Pacific Books, 1973), 133.

15. Author's interview with Laura Hoptman, September 1997.

16. Laura Hoptman, *Projects* (New York: Museum of Modern Art, 1997), unpaginated.

17. Taaffe, "Talking Abstract," 122.

18. David Pye, *The Nature and Art of Workmanship* (Bethel Court, U.K.: Cambrium Press, 1995), 25–26.

19. Pye, *Nature and Art,* 20.

20. Pye, *Nature and Art,* 61–62.

21. Jeanne Silverthorne, "Vija Celmins in Conversation with Jeanne Silverthorne," *Parkett* no. 44 (July 1995): 42.

22. Meyer, "The Gallery Is a Theater," 101.

23. Nancy Princenthal, "Vija Celmins: Material Fictions," *Parkett* no. 44 (July 1995): 25.

24. Maurice Merleau-Ponty, "Eye and Mind," *The Primacy of Perception and Other Essays*, John Wild, ed. (Evanston, Ill.: Northwestern University Press, 1964), 162.

25. See Mark Johnson, *The Body in the Mind: The Bodily Basis of Meaning, Imagination and Reason* (Chicago: University of Chicago Press, 1987) and Bernard J. Baars, "Can Physics Provide a Theory of Consciousness?" *Psyche* vol. 2, no. 8 (May 1995): at http://psyche.cs.monash.edu.au (accessed September 30, 2002).

26. Paul Crowther, *Art and Embodiment: From Aesthetics to Self-Consciousness* (Oxford: Oxford University Press 1993), 106.

27. Paul Crowther, *Critical Aesthetics and Postmodernism* (Oxford: Clarendon Press, 1993), 48.

28. Crowther, *Art and Embodiment*, 107.

29. David Hume, quoted in Daniel Dennett, "The Self As a Center of Narrative Gravity," in *Self and Consciousness: Multiple Perspectives*, F. Kessell, P. Cole, and D. Johnson, eds. (Hillsdale, N.J.: Erlbaum, 1992). This paper was published online at http://ase.tufts.edu/cogstud/papers/selfcr.htm (accessed September 30, 2002).

30. Crowther, *Critical Aesthetics and Postmodernism*, 17.

31. Patricia Search, "The Semiotics of the Digital Age," *Leonardo* vol. 28, no. 4 (1995): 312.

32. Johan Pijnappel, "Introduction to Art and Technology Section," *Art and Design* vol. 9, no. 11–12 (November/December 1994): 7.

33. Search, "The Semiotics," 313.

34. Pye, *Nature and Art,* 137.

35. Maurice Merleau-Ponty, quoted in Richard Kearney and Mara Rainwater, *The Continental Philosophy Reader* (New York: Routledge, 1996), 82.

36. Polly Ullrich, "Beyond Touch: The Body As Perceptual Tool," *Fiberarts* vol. 26, no. 1 (Summer 1999): 47.

37. Virginia Rutledge, "Art at the End of the Optical Age," *Art in America*

vol. 86, no. 3 (March 1998): 76.

38. Johan Pijnappel, "Paul Sermon: Telematic Presence," *Art and Design* vol. 9, no. 11–12 (November/December 1994): 87.

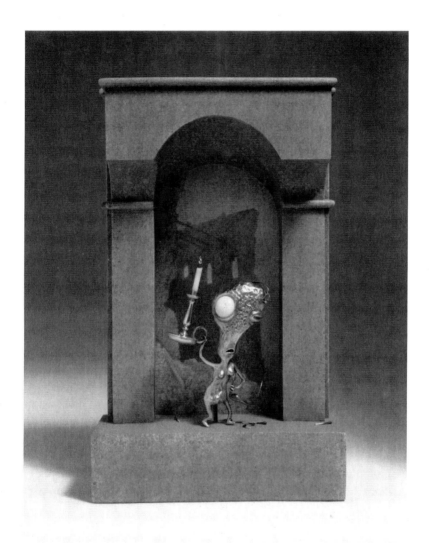

Bruce Metcalf, A Candle in the City of Darkness (brooch with stage). Brass, painted wood, sterling silver, 14k gold, delrin, and corian, 7½ × 5 inches, 1996.

Evolutionary Biology and Its Implications for Craft

Bruce Metcalf

Recent artworld discourse maps the familiar struggle between form and content, between modernist ideas about the aesthetic experience and postmodernist theories about the cultural embeddedness of art. As the reductive formalism of Clement Greenberg lost its cachet, the idea that art must perform a critique on the dominant culture became a dominant force itself. A notable example of art as critique appeared at the 1993 Whitney Biennial in the form of a set of five little metal admission tags by Daniel J. Martinez commissioned especially for the show. The five tags read, "I can't," "imagine," "ever wanting," "to be," and "white," the punch line being that the Whitney's mostly white audience had to fix fragments of this message on their bodies after buying their tickets. Okay, whatever. But the problem was that the artwork was resolutely unengaging to look at. One could think about the tags at length, but seeing them provided no special charge.

Naturally, some artworld observers objected and decried the absence of visual stimulation in an exhibition that was supposed to feature visual arts. Against a tide of political correctness, it appears that aesthetic pleasure has not been drowned by content yet. But the two views seem to be mutually incompatible: there appears to be no theory that can encompass both positions.

In craft, both positions have long been accommodated. I speak of craft as a class of objects and as a practice rooted in late-industrial so-

This essay was adapted from "Morality, Biology, and Other New Aesthetic Territories," presented at the 1996 College Art Association session "Upstream: Theoretical Headwaters of the Craft Arts."

cial conditions. I do not use the word as simply designating skillful accomplishment. To craft practitioners, it has never been seen to be a contradiction to make a beautiful, useful pot, for instance. This ability to tolerate seeming logical inconsistencies may be a legacy of the craft world's refusal to engage and clarify its ideologies. However, craft's ability to fuse form and content may not be as ignorant and uninformed as it initially appears.

A possible solution to the artworld quandary is in the adoption of multivalence as a structural principle. The opposition between form and content depends on a philosophical commitment to monism: the idea that a system of thought can be constructed from a single assertion, property, or concept of the good. Craft, by its very nature, refuses monism of any kind.

By definition, craft is multivalent. I can locate five aspects which identify a craft object, each of which have different implications. First, craft must be an object. Second, the object is usually made substantially by hand. Third, the craft object can be made from traditional craft materials (like clay, glass, or fibers) utilizing traditional craft techniques—but it doesn't have to be made with these materials and techniques. Fourth, the craft object can, but again doesn't have to, address traditional craft functional contexts, like furniture or clothing. And last, the craft object can refer to the vast histories of craft. Thus, the craft identity is incremental: the more of these aspects that are embodied in an object, the more craft it is. There is no simple black-and-white here, only matters of degree.

Craft practice emerges from several subcultures, and the values of these cultures largely determine what kind of objects emerge from them. My mother, for instance, learned how to weave at the Hill Institute in Florence, Massachusetts, and she internalized the values they taught. She made placemats, table runners, and the occasional coverlet. For a while, she even had a production line of placemats and runners, no two sets the same, which she sold for far less than they were worth. Weaving served several purposes for my mom. First, weaving was social: it gave her a group of friends who had the same interests. But it also enabled her to make useful, unique, and good-looking objects to send out into the world. The low prices were her version of noblesse oblige. According to my mother, woven "wall hangings" did not interest her because they did not serve any useful purpose. She had no ambition to be an artist.

There are numerous other craft subcultures that uphold similar values. There are timber-framers, replica furniture makers, amateur knitters and seamstresses, guys who make flintlock rifles, women who embroider. All of these craft practices prosper alongside of the mainstream art/crafts that are documented by *American Craft, Metalsmith,* or *American Ceramics.* I propose here that many of those craft cultures are not just superficial adaptations to late-industrial conditions—although they are partly that—but that they uphold values that represent specific human mental structures, formed by the process of evolution. That is to say, craft is rooted in a biological human nature. Furthermore, I propose that some of these craft values are highly moral and that this moral component is also rooted in human nature. I realize that these assertions might sound preposterous, so let me explain.

In the past twenty years, a substantial body of research has emerged that provides strong evidence for an innate human nature, which has been formed in part by Darwinian natural selection. Put another way, evidence indicates that the human mind exhibits pancultural "mental structures" that are very similar in every individual and that these structures were formed as biological evolutionary adaptations. Much of this thinking is influenced by Noam Chomsky and his idea of a "universal grammar," by which language is learned and used according to innate mental structures. Basically, Chomsky and his adherents believe in a human nature.

It should go without saying that such an assertion is controversial, for the idea of a definable human nature flies in the face of the Standard Social Science Model (SSSM), which asserts that the human psyche is molded by the surrounding culture. Franz Boas and his followers developed the SSSM specifically to counter social Darwinism. In the late 19th century, some intellectuals seized on Darwin's idea of the survival of the fittest, which dealt with species of animals, and mutated it into a social theory that held that the most fit societies would survive best. Of course, the purpose of social Darwinism was to justify colonial exploitation. The theory held that weaker, presumably more primitive societies could be overrun by the presumably superior Western powers. Survival of the fittest, right? The fact that the theory was based on a fallacious analogy between species and societies was conveniently overlooked.

Boas was offended by the popular opinion that preliterate people were nothing but savages. His goal was to place preliterate peoples on

an equal footing with Europeans, and his method was to deculture all humans. If we are all equally blank, then we are all equal. So Boas and his followers sought evidence that culture imposes all forms of behavior and language upon a human *tabula rasa*. One of the most significant documents in the debate was Margaret Mead's *Coming of Age in Samoa*, published in 1928. In her fieldwork, Mead thought she had discovered a society in which the normal rules of Western conduct no longer applied: there were no hierarchies of status and power; no competition; no sexual jealousy; and no monogamy. The supposed elements of human nature were voided, and the SSSM proved beyond a doubt. Social Darwinism was discredited. In turn, the conception that there is no such thing as a pancultural human nature is the foundation of a great deal of twentieth-century thinking. Another term for this thesis is environmentalism; one of its champions was B. F. Skinner. Ultimately, environmentalism underlies much of what passes for postmodernism. The conventional wisdom holds that we are formed exclusively by culture and especially by language.

At the age of twenty-three, Mead spent nine months in Samoa, but the anthropologist Derek Freeman spent six years there in the late 1970s. He discovered that Mead didn't live with her subjects and that her informants were often goofing on her. Some of Mead's conclusions were flat-out wrong. For instance, while Mead said that unmarried Samoan women freely experimented with sexual intercourse, Freeman found that Samoans put a great value on virginity at marriage and that nonvirgins were beaten and shamed. Many of Mead's other conclusions turned out to be suspect as well.[1]

In the past two decades, a great deal of research has emerged that points to a biological human nature that was formed largely by evolution.[2] Much of the evidence comes from rigorous anthropological fieldwork and some comes from sociology. But the most persuasive evidence has come from research into the human brain, particularly studies of damaged brains and how they function differently from normal ones. The most famous book about this kind of research is Oliver Sacks's *The Man Who Mistook His Wife for a Hat and Other Clinical Tales*. Sacks recounts amazing stories of how damage to very precise areas of the brain causes very particular (and curious) losses in function. In one case, Sacks describes a patient with Korkasov's Syndrome (caused by destruction of the mammillary bodies, two small protuberances under the fore ventricles of the brain) who had completely lost his short-term

memory. He remembered nothing after 1945 and otherwise had complete amnesia. He thus remained in an eternal now, unable to remember anybody he met, anything he read, or most of what he experienced. Other cases of specific brain damage can cause people to fail to recognize things (visual agnosia), fail to perceive things in half their sphere of vision, or be unable to learn how to read. In the end, it appears that much of what it is to be human is sited in very specific areas of the brain.

Other research suggests how human behavior is formed by genetic imperatives. Evolutionary theory assumes that humans evolved in small groups on the African savannah. Certain facts of human life predominate. First, human babies are helpless at birth and need about fifteen years to mature, demanding a great deal of care and attention. Females provide milk for infants, which males cannot do. It appears that females and males adapted to the conditions of child-rearing by specializing in gathering and hunting, respectively, and this division of labor led to genetic modifications. Women, for instance, have more neural connections between the two halves of the brain. It has been suggested that these connections make women better at perceiving small events in a wide field of vision, enabling them to find plants and berries better than men. Men, on the other hand, seem to be better at detecting motion at the center of the field of vision, which is exactly the skill demanded by hunting animals.

Another fact of human life is sexual: males and females have radically different ways of getting their genes into the next generation. Under normal conditions, females can have between one and ten babies during their fertile years. Men, not being limited by pregnancy, can father dozens or even hundreds of children. If the evolutionary imperative is simply to get the maximum amount of genetic material into succeeding generations, it's pretty obvious that women and men will develop rather different strategies for doing so. And so, it seems the peculiar differences in male and female sexual behavior make sense when seen in this light. That sleazy guy sitting at the bar might not be just an insensitive cad—he might be employing the best strategy to spread lots of his genes into the world.

There appear to be other behavioral adaptations as well that are shared by both sexes. Helping a close relative in danger turns out to be an adaptive behavior if the individual being helped is your offspring: more of your genes are likely to survive into the next generation. But

surprisingly, such helping is also adaptive if you help your niece or nephew; again, more of your genes are likely to survive. Obviously, helping is extended to nonrelatives as well; an individual who helps other people in his or her group will be more likely to have such favors returned at a later time and is more likely to prosper. The mechanisms of helping appear to be the source of much of our social behavior: we expect our favors to be returned; we admire people who unselfishly give to others; we learn to anticipate how other people feel. All of these behaviors and many others now appear to be genetically programmed into the human brain, and these behaviors constitute human nature.

The field that studies innate human behaviors and mental structures has been called evolutionary biology. I should point out that little of the evidence about an innate human nature suggests that biology is destiny, exactly. While we are all evidently primed to learn a language between the ages of two and ten, and while all human languages share certain characteristics, we are not programmed to learn a specific language. The biological brain simply offers a menu of characteristics and possibilities. We will tend to behave certain ways, given the nature of our brains, but the specific behaviors are subject to considerable cultural and individual variation.

I was once very skeptical that anybody could delineate an innate human nature, and I was a true believer in the SSSM. But four books, each one a summation of a broad range of research from many different disciplines, changed my mind completely. In his book *The Language Instinct*, Steven Pinker[3] details how all languages show remarkable pancultural similarities, especially in the means by which language is learned and structured. Pinker persuasively defends Chomsky's thesis: that the human mind is a biological organ that predetermines many of our capacities and that is far from being an arbitrary cultural construction. Reinforcing this view, educational psychologist Howard Gardner argues that the mind has several discrete capacities located in different areas of the brain.[4] His idea of a distinct "bodily intelligence" has much to say about craft, in that the impulse toward physical mastery is both intelligent and innate.

A potter who learns to throw with great skill is exercising a biological aspect of mind, and he is doing so at a high level comparable to great athleticism, great musicianship, great science, or great writing. Skilled work is, in fact, a manifestation of intelligence. The hierarchy promoted by this culture's emphasis on verbal and mathematical intelligence is

overthrown, in Gardner's view, because privileging one aspect of the biological mind over another is plainly arbitrary, nothing more than a social construction. His theory of multiple intelligences strongly suggests a multivalent approach to both art and craft and provides a foundation in observable fact for a future aesthetic system. It also undermines any attempt to dismiss craft due to an ostensible lack of intelligence—which is the basis of an argument often encountered in the art academy. I recall a review of a Robert Arneson show years ago; the reviewer said the work "stank of the kitchen." Obviously, she favored the refined scent of the library. This type of snobbery would be much more difficult to defend if Gardner's theory were taken into account.[5]

I could continue examining the theory of multiple intelligences for some time, but I want to turn now to the moral component of craft. My thinking is based on two very interesting books that offer evidence that a sense of morality may be part of the biological mind. One is Robert Q. Wilson's *The Moral Sense*,[6] and the other is Robert Wright's *The Moral Animal*.[7] Both provide a wide range of scientific evidence that suggests that certain moral tendencies may be part of our genetic makeup, and both speculate as to the evolutionary conditions that might have produced morality as an adaptive mental structure of the human organism.

Both books propose a stable human nature that is pancultural and from which springs a moral instinct. Morality dictated by religious fundamentalism is absolute and restricts interpretation. A more moderate moral position, ethical conditionalism, asserts that morality is determined by human nature and the human condition. This can be called the dependency thesis, because it holds that morality depends on human conditions in the world and does not emanate from some transcendent source. As such, ethical conditionalism relies on the concept of a stable and pancultural human nature, which, of course, is what Wilson and Wright argue for.

Both Wilson and Wright offer a persuasive case for ethical conditionalism. Both locate the moral sense in human nature, which is itself rooted in ordinary facts of living. The view is interesting because it neither assumes a moral law based on religious belief nor submits to complete cultural relativism. Specifically, James Q. Wilson cites numerous studies about how people cope with families and child rearing, how people make and keep relationships, and how people face ethical decision making. He points to certain facts of human existence: that mater-

nal feeling for small children is universal; that children are not abandoned in large numbers, even though it is inconvenient to care for them; and that some moral universals, like the prohibition against incest and unjustified murder, appear to exist. From the vast amount of evidence he assembled, Wilson concludes that there is a moral sense shared by all of humanity. He summarizes his case by claiming that

> people necessarily make moral judgments, many of those judgments are not arbitrary or unique to some time, place, or culture, and that we will get a lot further in understanding how we live as a species if we recognize that we are bound together both by mutual interdependence and a common moral sense. By a moral sense I mean an intuitive or directly felt belief about how one ought to act when one is free to act voluntarily (that is, not under duress). By "ought," I mean an obligation binding on all people similarly situated.[8]

Wilson proposes four basic moral sentiments that appear to be pancultural and provides numerous studies (mostly from the United States and Europe, but also from anthropological studies all over the world) as evidence. While space is far too limited here to give an adequate defense of Wilson's conclusions, I can outline them.

First, Wilson talks about sympathy, which he defines as the "human capacity for being affected by the feelings and experiences of others." Sympathy has two components: first as a standard of judgment in that we are disposed to regard worthiness as a precondition for our sympathy. Secondly, sympathy sometimes motivates benevolent actions, especially when people feel personally responsible for helping. As with any of the moral sentiments, Wilson insists that sympathy acts not as a monistic principle that applies in each and every case, but as a sense of conscience that can be ignored and that some individuals seem to lack entirely. As a moral sentiment, sympathy motivates altruistic acts like putting one's own life in jeopardy to save a drowning person, intervening to stop a crime in progress, or donating blood. Wilson cites studies that show those most likely to help others in dire need were themselves the beneficiaries of a warm family life where the importance of dependability, self-reliance, and caring for others were stressed. They saw people as basically good and usually had many close friends. Obviously, we don't always act in an altruistic manner, and calculations as to the cost of helping are important. Sympathy is a "fragile and evanescent emotion . . . easily aroused but

quickly forgotten," often subverted by authorities and peer pressure. Nonetheless, sympathy is surprisingly durable and motivates many of the actions we most admire.

Wilson defines self-control as another of the moral sentiments. He sees self-control as manifested in moderation and prudence, usually in making a choice between immediate gratification and long-term benefits. Self-control tempers impulsive action and moderates self-expression. Wilson contrasts self-control with destructive and violent behavior. For example, in tests given to preteen children, impulsiveness in combination with aggressiveness and lack of sympathy predicts a high probability of future criminal behavior. Self-control is demonstrated by the mastery of skills, which has clear implications about craftsmanship. A well-made chair demonstrates that the woodworker who made it was steadfast enough to learn the requisite skills and patient enough to fabricate the chair itself. Mastery is evidence of self-control.

Wilson describes two other moral sentiments, fairness and duty. Fairness is the sense of just and proportionate distribution and is usually manifested in sharing and reciprocity. It's the most legalistic of his four sentiments, closely related to making impartial judgments, assigning and claiming entitlements, and distributing property. The idea of fairness governs the business of helping, in the sense that we usually expect people to assist us once we have helped them and think it unfair when they don't.

Duty is "willing[ness] to honor obligations in the absence of social rewards for doing so." Wilson says it is roughly equivalent to conscience, but not in the Freudian sense of superego, which he rejects. Instead, he sees duty as rooted in the innate desire for human connectedness, in that conscience leads us to do what others expect, and thus gain their approval and respect. Wilson concedes that duty is one of the weaker moral senses. It's also the moral sense that makes life civilized and not brutal.

Obviously, Wilson's thesis that sympathy, self-control, fairness, and duty comprise an innate moral sense will be rejected by those who deny the possibility of a human nature. Those individuals should read both books with an open mind.

Wilson finds extreme individualism—one of the more dubious inheritances from the Enlightenment—to be corrosive to modern society. He questions whether rights belong primarily to individuals (as in the United States) or to groups (as in Eastern Asia). He says that

the philosophical commitment to radical individualism is destructive not only of family life but also those mediating institutions—small communities and face-to-face associations—that sustain a morally competent, socially connected individual against the estrangement of mass society.[9]

He continues to say that Western individualism, while reducing some mass violence and social prejudice, has resulted in "a lessened sense of honor and duty, and a diminished capacity for self-control." Given the annual increases in rape, child abuse, and battering of women in the United States, his critique of the cult of individuality has some urgency. While he does not advocate abandoning the concept altogether, he links runaway individualism with alienation and implies that a moderating influence is necessary. Unfortunately, he prescribes no cures. But he does locate the most effective devices for reinforcing social connectedness in modest areas like families, small groups, and neighborhoods. It is precisely these social spheres that art has abandoned and that craft continues to occupy.

What if an aesthetic theory embodied the moral virtues of sympathy, self-control, fairness, and duty? Instead of a legalistic structure to establish an aggressive hierarchy of exclusion, could there be an aesthetic of caring, a moral system of sympathy transposed into the realm of art? James Q. Wilson makes no claims in *The Moral Sense* that his understanding of human nature should have any impact on aesthetics. However, if a renaissance of moral thinking is demanded by current social conditions, then Wilson's idea of moral sense offers an excellent concept to begin with.

Craft, as a practice, has always had a moral component, and American craft in particular has been guided by an ethic of helping. Several prominent craft schools (Penland and Arrowmont among them) grew from altruistic projects intended to preserve local craft traditions while simultaneously providing livelihoods for the rural poor. The School for American Craftsmen started as a rehabilitation program for returning soldiers during World War II. Certainly the many American craft guilds and medium groups founded in the past five decades were conceived as communal mutual-aid groups, recognizing the educational and monetary benefits of cooperation. In the sociology of craft, helping (both altruistic and self-interested) is a primary value. Craftspeople have intuitively created exactly the mediating institutions that Wilson speaks of. The culture of American craft is a culture of sharing and helping.

Furthermore, I believe certain types of craft objects—especially objects designed to be used, rather than just looked at—embody sympathy.[10] Because craft objects are substantially handmade, traces of the maker's body and its movements often remain in the object: the potter's fingerprint; the silversmith's planishing mark; the stitches of the needleworker; the irregular form of a glassblower's vase. Such marks record the presence of a living person who exists at one "degree of separation" from the user. Ordinary people recognize this intuitively, and they read a craft object as a symbol of human presence. As such, crafts stand in clear contrast to mass-produced objects, from which any trace of the human has been erased. It's the difference between a handmade and a manufactured plastic bowl, not merely a semiotic difference. In an increasingly dematerialized world, these records of human presence become increasingly important to people.

Secondly, a useful craft object becomes a helper in the home and, thus, embodies a sympathetic gesture. The more quotidian and intimate the object becomes, the more vivid the embodiment of sympathy. If I eat my breakfast cereal out of a handmade ceramic bowl, I am reminded of how the potter's effort is consummated in my use of the bowl. If I wear a piece of handmade jewelry, I am reminded how the jeweler helps me fabricate a persona to my liking. In these cases, and many others, the craft object intentionally benefits its user.

Craftspeople see their production as a means of distributing an experience. Most of them really like what they do (they're not in the business for the money!), and they are experts on the kind of experience their objects provoke. For instance, potters typically collect pots and use them all the time. They become familiar with the heft, the balance, the texture, and the functional properties of a vast array of pots. They study each pot under a variety of conditions: full, empty, in the hand, or next to another pot. This is a research of experiences, not just visual data. A serious potter will make qualitative judgments about every part of the encounter, even the sound. (A good pot will ring when you snap its rim with your finger, a poor pot will thud.) Their accumulated knowledge informs their studio work: each pot is intended to re-create, for the user, an experience its maker found good.

I think that the best useful craft unites helping with pleasure. Of course, helping is not the exclusive province of craft. Mass-produced consumer goods are sometimes very efficient at making our ordinary lives easier and more comfortable. I am a particular fan of plastic

food storage containers, with their airtight seals and clear bowls so you can see what's decaying inside. Rubbermaid® has become very good at designing and making those little vessels, but they are intended to be economical and efficient above all else. The experience of using them is utterly ordinary. They are helpful, but resolutely unspecial.

On the other hand, good production craft makes what might otherwise be an ordinary experience interesting and satisfying. The goal is to move art into life. Of course, this was the same goal proposed by the Arts and Crafts Movement in the 19th century and by some aspects of Russian constructivism in the 20th. Both movements recognized that purely efficient products might serve their purposes well, but might remain uninteresting, and accordingly tried to produce useful objects that also provided (what might be regarded as) an aesthetic experience. In this new century, useful craft has the same agenda.

The craftsperson can orchestrate an experience that is fully encountered only through use. The scarf that is worn, the pot that holds food, the chair that is sat upon: each of these objects creates an experience for its user, and this encounter is designed to be more complex, more stimulating, and more pleasant than the experience of a similar mass-produced object. These pleasures might be small, but they are not insignificant. Such experiences pull our attention back to our own bodies, away from the many distractions of contemporary life. They create unexpected surprises, they offer pleasure where we have become accustomed to having none. (Unique craft objects also help in the project of asserting an individual identity, but that's another subject.) Taken together, the many types of experience engendered by the use of craft objects can be quite beneficial, even while they are unassuming. The maker of useful craft—in recreating her own pleasures for others—is performing an act of sympathy. The craft object embodies a moral act.

This kind of moral embodiment is pervasive because useful craft is not terribly expensive and persuasive because consumers often buy directly from the producers. Unlike fine art, production craft has never signified exclusivity with a steep price tag. Crafts have been purchased by hundreds of thousands of people, fulfilling the constructivist ambition to extend art into life. In addition, consumers often meet craftspeople at fairs and occasionally develop relationships over a period of years. Many people speak fondly of their encounters with

craft producers, and the relationship underlines the sympathetic nature of the object.

In conclusion, a biological basis for examining craft objects and craft practice has three implications. First, we can align craft with a secular sense of morality, which I believe is demanded in the present social and political climate. Second, the biological basis implies a multivalent evaluation of both art and craft. I have been speaking of a moral component to craft, but only as one component among many possibilities. Other criteria remain. Instead of holding art or craft up within a single frame—the aesthetic frame, the embodied meaning frame, or whatever—it seems increasingly likely that we can apply any number of points of view to the object at hand. And lastly, the biological basis suggests that any one of these points of view may not be inherently superior to another. The business of privileging one form over another becomes more difficult, while the tolerance of difference becomes easier. Craft thus serves as a vehicle for a number of important values and encourages an open and multivalent interpretation.

NOTES

1. Freeman, Derek. *Margaret Mead and Samoa: The Making and Unmaking of an Anthropological Myth.* Cambridge, Mass.: Harvard University Press, 1983.

2. The first important text to argue for a biological human nature was Wilson, Edward O., *Sociobiology: the New Synthesis.* Cambridge, Mass.: Harvard University Press, 1975. It was widely attacked by the ranks of the politically correct when it first appeared. Also see Brown, Donald E. *Human Universals.* New York: McGraw-Hill, 1991; Wright, William, *Born That Way: Genes, Behavior, Personality.* New York: Alfred A. Knopf, 1998; and Pinker, Steven. *How the Mind Works.* New York: W. W. Norton, 1997.

3. Pinker, Steven. *The Language Instinct.* New York: William Morrow, 1994.

4. Gardner, Howard. *Frames of Mind: The Theory of Multiple Intelligences.* New York: Basic Books, 1985.

5. See the author's chapter in *The Culture of Craft*, edited by Peter Dormer, Manchester, U.K.: Manchester University Press, 1997, for a more detailed analysis of the theory of multiple intelligence and its implications for craft criticism.

6. Wilson, Robert Q. *The Moral Sense.* The Free Press, 1993.

7. Wright, Robert. *The Moral Animal, the New Science of Evolutionary Psychology*. New York: Pantheon Books, 1994.

8. Wilson, *Moral Sense*, xii.

9. Wilson, *Moral Sense*, 218.

10. For a more detailed exposition, see Metcalf, "Embodied Sympathy," *Metalsmith* (Summer 2002): 35.

About the Contributors

Rob Barnard is a potter, writer, and lecturer in ceramics at the Catholic University of America in Washington, D.C. He studied pottery at the University of Kentucky in 1971 and at Kyoto University of Fine Arts under the late Kazuo Yagi in Kyoto, Japan, where he was a research student from 1974 to 1977. He received two fellowships from the National Endowment for the Arts in 1978 and 1990. He exhibits widely in the United States, Japan, and Britain and has had solo exhibitions in New York, Washington D.C., Boston, London, Amsterdam, Tokyo, Nagoya, and Osaka. His work is in the collections of the Smithsonian Museum of American Art's Renwick Gallery, the American Craft Museum, the Everson Museum, and the Mint Museum. Barnard was ceramics editor for the *New Art Examiner* from 1987 to 1993 and has written articles for *Studio Potter, American Craft, Ceramics Monthly, Ceramics, Art & Perception, Keramich,* and the *New Art Examiner.* He lives in Timberville, Virginia.

Johanna Drucker is the Robertson Professor of Media Studies at the University of Virginia. Her scholarly books include: *Theorizing Modernism; The Visible Word: Experimental Typography and Modern Art; The Alphabetic Labyrinth; The Century of Artists' Books*; and a volume of collected essays, *Figuring the Word.* She has held fellowships from the University of California, the Fulbright Commission, and the Getty and has lectured on contemporary art at the Whitney Museum of Contemporary Art, the Pompidou Center in Paris, and at many colleges and universities. In addition to her scholarly work, Drucker is a book artist and an experimental, visual poet. Her work is in the collections of museums and

libraries throughout the United States and Europe. Her most recent publication, a collaboration with artist Susan Bee, is titled *A Girl's Life*. She lives in Charlottesville, Virginia.

M. Anna Fariello is an independent curator with Curatorial InSight and a faculty member of the Center for Interdisciplinary Studies at Virginia Tech. She is a former Renwick Research Fellow at the Smithsonian Museum of American Art; a Fulbright scholar to Latin America; and material culture cochair for the Smithsonian Folklife Festival 2003. She has lectured widely and curated such exhibitions as *Movers & Makers: Doris Ulmann's Portrait of the Craft Revival, ReFORMations: New Forms from Ancient Techniques,* and *Color & Clay* and is author of exhibition catalog essays on blacksmiths Samuel Yellin and Francis Whitaker. Her writing has appeared in magazines including *American Craft, Style 1900, Metalsmith, Ceramics: Art and Perception,* and *19th Century.* She contributed a chapter to *Women, Art and the Landscape of Southern Memory* and is art editor for the *Encyclopedia of Appalachia.* She holds an M.F.A. from James Madison University and an M.A. from Virginia Commonwealth University. From the mid-1970s to the mid-1980s, Fariello was a studio ceramist whose work appeared in *Ceramics Monthly, Ms.* magazine, and *Women Artists News.* She lives near Blacksburg, Virginia.

Michele Hardy is a textile artist and lecturer in cultural anthropology. She recently completed her doctorate in anthropology at the University of British Columbia, Vancouver, Canada. She also holds an M.A. in clothing and textiles from the University of Alberta; a B.A. in anthropology from the University of British Columbia; and a B.F.A. in textile studio from the Nova Scotia College of Art and Design. She has exhibited her textile sculpture across Canada, with solo exhibitions in both Halifax (1985) and Vancouver (1990, 1991). She has participated in numerous academic conferences, most recently presenting papers at the Berkshire Conference on the History of Women (2002) and the Textile Society of America's 7th Annual Symposium (2000). Hardy lives in Vancouver, Canada.

Patricia Malarcher is currently the editor of the *Surface Design Journal* and a practicing artist. Her articles have appeared in *American Craft, Fiberarts, Metalsmith,* and the *New York Times.* She has con-

tributed chapters to books, including *Helena Hernmarck: Tapestry Artist* and *Michael James: Studio Quilts,* and wrote an entry on weaving for *The Encyclopedia of Women and World Religion.* She has written catalog essays for numerous exhibitions and has lectured on contemporary crafts in Canada, Finland, and Russia, as well as throughout the United States. In 1989 she was the recipient of a James Renwick Fellowship to research critical writing on contemporary American crafts. Her pieced constructions have been exhibited internationally and are in the collections of the American Craft Museum and the Cleveland Art Museum. She holds an M.F.A. from the Catholic University of America, Washington, D.C., and has pursued further studies at New York University. She lives in Englewood, New Jersey.

Bruce Metcalf has been described as the "Socratic gadfly of metalsmithing" by art historian Sean Licka. He earned a B.F.A. from Syracuse University and an M.F.A. from Tyler School of Art in Philadelphia. He has taught at the Massachusetts College of Art, Colorado State University, Kent State University, and the University of the Arts in Philadelphia. He has been awarded two fellowships from the National Endowment for the Arts; three Ohio Arts Council Fellowships; a Fulbright Teaching and Research Fellowship; and a Pew Fellowship in the Arts. His figurative pins and necklaces have been exhibited internationally and can be seen in a number of books about contemporary art jewelry. Among public collections that include his work are the Cooper-Hewitt Museum of Design in New York, the Renwick Gallery in Washington, D.C., and Le Musée des Arts Décoratifs de Montréal, Quebec. His writing on modern craft has been published widely. Metcalf lives near Philadelphia.

Paula Owen has been the director of the Southwest School of Art and Craft in San Antonio, Texas, since 1996 and is former director of the Hand Workshop Art Center in Richmond, Virginia. She has served on several national and regional boards and panels, including visual arts panels for the National Endowment for the Arts, and has written for the *New Art Examiner, Art Papers, Metalsmith,* and *American Ceramics.* Owen has organized numerous exhibitions, including traveling exhibitions such as *Mark Lindquist: Revolutions in Wood, Touch: Beyond the Visual,* and *Ken Little: Little Changes.* She has also organized regional and national conferences, including Women and the Craft Arts at the National Museum of Women in the Arts. Owen is also an exhibiting

artist. She holds an M.F.A. from Virginia Commonwealth University in painting and printmaking and an M.S. in art education from Moorhead State University. She lives in San Antonio, Texas.

John Perreault is a contributing editor for *N.Y. Arts Magazine* and *American Ceramics.* He was the executive director of UrbanGlass, Brooklyn, New York, and the editor of *GLASS Quarterly* until 2002. He is former senior curator of the American Craft Museum, director of the Newhouse Center for Contemporary Art, and chief curator of the Everson Museum of Art. From 1966 to 1974 Perreault was lead art critic for the *Village Voice* and from 1975 to 1982, senior art critic and art editor for the *Soho News.* His writings have appeared in *Art in America, Artforum, Arts, American Craft, American Ceramics, GLASS,* and in journals and anthologies of criticism. He is the author of *Philip Pearlstein: Drawings and Watercolors.* He has taught at the New School and the School of Visual Arts in New York City; the University of Arizona, Tucson; the University of California, San Diego; the State University of New York, Binghamton; and the University of Australia, Canberra. He is currently a trustee of the Louis Comfort Tiffany Foundation. Perreault lives in New York City.

Suzanne Ramljak is editor of *Metalsmith* magazine. She is former curator of exhibitions at the American Federation of Arts; editor of *Sculpture* magazine; editor of *Glass* magazine; and associate editor of *American Ceramics* magazine. Ramljak is the author of *Crafting a Legacy: Contemporary American Crafts in the Philadelphia Museum of Art; Elie Nadelman: Classical Folk;* and *United in Beauty: The Jewelry and Collectors of Linda MacNeil.* She has contributed to numerous other publications, including *One of a Kind: American Art Jewelry Today* and *Turning Wood into Art: The Jane and Arthur Mason Collection.* She has lectured widely on twentieth-century art and served as guest curator for several exhibitions, among them *Seductive Matter* and *Romancing the Brain.* Ramljak holds graduate degrees in art history from the University of Michigan and the Graduate School of the City University of New York. She lives in Bethel, Connecticut.

James H. Sanders is former director of the Sawtooth Center for Visual Art; founder and principal of the Arts-Based Elementary School in Winston-Salem, North Carolina; and former director of the Ozark Craft Guild,

Arkansas. He earned his B.F.A. at Arkansas State University; an M.F.A. from Southern Illinois University Carbondale; and a Ph.D. in education from the University of North Carolina, Greensboro. Sanders is author of *Founders: A Social History of a Community School of Art* and numerous scholarly essays on queer theory and arts education. He serves on the National Art Education Association's Lesbian, Gay, Bisexual and Transgender Issues Caucus and the Curriculum and Pedagogy Conference. He is associate editor for the *International Journal of Gay and Lesbian Issues in Education*. He is visiting associate professor at Ohio State University and lives in Columbus, Ohio.

Marcia Tucker is founding director emerita of the New Museum of Contemporary Art, New York, where from 1979 until 1999 she organized such major exhibitions as *The Time of Our Lives: A Labor of Love* and *Bad Girls*. She was the series editor of *Documentary Sources in Contemporary Art* and of five books of theory and criticism published by the New Museum. Prior to founding the museum, she was curator of painting and sculpture at the Whitney Museum of American Art, where she organized major exhibitions of the work of Bruce Nauman, Richard Tuttle, Lee Krasner, and Joan Mitchell, among others. She was the 1999 recipient of the Bard College Award for Curatorial Achievement and received the Art Table Award for Distinguished Service to the Visual Arts in 2000. She has taught, written, lectured, and published widely in America and abroad and lives in New York City.

Polly Ullrich has combined careers as an art critic and a studio potter. She holds an M.A. in art history, theory, and criticism from the School of the Art Institute of Chicago and an M.A. and B.A. in journalism from the University of Wisconsin, Madison. She has served on panels, curated and juried art exhibitions, and lectured frequently about the impact of work based in craft traditions on contemporary art. Ullrich has written analyses and reviews for the *New Art Examiner, Sculpture, Fiberarts, American Craft, Surface Design Journal, Ceramics: Art and Perception, Metalsmith*, and *Bridge* magazine, while maintaining a pottery studio in Chicago. Before turning to ceramics and art criticism, Ullrich worked as a freelance journalist, writing for the *New York Times, Newsweek, Chicago* magazine, and the *Chicago Sun-Times*. She lives in Chicago.